Love and Marriage in Renaissance Florence

The Courtauld Wedding Chests

THE
COURTAULD
Gallery

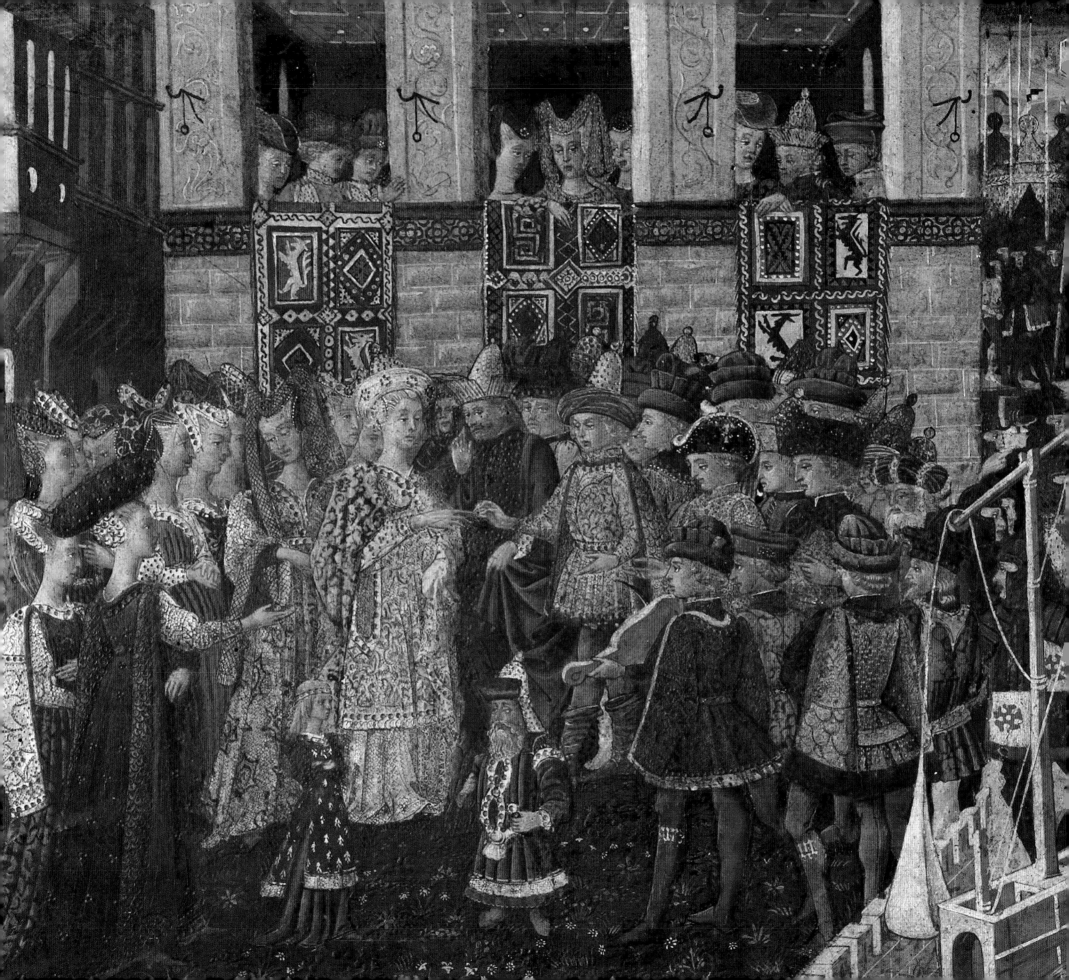

Love and Marriage in Renaissance Florence

The Courtauld Wedding Chests

Caroline Campbell

with contributions by
Graeme Barraclough and Tilly Schmidt

THE COURTAULD GALLERY
IN ASSOCIATION WITH
PAUL HOLBERTON PUBLISHING
LONDON

First published to accompany the exhibition

Love and Marriage in Renaissance Florence
The Courtauld Wedding Chests

at The Courtauld Gallery
Somerset House, London
12 February – 17 May 2009

The Courtauld Gallery is supported
with funds from the Arts and Humanities
Research Council (AHRC)

Arts & Humanities
Research Council

ISBN 9781903470916

British Library Cataloguing in Publication Data

A catalogue reference for this book is
available from the British Library

Produced by Paul Holberton publishing
89 Borough High Street, London SE1 1NL
www.paul-holberton.net

Designed by Philip Lewis
Origination and printing by
e-graphic, Verona, Italy

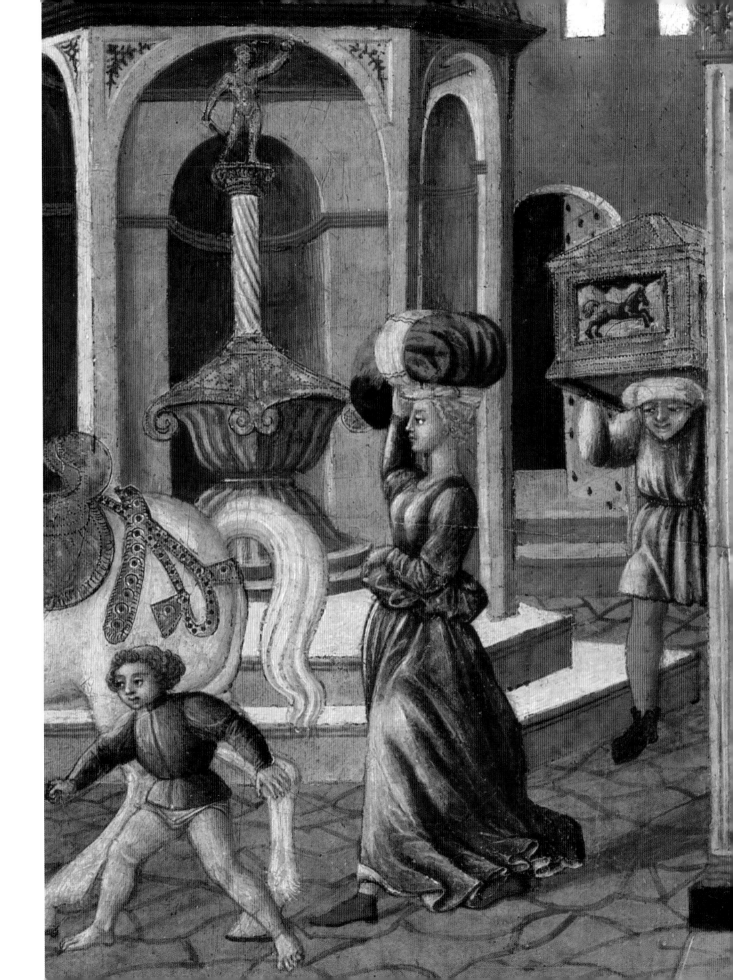

CONTENTS

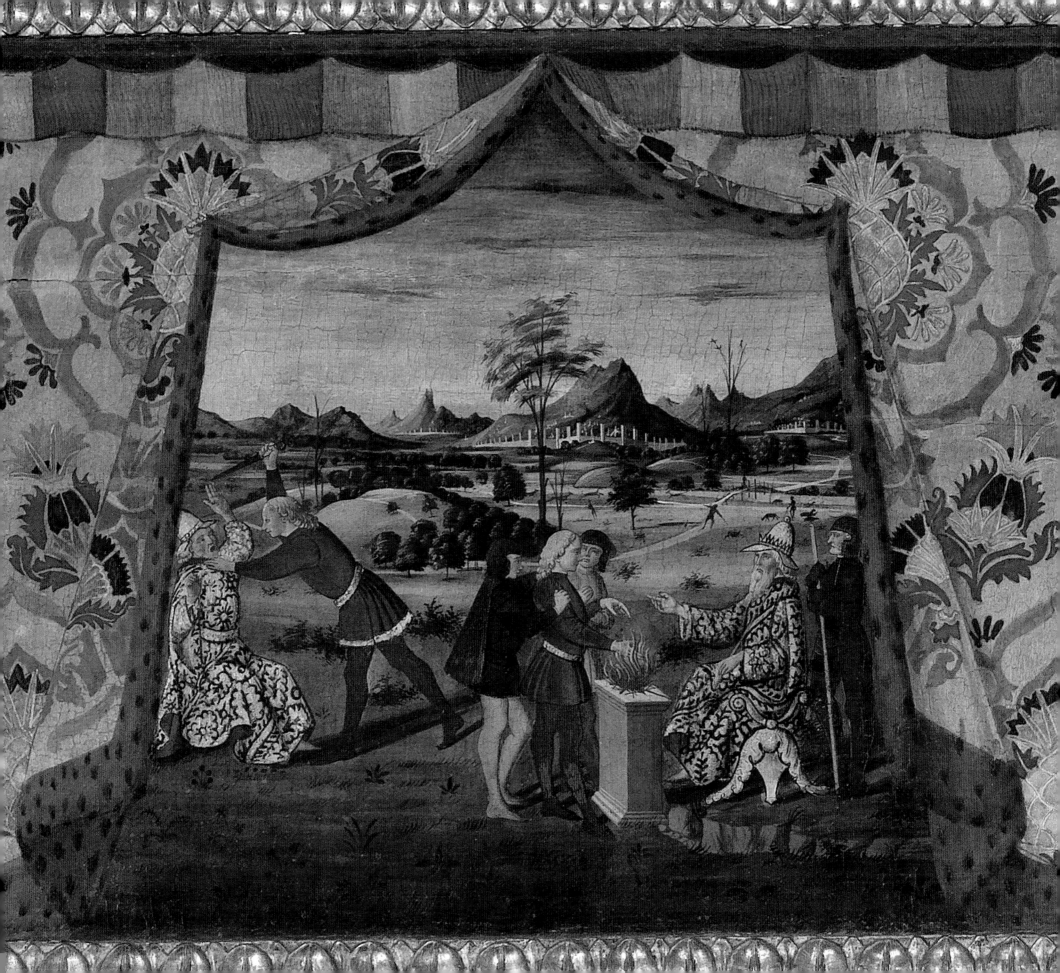

The collection owned by the Samuel Courtauld Trust and held at the Courtauld Gallery covers a broad chronological range and comprises paintings, drawings, prints, sculpture and decorative arts. We are fortunate that in each of these areas the collection includes works of singular importance which can claim status as reference pieces. This exhibition examines two such works: the Morelli-Nerli *cassoni*. These magnificently decorated objects are unique as the only pair of Renaissance wedding chests to remain with the *spalliera* panel or backboard which was made for them. In addition, the rare survival of their commissioning documents means that the circumstances of their creation can be re-created. This exhibition sheds new light on these works and in so doing makes a significant contribution to this field of study.

The Courtauld has a successful and distinctive exhibition policy, which asserts the value of the study and enjoyment of works of art in depth. Our approach relies heavily on a group of generous and loyal supporters who share our ethos and our belief that works of art reward such focused attention and research. *Love and Marriage in Renaissance Florence* could not have been mounted without the support and enthusiasm of the exhibition benefactors, Madeleine and Timothy Plaut, whom The Courtauld is very fortunate to count among its closest friends. I also wish to extend my warm personal thanks to Hugues and Emmanuelle Lepic, who have once again given us their generous support. No less thanks are due to the exhibition's other supporters: The Italian Cultural Institute, The Samuel H. Kress Foundation and The Michael Marks Charitable Trust. We are profoundly grateful to them for their continued support, which has enabled us to organise this exhibition, the first to focus on *cassoni* in the United Kingdom.

DEBORAH SWALLOW
Märit Rausing Director
The Courtauld Institute of Art

In November 1472 a young Florentine merchant, Lorenzo Morelli, brought his new wife Vaggia Nerli to her marital home, his palace on the city's Borgo Santa Croce. Among the most important of the worldly goods commissioned to celebrate this alliance between two of the city's powerful patrician families was a pair of wedding chests with a *spalliera* or backboard running behind them.

Painted wedding chests, or *cassoni*, were an integral part of the marriage rituals of the Florentine elite during the fifteenth century. They were highly significant objects, representative of family status and aspirations, whose manufacture involved a greater financial outlay than many of the fifteenth-century paintings we value so highly today. However, Lorenzo Morelli's chests were particularly special. He was a young man with a deep interest in the arts, and these were the most expensive art objects he ever commissioned for his home. Adorned with gold, and beautifully painted with stories from Roman history, the chests were given a privileged position in the bridegroom's *camera* or chamber. In 1680, over two hundred years after they were made, the chests were still in the Morelli house in Florence.

In 1947 the Morelli-Nerli chests were bought by Arthur Lee, Viscount Lee of Fareham, for the considerable sum of £10,000. Lee died later that same year and the chests formed part of his great bequest to the Courtauld Institute, which he had founded in 1932 with Samuel Courtauld and Sir Robert Witt. The acquisition of the Morelli-Nerli chests was a fitting end to Lee's career as a collector, encapsulating his deep interest in Renaissance art and craftsmanship.

Lord Lee hoped that the collection with which he endowed The Courtauld would serve as a basis for the Institute's object-based teaching and research, with the Gallery ensuring that this benefited a wide audience. *Love and Marriage in Renaissance Florence* would surely have delighted him. Not only does it shed significant new light on two defining works of his collection but it arises fully out of the culture which he hoped to foster at the Institute with his bequest: the exhibition curator began her explorations of this subject through the Morelli-Nerli chests as a post-graduate student at The Courtauld over a decade ago.

The Courtauld Gallery has built a reputation for focused exhibitions in which the study of masterpieces from the permanent collection frequently acts as a means of presenting new research on important and sometimes neglected areas of art historical study. This approach is particularly rewarding in the present case. The value accorded to painted *cassoni* by Lorenzo Morelli and his contemporaries stands in stark contrast with their later debased art historical status. The serious scholarly study of *cassoni* is, in fact, a development of the last thirty years, and this exhibition is the first in the United Kingdom dedicated to the subject. The exhibition and its catalogue are a significant contribution to the understanding and appreciation of these remarkable and complex works in which Lee saw the Florentine Renaissance so richly manifested. We are deeply indebted to the lenders, sponsors and other supporters whose great generosity has made this possible.

ERNST VEGELIN VAN CLAERBERGEN
Head of the Courtauld Gallery

SAMUEL COURTAULD SOCIETY

The Courtauld is grateful for the significant annual support that it receives from the members of the Samuel Courtauld Society.

DIRECTOR'S CIRCLE

Anonymous
Andrew and Maya Adcock
Apax Partners
Christie's
Nicholas and Jane Ferguson
Sir Nicholas and Lady Goodison
James Hughes-Hallett
Madeleine and Timothy Plaut
Paul and Jill Ruddock
Sotheby's
The Worshipful Company of Mercers

PATRONS' CIRCLE

Anonymous
Agnew's
Lord and Lady Aldington
Jean-Luc Baroni Ltd
Philip and Casie Bassett
Sabine Blümel
Charles and Rosamond Brown
The Lord Browne of Madingley
Mr Damon Buffini
David and Jane Butter
Julian and Jenny Cazalet
Mr Colin Clark
Mark and Cathy Corbett
Mr Eric and Mrs Michèle Coutts
Nick Coutts
Mark Cunningham and Her Royal
 Highness Princess Charlotte
 of Luxembourg
Samantha Darell
David Dutton
Mr Gary Eaborn and Miss Sylvia Wong
Mr and Mrs Thomas J. Edelman

Mr Roger J H Emery
Ms Veronica Eng
Mr Sam Fogg
The Lady Goodhart
Lucía V. Halpern and John Davies
Elaine Hansen
David Haysey
Hazlitt, Gooden & Fox
Mr and Mrs Schuyler Henderson
Philip Hudson
Nicholas Jones
Daniel Katz Ltd
James Kelly
Norman A. Kurland and Deborah A. David
Helen Lee and David Warren
Gerard and Anne Lloyd
Stuart Lochhead and Sophie Richard
Mr Jay Massey
Clare Maurice
The Honourable Christopher McLaren
Norma and Selwyn Midgen
Cornelia S. Edelman Moss and
 James Moss
John and Jenny Murray
Mr Morton Neal CBE
Mrs Carmen Oguz
Mr Michael Palin
Lord and Lady Phillimore
Mr Richard Philp
Leslie Powell
Mr and Mrs Herschel Post
Pam Scholes
Richard and Susan Shoylekov
William Slee and Dr Heidi Bürklin-Slee
Sir Angus Stirling
Johnny Van Haeften
Mrs Elke von Brentano
Erik and Kimie Vynckier
The Rt. Hon. Nicholas & Lavinia Wallop
Susan Weingarten
Jacqui and John White
Matthew and Molly Zola

ASSOCIATES

Anonymous
Mrs Kate Agius
Lord Jeffrey Archer
Hugh Arthur
Rupert and Alexandra Asquith
The Hon Nicholas Assheton CVO, FSA
Mrs James Beery
Bonhams 1793 Limited
Mr Oliver Colman
Emma Davidson
Simon C. Dickinson Ltd.
Mr Andrew P Duffy
David and Diane Frank
Margaret L. Ford
Mrs Judy Freshwater
The Rev. Robin Griffith-Jones
Jill Kastner
Timothy and Megan Kirley
Mark Lewisohn
Anthony Loehnis
Mark and Liza Loveday
Dr Chris Mallinson
Philip Mould Ltd
Roger Orf and Lisa Heffernan
Mary Oury
Jilly Parsons
The Lady Ridley of Liddesdale
Paul Stimson
Mr Robert Stoppenbach
Dr Deborah Swallow
Yvonne Tan Bunzl
The Ulrich Family
Nicholas and Venetia Wrigley

EXHIBITION BENEFACTORS AND SUPPORTERS

This exhibition has been made possible by the following:

EXHIBITION BENEFACTORS

Madeleine and Timothy Plaut

EXHIBITION SUPPORTERS

The Italian Cultural Institute
The Samuel H. Kress Foundation
Mr and Mrs Hugues Lepic
The Michael Marks Charitable Trust

ACKNOWLEDGEMENTS

On behalf of The Courtauld, I would like to thank all those who have lent generously to this exhibition: The National Gallery of Scotland, the Earl and Countess of Harewood and the Harewood House Trust, and several lenders who wish to remain anonymous.

The exhibition would not have been possible without the support of the Government Indemnity Scheme and our thanks are due to Louise Adkin and her colleagues.

I would like to acknowledge the generous support I have received from Deborah Swallow, Director of the Courtauld Institute and Ernst Vegelin van Claerbergen, Head of the Courtauld Gallery, as well as from the staff of the Courtauld Book and Image Libraries, the Warburg Institute Library, the National Gallery Library, the British Library and the following individuals:

The Duke of Abercorn, Marta Ajmar-Wollheim, Cristelle Baskins, Andrea Bayer, Alex Bell, Julia Blanks, Sue Bond, Alixe Bovey, Helen Braham, Virginia Brilliant, Anthea Brook, Beverly Brown, Stephanie Buck, Aviva Burnstock, Jill Burke, Jennifer and Norman Campbell, Maryellen Cetra, Michael Clarke, Ron Cobb, Robert Colby, The Earl and Countess of Crawford and Balcarres, Fionnuala Croke, Louisa Dare, Emma Davidson, Flora Dennis, Jill Dunkerton, David Ekserdjian, Caroline Elam, Helen Faubert, Thomas and Debbie Fenton, Sacha Gerstein, Kerstin Glasow, John Goodall, Dillian Gordon, Heather Griffiths, Elspeth Hector, Tom Henry, Henrietta Hine, Paul Holberton, Antony Hopkins, Nick Humphrey, Frederick Ilchmann, Larry Keith, Kirstin Kennedy, Éowyn Kerr, Sally Korman, John Leighton, Philip Lewis, Clare Lodge, Janet McLean, Sophie Mallinckrodt, John Marciari, Liz Miller, Peta Motture, Jacqueline Musacchio, Natalia Owdziej, Laura Parker, Nicholas Penny, Madeleine Plaut, Carol Plazzotta, Anne Puetz, Victoria Reed, Francis Russell, Robert Sackville, David Scrase, Joanna Selborne, Nathaniel Silver, Carl Strehlke, Luke Syson, Paul Tear, Dora Thornton, Giovanni Tomasso, Dominique Vingtain, Richard Valencia, Aidan Weston-Lewis, Catherine Whistler, Joff Whitten, Timothy Wilson, Martha Woolf, Alison Wright, Barnaby Wright, Martin Wyld and James Yorke.

In addition, I wish to thank Alan Chong for the important role he played in the genesis of this exhibition and its catalogue, as well as Scott Nethersole, who has shared most kindly with me his unpublished research on representations of battles on *cassoni*. I also owe a large debt to Graeme Barraclough and Tilly Schmidt, who have been the most thoughtful and helpful of colleagues.

I am most especially grateful for all the encouragement I have received from Timothy Plaut, whose scholarly enthusiasm for the subject of *cassoni* knows no bounds. This exhibition and catalogue could not have happened without him.

Many people over the years have assisted me most generously with the research which has become this catalogue, and I hope I have not left out anyone inadvertently. However, I am particularly indebted to my teachers at The Courtauld, Jennifer Fletcher and Patricia Rubin. Pat supervised the PhD thesis which began my explorations of *cassoni*. My thinking on this – and many other subjects – owes a great deal to Pat. I would like to dedicate this catalogue to her, in deep appreciation and admiration of her work as a scholar and a teacher.

CAROLINE CAMPBELL
Schroder Foundation Curator of Paintings

The Wedding Chest in Fifteenth-Century Florence

'Many things are necessary for marriage – precious garments, gems, a ring, various household goods, beds, great chests.'

Anonymous, *Book of the Four Cardinal Virtues*, Florence, c. 1450[1]

Marriage was one of the defining events in the lives of most fifteenth-century Florentines, as recounted in numerous texts, even those as insignificant as the *Book of the Four Cardinal Virtues* quoted here. Marriages at all levels of society were marked by symbolic exchanges of goods and gifts between the new husband and wife and their respective families. However, those marriages contracted between members of Florence's elite, the patriciate, were necessarily more lavish and costly than those of their social inferiors. As a mark of its importance, the achievement of a successful match involved a huge financial outlay, on the part of the families both of the bride (who provided her dowry) and of the groom. Patrician men tended to marry around the age of thirty, taking wives perhaps fifteen years younger than them. At the time of setting up their own household – which often coincided with their marriage – they made the most significant expenditure of their lives on furnishings and other domestic goods.

The present catalogue is devoted to one of the most significant categories of objects made in association with patrician marriages in Renaissance Florence: painted great chests. These grand pieces of furniture (often made in pairs) adorning the palaces of the Florentine elite were lavishly decorated with gold, silver and figurative paintings. Intended for use in private houses, and to provide storage, these chests are now displayed in many public museums as art objects. Their production was not restricted to Florence or Tuscany. They were made throughout Italy, and for courts as well as cities. However, the largest single number of surviving chests can be associated with Florence (for an examination of their attraction to collectors, see below, 'Creating *Cassoni*'), and historians have studied Florentine marriage customs and rituals more comprehensively than those of the rest of Italy. As a result it is possible to acquire a greater understanding of the use, development and relatively brief popularity of painted great chests in Florence than elsewhere in late fourteenth- and fifteenth-century Italy. Yet at the outset this story is also confused by their complicated historiography, which was responsible for their wholesale reconstruction in the nineteenth and early twentieth centuries.

Definitions

The very question of what these objects should be called remains an issue of debate. Today, Renaissance painted great chests tend to be called *cassoni*,[2] but this is only one of the names given to chests in contemporary documents. The issue is further complicated by translation, as the English word 'chest' (Italian *cassa*, *cassone* meaning 'large chest') covers a number of Italian possibilities. The chest was one of the most significant items of furniture in fifteenth-century Florentine households. Chests could be used as seats, or even – if necessary – as temporary beds. In spite of the proliferation of furniture types, they remained the most important storage piece in Florentine homes well into the sixteenth century.

Chests could be subdivided into a number of different categories, each of which had a proper name. Recent studies of fifteenth-century Florentine inventories have shown that there were four classes of chests in existence.[3] The most basic (*casse*) were simple storage boxes. A larger chest, sometimes decorated with carving or other ornament, and occasionally with painting, was called a *cassone*.[4] The closely related *cofano* appears to have been a chest like a *cassone* but with a rounded lid. The most impressive category was the *forziere*. These were great chests adorned with front and side panels painted with narrative scenes, and sometimes also with painted lids and backs. Sometimes these were decorated further on their interior with simple textile-inspired patterns (see cat. 1, 2, 3 and 4). A few surviving examples contained figurative decoration on their inside lids (see fig. 1). The word's etymology (derived from the medieval French word *forcier*, to close by force) implies that it meant specifically a chest with a lock.[5] Both the evidence of surviving chests (such as fig. 25) and of contemporary inventories suggest that the majority of painted great chests fitted into this category, although the term was not exclusively reserved for them.[6]

Fig. 1
Giovanni di Ser Giovanni (Lo Scheggia),
*Chest with Hersilia interrupting the Battle
between the Romans and the Sabines,*
around 1460
Statens Museum for Kunst, Copenhagen

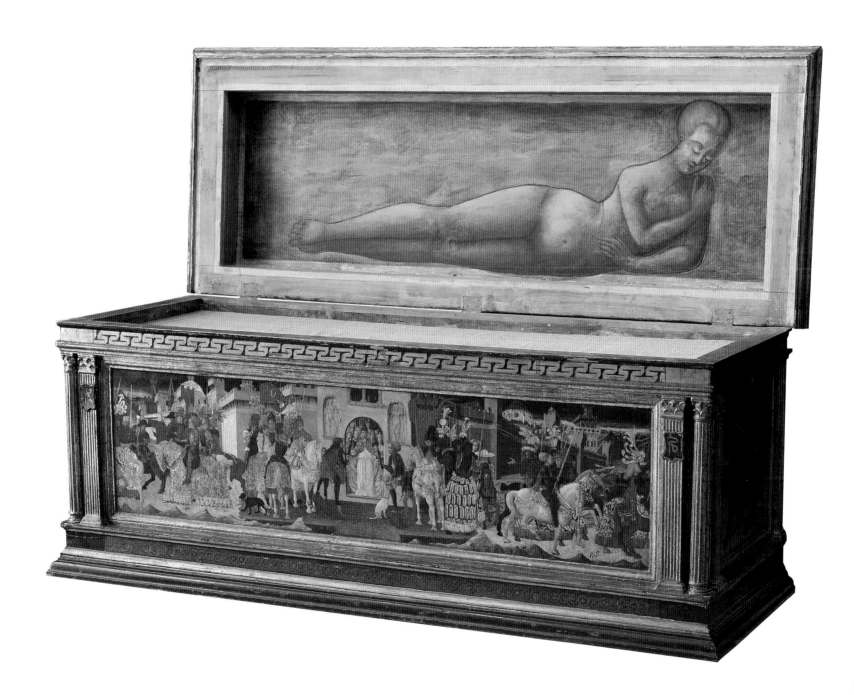

The use of the word *forziere* as a precise descriptive term was short. By the mid sixteenth century, the word *cassone* had supplanted *forziere* as the specific name for a painted chest. The latter term became used more in its modern meaning, as a strong box.[7] This change seems to mark the demotion of the painted chest from a highly valued form to a shockingly old-fashioned – if historically significant – object. It is certainly in this sense that the sixteenth-century painter and writer Giorgio Vasari (1511–1574) described painted chests (fifteenth-century *forzieri*) as *cassoni*. Vasari was the first person to attempt a historical definition of the painted chest (see below, 'Creating *Cassoni*'), and he has been censured roundly – and somewhat unfairly – by subsequent scholars for the supposed inaccuracy of his study and for this usage, as for much else in his *Lives of the Artists*.

Vasari's use of *cassone* has meant that the word has – wrongly – become a catch-all term for all varieties of furniture painting, used without reference to its fifteenth- and sixteenth-century meaning. It is unfair, however, to criticise Vasari for the failings of some of his later readers. He was simply following the terminology current in the later sixteenth century. It is similarly employed in inventories to describe what was by that date an antiquated type of painted decoration. For example, the inventory taken of the paintings and statues in the Guicciardini house in Florence after Marchese Piero d'Agnolo's death in 1626 mentions several paintings 'which were … fronts of *cassoni*'.[8] A hundred years earlier, when they would have probably been in a prominent space rather than a storeroom they would have been more likely called 'fronts of *forzieri*'.[9]

What should these objects be called today? There is no doubt that the term *cassone* was not usually employed for painted chests in the fifteenth century. However, the term is the only one familiarly used for what are not now familiar objects. It is generally understood as a shorthand for a chest with painted panels set into its front and sides. The word *cassone* has a further advantage, in the insight it gives into the complicated history of the extant wedding chests, in particular their classification as 'relics' by Vasari, and their widespread remaking in nineteenth-century Florence as '*cassoni*', following Vasari's description in his 'Life of Dello Delli' (see below, 'Creating *Cassoni*'). For these reasons I have decided to retain the modern usage.[10] But regardless of what they were – or are – called it is undeniable that in their heyday during the fifteenth and early sixteenth centuries, painted chests were the most opulent category of chest, created to celebrate and symbolise great familial occasions. Highly decorated, gilded and painted, these substantial objects were designed to impress.

Functions

'*Giovanni di Marcho the painter had 55 florins on the 25 March 1422 They are for a pair of painted chests . . . which will be given to Constanza my niece when she goes to her husband.*'[11]

'*On the 23rd day of June Maria came to our house, and accompanying her were Antonio di Giovanni Minerbetti … and Messer Tomasso my father … and it was desired that she had her* forzieri *behind* [*her*].'[12]

The commissioning of pairs of painted great chests was generally associated with marriage. Their systematic production began in the late fourteenth century, when increasingly elaborate furnishings began to be made for patrician households.[13] The workshop book of the painters Apollonio di Giovanni and Marco del Buono Giamberti, part of which survives in a seventeenth-century transcription, records (from 1446 onwards) their commissions to paint *forzieri* destined for young women (who are identified by their father or brother's name, sometimes also by that of their husband).[14] Until the middle of the fifteenth century these objects regularly played an important role in the last public act of the marriage ritual (the *nozze*), the procession which accompanied the young bride and her trousseau from her father's house to her husband's.[15] A painting by Lo Scheggia of *Trajan and the Widow* (fig. 2) gives a slightly fictionalised depiction of such a procession, adapted to the circumstances of the Widow's wedding to the

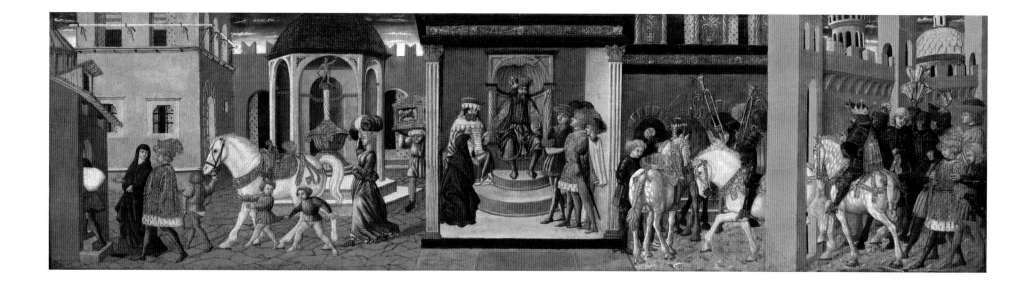

Emperor Trajan's son, including a servant bowed under the weight of a painted chest. Ironically, Lo Scheggia's panel – which must been made as the frontispiece of a great chest – records a custom that was no longer normal practice. By the date of its execution the bride's material possessions were generally carried to her marital home in straw baskets (*zane*).[16] The responsibility for purchasing the chests which had performed this function passed from the bride's father to the groom and his family. Together with sumptuous dresses and expensive jewels they became an important constituent of the counter-dowry (*contra-donora*), a riposte to the dowry provided by the bride's family. The symbolic message was clear. The bride was not only clothed by her husband, her new male protector in place of her father. Even the chests used to store such valuable possessions belonged to him. Their adornment and decoration was carefully chosen, not left to chance (see below, '"Many different things"').

Where were painted great chests displayed, once they were inside the palace of the bridegroom's family? Florentines were inveterate record keepers, and surviving inventories, especially those associated with the city's Office of Wards, give a clear account of

the contents of rooms, if not their internal arrangement. Painted great chests were one of the three most expensive categories of furniture found in fifteenth-century interiors. The others were *letti* (beds) and *lettucci*. The latter is another term for which an English translation is not readily forthcoming, but in essentials the *lettuccio* could combine the functions of a bed, a chair (or sofa) and storage.[17]

Florentine inventories, studied in particular depth by Attilio Schiaparelli and John Kent Lydecker, record that painted great chests were generally found in one type of room, the *camera* or chamber. This was the first category of room to become decorated richly.[18] These spaces, smaller than the *sala*, were where the majority of art objects were placed (these of course depicted devotional at least as much as secular subjects). Pairs of chests commissioned at marriage were located in the room described by several fifteenth-century patricians as 'my' chamber, *la camera mia*. For example, the painted great chests commissioned by Lorenzo Morelli at the time of his marriage to Vaggia Nerli in 1472 (cat. 1 and 2) were made specifically for this space. They joined several other very fine pieces of furniture which were described carefully in Lorenzo's account books of

seven years earlier: a massive *lettuccio* decorated with inlaid woodwork, including three *intarsia* triumphs, by Giuliano da Maiano, and its companion, a bed designed by Piero de' Servi, festooned with four candleholders and four more *intarsia* panels. A gesso Madonna in a tabernacle, a mirror in a carved frame, and a further terracotta of the Virgin Mary completed this ensemble.[19] Further additions were made to the existing furniture in 1472, such as a pair of curtains for the bed, and the decorative friezes on the bed and *lettuccio* were gilded.[20] This was presumably so that they would accord visually with the golden chests. The very detailed descriptions found in Lorenzo Morelli's accounts suggest his unusually high appreciation of exquisite furniture and objects. However, he placed them in a room entirely typical for his lifetime and social status. In addition, they were ordered, as was conventional, as part of 'My expenses … when I took my wife home'.[21]

Painted great chests belonged to decorative ensembles commissioned usually at the time of a patrician's first marriage. Second wives (a regular occurrence in this age of high mortality in childbirth) often had to resign themselves to living with some of the furnishings made for the arrival of their predecessor. Ginevra Gianfigliazzi married Lorenzo Tornabuoni in 1491. However, the 'two gilded and painted marriage chests with gilded and painted *spalliera* panels' recorded in 'Lorenzo's beautiful chamber'[22] following his execution for treason in 1497 were in all likelihood commissioned not for her, but for her husband's first marriage to Giovanna degli Albizzi in 1486.

Chests were immensely significant as memorials of marriage and family alliances, and once inside the bridegroom's palace were only accessible to household members, and the most privileged of guests. There is evidence to suggest that women had a particular emotional attachment to these chests, as physical souvenirs of their first marriage, the key event of their lives. They might stay in families for generations, and were placed in favoured locations. The pair of chests and their associated *spalliera* (a panel set into the wall of a room, sometimes above painted chests)[23] made for Lorenzo Morelli (cat. 1 and 2) – together with the rest of

his *camera* – passed into the usage of his son Leonardo at the time of the latter's marriage to Cornelia di Bartolomeo Buondelmonte in 1507.[24] They remained in the family's possession, in their main Florentine house, for more than two hundred years after their production. An inventory of 1680 records 'two painted, gilded and historiated chests with their *spalliera* and the arms of the Morelli and the Nerli' in the *camera grande* of the Morelli house on Borgo Santa Croce.[25]

These objects of value held further treasures within. Paul Schubring, the author of what remains the *magnum opus* on furniture painting (published in 1915), hypothesised that the very measurements of painted chests depended on the folded dimensions of the clothing they were accustomed to store.[26] The fifteenth-century Florentine theorist Leon Battista Alberti (1404–1472) was insistent on the proper use of these chests. In his treatise *On the Family* the main interlocutor Giannozzo advises his young wife to take care what she placed inside a chest. Dresses and textiles were suitable; chickens and oil were not.[27]

Production

*'The chest will be made in the usual manner,
it will cost between 70 and 75 florins.'*[28]

Giovanni d'Amerigo del Bene to Francesco del
Jacopo del Bene, 20 February 1381

The documentary record makes it clear that production of a chest or pair of painted chests was a normal and unremarkable part of marriage ritual, and they must have been made in considerable quantities. Although the earliest date of their production is not known for certain, they were being made in sufficient numbers that by 1349 Florence's Guild of St Luke included *pittori di casse* (painters of chests).[29] Approximately thirty years later, they were a recognised subgroup within the guild.[30] According to the regulations of the guild of carpenters (*legnaiuoli*), which was in existence by 1296, all chests were to be made by a member of the guild, presumably a specialist *cofanaio* (maker of chests).[31] The 1342 statutes set down their dimensions –

Fig. 3
Florentine, *Chest with a Wedding Procession,*
around 1430-40
Victoria and Albert Museum, London

although they could come in three sizes.[32] In the 1380s, these regulations were somewhat relaxed, and it was no longer necessary to pay extra (or supply a drawing) for chests which exceeded these measurements. The category of chest painters (also called *cofanaii*) seems to date from the 1320s, soon after the admittance of painters into the Guild of the Medici e Speciali, but they do not seem to have made complex narrative pictures for chests until the late fourteenth century.[33]

The production of painted furniture depended on a particularly close relationship between the makers of the furniture and the artists who subsequently decorated it. The physical condition of many surviving chests does not, unfortunately, provide secure evidence for their manufacture because the overwhelming majority underwent considerable reconstruction in

the nineteenth and early twentieth centuries (see below, 'Creating *Cassoni*' for further discussion of this topic).[34] Very few Florentine fifteenth-century painted chests have survived the five hundred years since their manufacture without almost complete restoration.[35] Among these are the Morelli-Nerli chests at the Courtauld (cat. 1 and 2), the Trebizond chest (fig. 25),[36] and a *pastiglia* and painted chest with a wedding procession in the Victoria and Albert Museum (fig. 3).[37] Some alterations have been made to the Morelli-Nerli and Trebizond chests, but they remain more substantially intact than the majority of the other surviving examples.[38] However, the Victoria and Albert chest is of particular interest since it retains its *predella* or base, on which other chests – including the Morelli-Nerli pair – originally sat.[39]

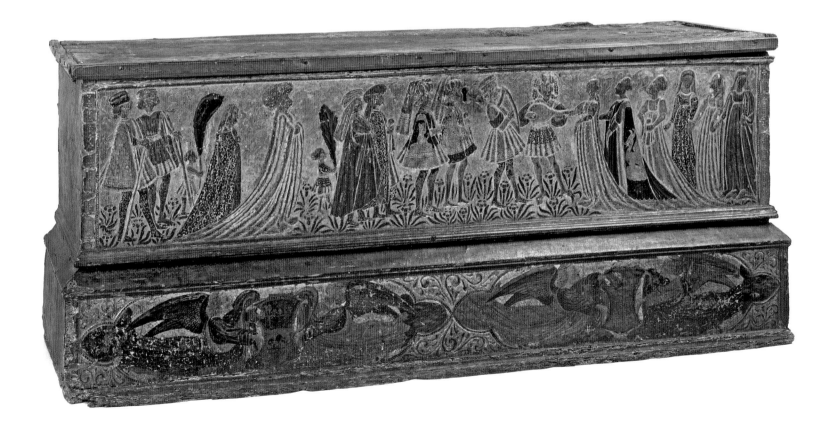

Although the surviving sample of Quattrocento painted chests is very small, it seems that their shape altered substantially between the late fourteenth and mid fifteenth centuries.[40] A chest from around 1380 now in the Victoria and Albert Museum (fig. 4), covered with chivalric motifs, is a good example of a late fourteenth-century chest.[41] It has a rounded lid, and is decorated with charming, colourful – albeit somewhat repetitive and simplistic – paintings of ladies and gentlemen on horseback and engaged in falconry. From the early fifteenth century, painted chests were more likely to adopt a box shape (for an example, see fig. 3). Later in the century, they tended to resemble sarcophagi with raised lids, such as the Morelli-Nerli chests (cat. 1 and 2). It is probable that this was in response to the production of burial sarcophagi, notably Verrocchio's magnificent example for the

tomb of Piero and Giovanni de' Medici in the Old Sacristy at San Lorenzo.[42]

Whatever the precise shape, three painted panels formed part of this structure – a long, thin one along the front, and two squatter pieces of wood which made up the left and right sides. The side panels, or *testate*, contained relatively simple decoration – perhaps an allegorical figure (such as the sides of cat. 1 and 2), several *putti*,[43] or a figure on horseback (cat. 8). The front panel was more elaborate, and tended to depict a narrative subject, drawn from a range of suitable sources from ancient and modern poetry and history (see below, '"Many different things"').

Cennino Cennini's *Libro d'Arte* (written by 1427) describes how a painter should work on a chest, starting with the application of the ground, followed by gold and colours, and then finally painting, ornamenting

Fig. 4
Tuscan (possibly Florentine), *Chest with chivalric motifs*, around 1380
Victoria and Albert Museum, London

Fig. 5 (*opposite*)
Francesco Pesellino, *The Triumphs of Love, Chastity, and Death*, around 1450
Isabella Stewart Gardner Museum, Boston

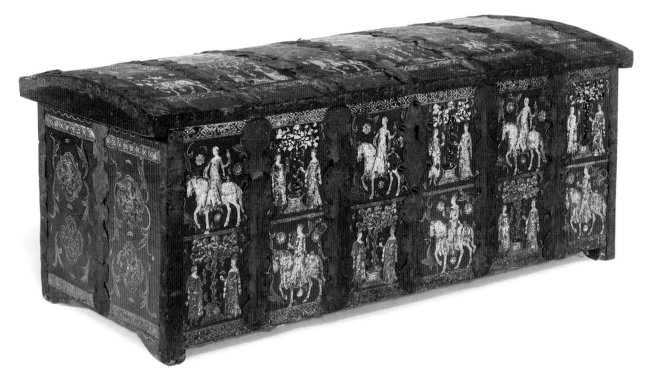

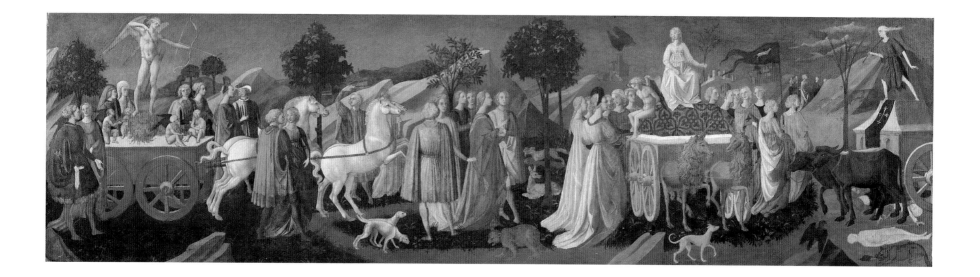

and varnishing.[44] This implies that when chests entered painters' workshops they were structurally complete, ready for gilding and painting. The Morelli-Nerli chests (cat. 1 and 2), as well as their accompanying *spalliera* and the lost base on which the chests once stood, are known to have been constructed by the carpenter Zanobi di Domenico, from whom Lorenzo Morelli also commissioned other carpentry around the time of his marriage.[45] Examination of the body of the chests has shown that they consisted of a basic box on to which the frame mouldings and decorations were attached. Jacopo del Sellaio and Biagio di Antonio were responsible for their decoration with paint and gold once the chests and *spalliera* were structurally complete.[46] The painting and gilding was completed within two months, November and December 1472.[47]

Lorenzo Morelli's chests were expensive, yet they were made wholly in accordance with the usual processes and procedures recorded by Cennino. For instance, his remark that the panels to be painted be attached to the chest with cloth soaked in animal glue and gesso was confirmed by x-radiography of the Morelli *cassone*.[48] Cennino comments that those wishing to paint chests really well should follow the method of painting on panel he has already described. However, he singles out several practices that he considered particularly important for painted chests. One was the careful application of cut-out designs in metal to the panel once it had been prepared with priming, ground and size. This technical feature was crucial for the front panels of painted great chests, which contain many areas of metal leaf, such as the elaborate gilded costumes and the silver (now blackened and tarnished, and overpainted in grey) applied to the armour of the soldiers in *The Siege of Carthage and Continence of Scipio* (cat. 7).[49] Subsequently, Cennino recommended that the painter draw outlines round the metal cut-outs. Then, after having varnished the ground, and prepared this further with beaten egg white, the painter should add drawing and ornamentation, presumably again to the areas of metal leaf, which were normally decorated with incision and simple punching (see cat. 1, for punching; cat. 7, for incision).[50]

It is easy to underestimate the appearance of painted great chests today, particularly as they are often displayed under objects of greater perceived value to give 'historical context'. Much abraded by their function as a unit of storage (most extant panels from chests show damage around the site of their keyhole), their gold and silver plate tarnished and overpainted, these chests are often sad shadows of the brightly coloured and expensively decorated pieces of painted furniture made for members of Florence's elite.

Attribution

One of the few objects to give a fair impression of its past glory is the justly famous Trebizond chest (fig. 25). This has long been ascribed to the workshop of Apollonio di Giovanni (1415/17-1465) and Marco del Buono Giamberti (1402-1489). The chance survival of a partial copy (dating from 1670) of an account book belonging to this shop has provided historians with a most important tool for understanding the manufacture of painted chests.[51] Other workshop account books survive for painters who worked on chests, including that of Bernardo di Stefano Rosselli (1450-1526),[52] but Apollonio and Marco del Buono's book gives a better sense of the sheer quantity of these objects which were produced in fourteenth- and fifteenth-century Florence, because numerous paintings made for chests survive from their workshop.[53] From 1446 until the dissolution of their partnership no earlier than 1457, the shop of Apollonio di Giovanni and Marco del Buono accepted over one hundred and seventy commissions to paint great chests. There may have been more, and, certainly, theirs was not the only active workshop. Paul Schubring identified numerous craftsmen who made and painted chests, including seven who defined themselves as *forzerinai* in Florence between 1404 and 1424, and Werner Jacobsen's recent studies of Florentine painters in the first half of the fifteenth century have unearthed fifty-two who called themselves furniture painters.[54] In addition, one should remember that painters who did not describe themselves as furniture specialists also painted domestic furnishings - including Pesellino (fig. 5), Uccello (fig. 19),[55] Botticelli (fig. 6) and Piero di Cosimo.[56]

Margaret Haines has discovered an enclave around Borgo Santi Apostoli already populated in the fifteenth

Fig. 6
Sandro Botticelli, *Venus and Mars*, around 1485
The National Gallery, London

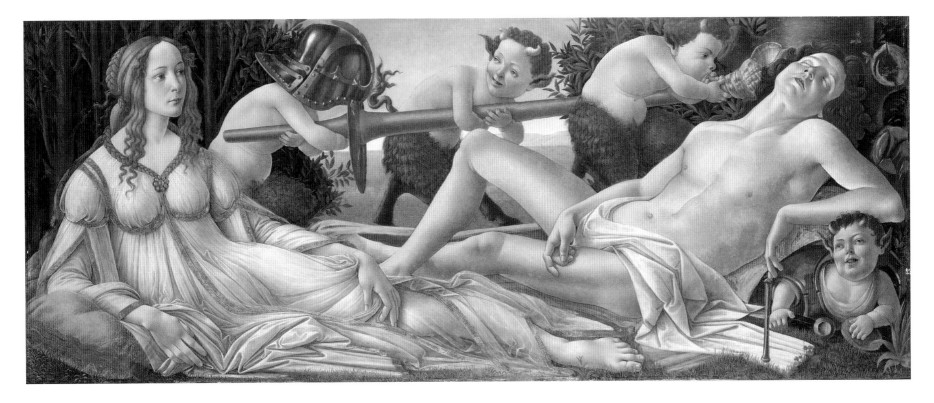

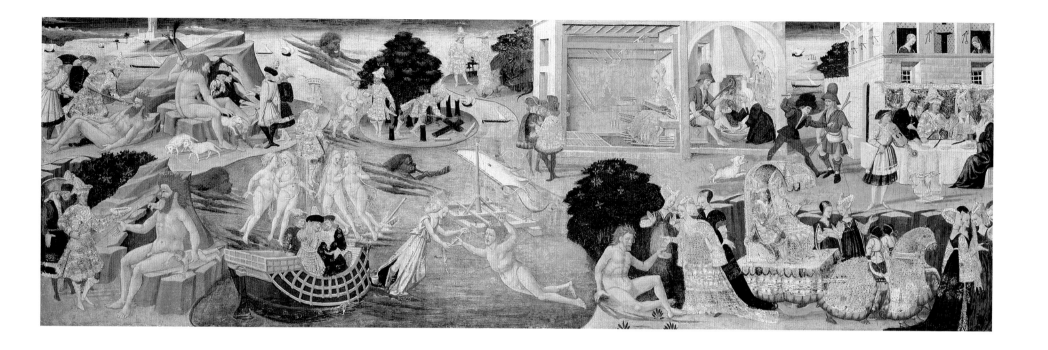

Fig. 7
Apollonio di Giovanni and Marco del Buono
Giamberti, *The Adventures of Ulysses*, 1435–45
The Art Institute of Chicago

century by furniture makers and artists specialising in chest painting. There seem to have been no less than three such painting workshops in the vicinity from the 1430s to the late 1460s, each occupied by a succession of different painters.[57] However, none of these masters' works can be identified with any surviving chests, or panels which have been subsequently detached from chests. This is a common problem, and as a result there has been an understandable tendency to attribute the bulk of the surviving panels from painted chests to one of the two workshops that anything substantial is known about – those respectively of Apollonio di Giovanni and Marco del Buono (see figs. 7 and 8) and of Giovanni di Ser Giovanni (1406–1486), commonly known (even in his own time) as Lo Scheggia, 'the splinter' (see figs. 1 and 2).

Although these two workshops were distinct they had a range of connections and inter-relationships. Lo Scheggia and Marco del Buono collaborated at the beginning of their careers, sharing premises, and jointly owing money to the *cofanaio* Luca di Matteo. This connection passed to the next generation, as Lo

Scheggia's grandson Tommaso and Marco's son Buono formed a partnership in the early 1480s.[58] It is also clear that motifs, perhaps transmitted by drawings, observation or the movement of personnel, passed between these painters and their workshops. For example, the two chest frontals representing *The Journey of the Queen of Sheba* and *The Meeting of Solomon and Sheba* (cat. 5 and 6) by Lo Scheggia are indebted to earlier compositions by Apollonio di Giovanni and Marco del Buono's workshop.[59] They are far from identical – Lo Scheggia's panels are inundated with members of Solomon and Sheba's entourages, while Apollonio's are characteristically slightly sparser. However, the main features of the later pair – the organisation of Sheba's procession, and in particular the architectural setting for her meeting with Solomon – derive from the models established by Apollonio di Giovanni and Marco del Buono.

Thanks to the surviving documentary and material evidence we know a considerable amount about both these artistic enterprises. Apollonio di Giovanni[60] was the first named Florentine painter specialising in

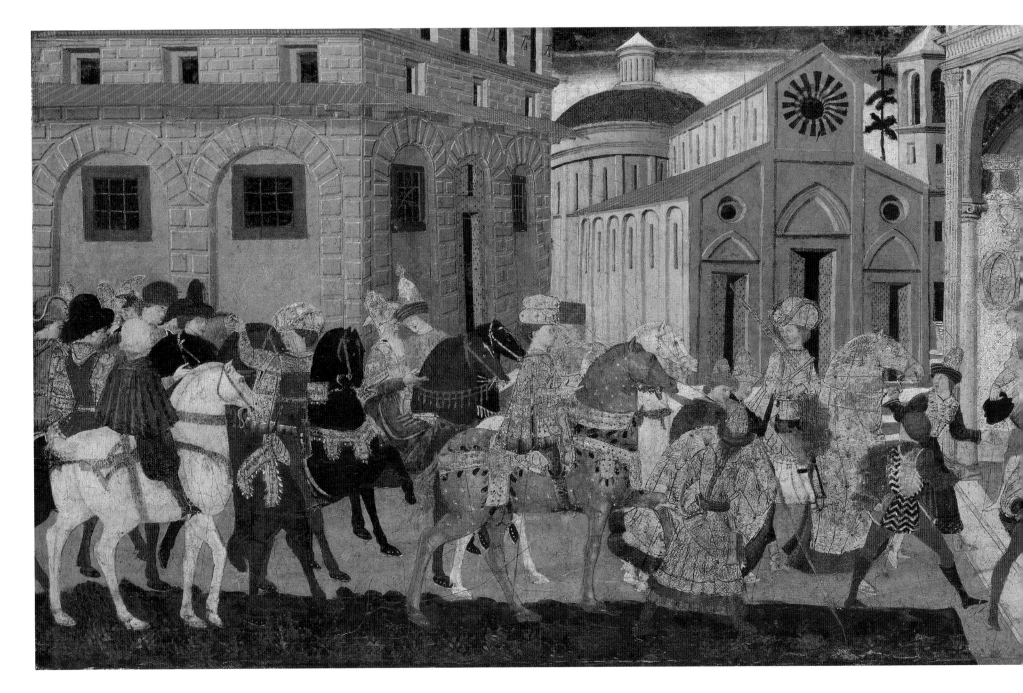

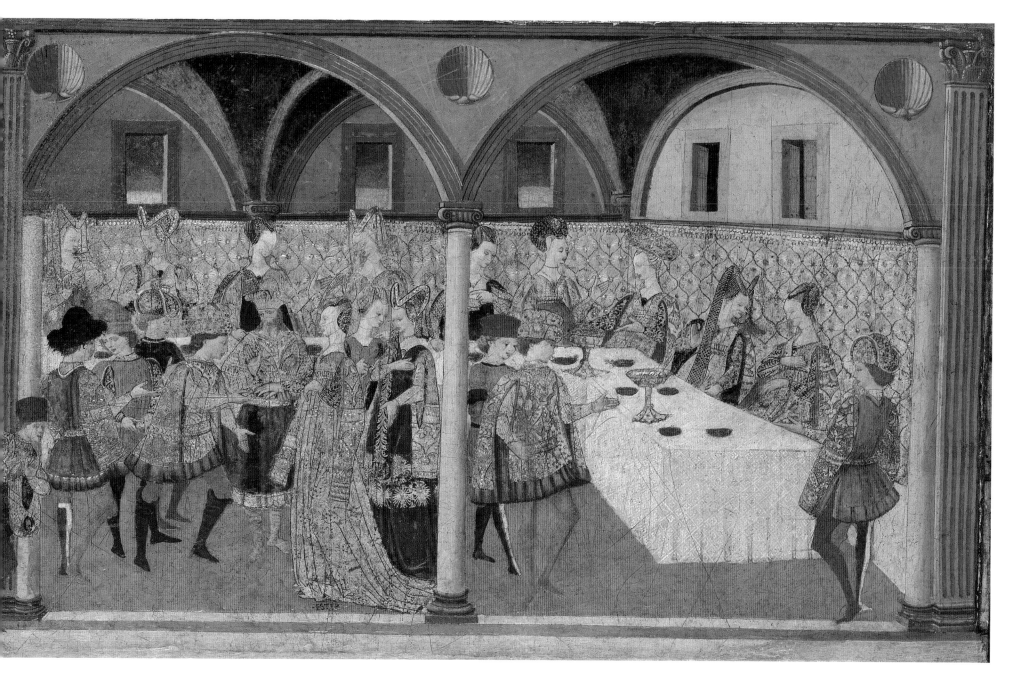

furniture to become familiar to modern historians, following Stechow's inspired identification of a painting in Oberlin of Xerxes's invasion of Greece with an entry in the account ledger of a *cassone* workshop discovered forty years earlier by Heinrich Brockhaus.[61] A Latin encomium by the humanist scholar Ugolino Verino praised the 'wonderous skill' (*mira … arte*) with which Apollonio, the 'Tuscan Apelles' (*tuscus Apelles*), painted the events of the Trojan War, even better than Homer and Virgil had sung them.[62] Those paintings which can be connected with Apollonio's shop make it clear that he specialised in depicting ancient histories, including those of Israel (fig. 8), but particularly those associated with Troy recounted in Homer (including fig. 7) and in Virgil's *Aeneid*. Apollonio was not simply a painter of furniture: he also illuminated manuscripts, and his masterpiece (Florence, Biblioteca Riccardiana, Ms 492) is a marvellously illustrated copy of the *Aeneid*. Less has been discovered about the work of his collaborator Marco del Buono, who trained in the workshop of Bicci di Lorenzo and matriculated as a member of the Arte dei Medici e Speziali in 1426.[63] On Apollonio's death, Marco's son Antonio inherited the contents of his workshop, and 'all that was good and bad within it'.[64]

Born in 1403, Giovanni di Ser Giovanni was Masaccio's younger brother. Following his training (also with Bicci di Lorenzo) he worked with his brother – notably on the celebrated Pisa Polyptych – becoming an independent master and a matriculated painter in the guild of the Medici e Speziali at the age of thirty. Befitting a specialist in furniture painting, he had also joined the carpenter's guild.[65] Lo Scheggia's closeness to woodworkers is evident in his involvement in the intarsia decoration of the Sacrestia delle Messe in Florence's Cathedral of Santa Maria del Fiore between 1436 and 1440. He is documented as one of the company of carpenters who produced this marvellously inventive inlaid woodwork, but his involvement was limited largely to drawing designs for it. Despite Lo Scheggia's other interests, the majority of his activity was apparently concentrated on art for the domestic setting. His clientèle included members of Florence's elite such as Marco Parenti (who married Caterina

Strozzi in 1447/8) and Lorenzo Morelli,[66] as well as Piero and Lorenzo de' Medici. The *desco* or birth tray (fig. 9) he made to commemorate Lorenzo's birth was found in Lorenzo's *camera* after his death,[67] and other domestic paintings by Lo Scheggia were recorded in the Medici Palace in 1492, including a *spalliera* and two *forzieri*.[68]

Lo Scheggia intended his workshop to be carried on by his son Antonfrancesco (who predeceased him) and his grandson Tommaso. By the time of his death in 1486 he had passed on his manner of painting not just to members of his family but to his many, still unnamed, artistic descendants who had passed through his workshop. He developed a busy, crowded style, but within well-defined and perspectival architectural settings. His paintings for chests are filled with bustling processions in which the participants almost jostle with each other. In contrast, Apollonio di Giovanni's narratives seem to take place only on one plane. The presence of dwarves or children is another characteristic of the work of Lo Scheggia and his followers (see cat. 7). His influence can be seen in the paintings produced by the partnership of Jacopo del Sellaio and Biagio di Antonio, including the chests and *spalliera* panel made for Lorenzo Morelli. This ensemble, Sellaio and Biagio's joint masterwork (cat. 1 and 2), was painted and gilded in a workshop in the Loggia dei Pilli which the pair shared with Giovanni di Ser Giovanni, and Antonfrancesco di Giovanni.[69]

Demise

Arguably, Lorenzo Morelli's pair of chests (cat. 1 and 2) mark the apex of the production of elaborate painted great chests in Florence. The heyday for these objects was relatively brief, between around 1400 and the third quarter of the fifteenth century. The movement towards more complex painted decorative schemes for patrician palaces[70] can even be seen in Lorenzo Morelli's commission. In 1472 he did not just order two chests: another panel, called a *spalliera* in his accounts, accompanied them.[71] This name was given to painted panels placed somewhere on the upper register of a

Fig. 9
Giovanni di Ser Giovanni (Lo Scheggia),
The Triumph of Fame (recto of Lorenzo de'
Medici's desco da parto), 1449
The Metropolitan Museum of Art,
New York

wall (yet the term is impossible to define consistently and precisely).[72] Sometimes they were commissioned to go with a pair of chests, as in Morelli's case, but they were not intended to form part of them physically.[73] Another comparable example is furnished by the exquisite paintings of the *Wooden Horse* and the *Death of Hector* by Biagio di Antonio (see fig. 15) which may be the '*ispalliere dorate e dipinte*' recorded with two painted chests in Lorenzo Tornabuoni's chamber in 1497.[74] However, the term *spalliera* had a number of usages in fifteenth-century inventories. It could be used to describe horizontal wall-hangings, or pieces of material placed on top of a bench,[75] and its name derived from the fact that it literally supported one's *spalle* (shoulders). Painted curtains draw back to reveal the historiated scenes on Lorenzo Morelli's *spalliera* panels, reflecting their descent from cloth hangings.

Some demand for painted great chests remained into the early sixteenth century. But rather than being done, as was customary before, by 'excellent masters',[76] such work was more often executed by *démodé* provincial painters. Among the last examples of Florentine paintings for chests to survive are a pair of panels produced by the Master of Marradi (cat. 9 and 10), who was active in the last quarter of the fifteenth century. This painter, associated with the Ghirlandaio workshop, specialised in historical (predominantly classical) scenes in contemporary dress.[77] His charming and colourful *Rape of the Sabine Women* and *Reconciliation of the Romans and the Sabines* are based on a model

devised by Apollonio di Giovanni and Marco del Buono's workshop at least twenty years earlier.[78]

If painted chests had become an outmoded form of domestic *décor*, what had replaced them? By the late fifteenth century their production had been oustripped by paintings which were generally less decorative and normally larger in size (such as fig. 6). It has often been assumed that all these paintings were made as *spalliere*, and that these were always set into the middle register of the panelling of a room. In fact, no hard and fast rules seem to have existed even as to what a *spalliera* panel might definitely be.[79] Unlike painted chests, the design, dimensions and placement of these paintings followed no set form. For instance, it is likely that Mariotto Albertinelli's *Creation and Fall* (App. no.1) is one of several *spalliera* panels commissioned for the Benintendi family in 1514–15, but it is unclear where or at what height this or the other parts of this ensemble were displayed.[80]

Nor were *spalliere* the only type of furniture painting to exist. In his 'Life of Dello Delli' Vasari also mentions paintings for *lettucci* and *cornici*.[81] The few documented schemes make it clear that there was no straightforward way of distinguishing between all these varieties of painting, since their figure scale remained very similar. Decorative ensembles could include every type of furniture painting, like the nineteen panels commissioned from Pontormo, Granacci, Bacchiacca, and Andrea del Sarto to decorate the 'Borgherini Bedchamber' in the Borgherini Palace between 1515 and 1518. Brenda Preyer

Fig. 10
Jacopo Pontormo, *Joseph's Brothers beg for Help*, probably 1515
The National Gallery, London

has identified this *camera* as the corner room overlooking the Piazza Santi Apostoli.[82] These paintings included panels probably placed in the front of chests at the foot of the bed (such as fig. 10), two small panels set into the side of the *lettuccio* and the corner of the bed, and a very large painting by Granacci, placed above the door to the *anticamera*.[83] The paintings did not exist in isolation. They were only one part of a *Gesamtkunstwerk*, made to decorate the furniture and panelling constructed by Baccio d'Agnolo, who was also responsible for the wedding chests, chairs, bed and ceiling.

By the mid sixteenth century, chests were generally decorated with carving (see fig. 11), not painting. The days of the painted chest as the primary variety of painted domestic decoration in Florence were long gone. The chest had been absorbed into more fluid and less regimented decorative schemes. However, the considerations that had shaped the production of painted chests remained. Marriage was the event which prompted their manufacture, and the requirements of paintings in the domestic setting stayed the same – to provide entertainment and instruction on a limited pictorial surface. The relative success of painted panels for chests to meet this difficult brief will be examined in the following essay.

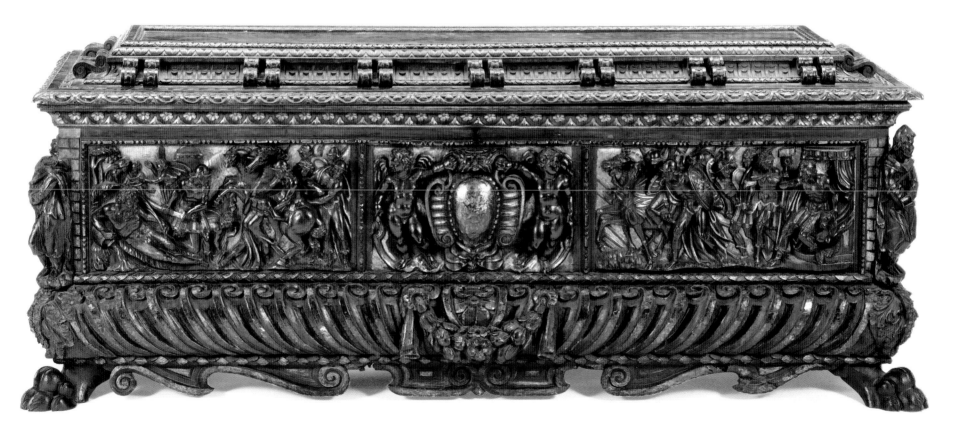

NOTES

1 Florence, Biblioteca Nazionale Centrale di Firenze (henceforth BNCF), II, I, 362, *Libro delle quattro uirtu chardinali*, f. 106r: '*molte sono le cose necessarie almatrimonio preziosi uestimenti gemme anella varie masserizie letterie forzieri*'.

2 This is the plural form of the word; the singular is *cassone*.

3 Thornton 1984; Thornton 1991, pp. 191–92; Lydecker 1987, pp. 156–58 and Appendix 5, pp. 286–88; Paolini 2006–07; Lindow 2007, pp. 144–45, 47–48.

4 Lindow 2007, p. 147 argues that there was also a subset of *cassoni*, those in the shape of a sarcophagus, and that sarcophagus-type *forzieri* were also found.

5 Paolini 2006–07, p. 120. In modern Italian, *forziere* is a strong box or safe.

6 Lindow 2007, pp. 147, n. 111 demonstrates that *cassoni* could also be painted.

7 For example, see Vasari 1550 and 1568, vol. 4, p. 540 (1568), where a student of Parmigianino breaks open a *forziere* in which prints and drawings are kept safe.

8 '*Due quadri, che sono due facciate di cassoni … Due quadri, che sono due altri faccie di cassoni*': Archivio di Stato di Firenze (henceforth ASF), CS-V 1430, p. 1, transcribed in Lydecker 1987, App. IX, p. 339.

9 Compare Lorenzo Morelli's credit account of 1472, where his wedding chests are called '*un paio di forzieri storiati e messi d'oro fine*' (ASF, Archivio Gherardi-Piccolomini d'Aragona 137, f. 72).

10 For similar reasoning, see Thornton 1991, p. 192.

11 '*Giovanni di Marcho dipintore de' avere a dì venticinque marzo 1422 fior. cinquanta cinque … Sono per un paio di forzieri … che li donai a la Chonstanza mia nipote quando si ando a marito*': Watson 2003, p. 376, n. 49.

12 '*A dì 23 di giugno [1493] ne venne la Maria a chasa nostra et achompagnolla Antonio di Giovanni Minerbetti … et messer Tommaso mio padre … et volle che l'avessi drieto i sua forzieri*': Biagi 1899, p. 13.

13 Lydecker 1987, pp. 209–21. Lindow 2007, pp. 145–46, disputes the assumption that most domestic furnishings were produced in association with marriage.

14 Callmann 1974, Appendix I, 'The Bottega Book', pp. 76–81 (Florence, BNCF, MS Magliabecchiano XXXVII, 305, Spogli di archivi, del Sen.re Carlo di Tommaso Strozzi, 1670, Sta Maria Nuova, 20, ff. 55r–64r).

15 For a summary of Florentine marriage customs in the fifteenth century, see Klapisch-Zuber 1984; Klapisch-Zuber 1985a, esp. 181–96; Randolph 1998; Syson and Thornton 2001, pp. 38–39; Rubin 2007, pp. 362–64; Krohn 2008–09.

16 Klapisch-Zuber 1985, esp. p. 219, nn. 18 and 19; Lydecker 1987, pp. 156–58 and Appendix 5, pp. 286–88; Paolini 2006–07, p. 120.

17 'Daybed' is a not absolutely accurate, but adequate translation.

18 Lydecker 1987a; Preyer 2006–07, pp. 40–41.

19 Lydecker 1987, pp. 115–17.

20 Lydecker 1987, pp. 119–20.

21 ASF, Archivio Gherardi-Piccolomini d'Aragona 137, f. 74, '*Spese per me nello sottoscritte chose quando menai la donna*' (see Lydecker 1987, p. 120).

22 ASF, Magistrato dei Pupilli avanti il principato, 181, f. 148r, col. 1, in the '*Camera di Lorenzo, bella … due forzieri da spose dorati e dipin[t]o chon ispalliere dorate e dipinte*'.

23 For a fuller discussion of the term *spalliera* (or *spalliere* in the plural) see below, pp. 24–26, nn. 71–75.

24 ASF, Archivio Gherardi-Piccolomini d'Aragona 184, f. 2r (Lydecker 1987, p. 187).

25 '*Dua [sic] cassone dipinti e dorati e storiati con sua spalliera con arme de' Morelli et Nerli*': ASF, Archivio Gherardi-Piccolomini d'Aragona 192 (loose sheets and booklets), 'Inventario delle masserizie della casa di Firenze, 1680' (Lydecker 1987, p. 287).

26 Schubring 1915, vol. 1, p. 15.

27 '*Donna mia, se tu nel tuo forziere nuziale insieme colle veste della seta e con tuoi ornamenti d'oro e gemme ponessi la chioma del lino, ancora v'asettassi il vasetto dello olio, ancora vi chiudessi entro e' pulcini e tutto serrassi a chiave, dimmi, ti parebbe averne forse cosí buona cura perché sono bene serrate? … E ben sai, moglie mia, che collocare e' pulcini in mezzo il lino sarebbe dannoso, porre l'olio apresso delle veste sarebbe pericoloso, e serrare le cose le quali tutta ora s'adoperano in casa sarebbe poca prudenza*': Alberti 1994, pp. 221–22.

28 '*Il forzerino si fa come s'usa: costano da 70 a 75 fiorini*': Brucker 1980, p. 254.

29 Nützmann 2000, pp. 11–12. For the most up-to-date account of the *forzerinai* see Jacobsen 2001, pp. 36, 42, 51–52.

30 Ciasca 1922, p. 308.

31 Watson 2003, p. 98.

32 Schiaparelli 1908, pp. 232–38.

33 Watson 2003, p. 98.

34 Technical examination has proved crucial in this regard: see for example Callmann 1999; Benoît 2004. I would like to acknowledge the (as yet largely unpublished) work of Tilly Schmidt, Graeme Barraclough, Aviva Burnstock and Éowyn Kerr (see Kerr 2008) on *cassoni* at the Courtauld Gallery and the Victoria and Albert Museum. The Furniture History Society Conference at the Victoria and Albert Museum in 2006 presented more exciting techincal study projects, all as yet unpublished.

35 Callmann 1974, p. 26; Callmann 1999.

36 For the Morelli-Nerli chests, see below, cat. 1 and 2; for the Metropolitan Museum chest, see most recently Krohn in Bayer 2008–09, cat. 56, pp. 129–33, with a comprehensive bibliography. The front panel representing the Battle of Trebizond was not the original panel set into this chest. Callmann 1974, cat. 23, pp. 63–64, was the first to hypothesise this.

37 I should like to thank George Bisacca in 2001 (Metropolitan Museum) and Éowyn Kerr (Kress Conservation Fellow at the Victoria and Albert Museum, 2006–07) for having kindly shared their knowledge of both objects with me.

38 See the entries for cat. 1 and 2.

39 Lydecker 1987, App V, p. 286.

40 There are many more surviving chests from the fourteenth than from the fifteenth century: see Callmann 1999, p. 342.

41 See Manton 2001.

42 I am indebted to David Ekserdjian for this suggestion.

43 For instance see London, National Gallery, NG 3826.

44 Cennini 2003, ch. 170, pp. 189–91, especially p. 189: '*Volendo lavorare choffani, overo forzieri, se gli vuogli fare realmente, ingliessali e tienne tutti quelli modi che tieni a lavorare in tavola, di mettere d'oro e di cholorire, e di granare, d'adornare, et di vernichare, senza distendermi a dirti di punto in punto.*'

45 ASF, Archivio Gherardi-Piccolomini d'Aragona 137, f. 63, credit entry (Lydecker 1987, App V, p. 286).

46 Davies 1995, vol. 1, pp. 35–36.

47 ASF, Archivio Gherardi-Piccolomini d'Aragona 137, f. 72 (Lydecker 1987, App. V).

48 Davies 1995, vol. 1, p. 35.

49 Cennini 2003, p. 190. I am extremely grateful to Tilly Schmidt for discussing with me her technical study and treatment of this panel at the Courtauld.

50 Cennini 2003, pp. 190–91.

51 Since it is a later copy, there are some legitimate doubts concerning the reliability of the Apollonio '*bottega* book'.

52 Padoa Rizzo and Guidotti 1986. Another chest painter who has been the subject of recent study is Giovanni dal Ponte; see Sbaraglio 2007.

53 Most of these are published in Callmann 1974, cat. 1–59.

54 Schubring 1915, vol. 1, pp. 82–90, esp. p. 87; Jacobsen 2001, p. 484.

55 Kanter 2000.

56 Geronimus 2006, chs. 3 and 4.

57 Haines 1999, pp. 42–44.

58 Haines 1999, pp. 41–43, p. 51.

59 Such as those reproduced in Callmann 1974, cat. 24–25 (pls. 145–46).

60 For a full summary of the documentary record which survives for Apollonio, see Jacobsen 2001, pp. 507–08.

61 Stechow 1944.

62 '*Maeonides quondam phoebeae moenia Troiae*
 Cantarat Grais esse cremata rogis,
Atque iterum insidias Danaum Troiaeque ruinam
 Altiloqui cecinit grande Maronis opus.
Sed certo melius nobis nunc tuscus Apelles
 Pergamon incensum pinxit Apollonius;
Aeneaque fugam atque iram Iunonis iniquae
 Et mira quassas pinxerat arte rates.
Neptunique minas summum dum pervolat aequor,
 A rapidis mulcet dum freta versa notis;
Pinxit ut Aeneas fido comitatus Achate
 Urbem Phoenissae dissimulanter adit
Discessumque suum, miserae quoque funus Elissae
 Monstrat Apollonio picta tabella manu': Verino 1940, Book II, VIII, p. 66; translation from Gombrich 1985, p. 12.

63 Jacobsen 2001, p. 287.

64 '*item iure legati reliquit et legavit iure legati Antonio Marci del Buono dipintore omne tutum et quicquid dictus testator haberet in apotheca pictoris ipsius testatoris tempore mortis ipsius testatoris. Et quod omnia debita e credita dicte apothece et omnes masseritias existentes in dicta apotheca et omne bonum et malum quod ipse testator haberet in dicta apotheca tempore eius mortis, legavit et*

reliquit suprascripto Antonio dummodo dictus Antonius solvat debita quod dictus Appollonius testator haberet in dicta apotheca et occaxione dicte apothece': Callmann 1974, App. II, pp. 83–84.

65 In 1433. See Jacobsen 2001, pp. 569–7.

66 Lydecker 1987, p. 117, n. 77.

67 Musacchio in Bayer 2008–09, cat. 70, pp. 154–56.

68 Spallanzani and Bertelà 1992, pp. 72–73.

69 Haines 1999, p. 60, Appendix, no. 6, p. 69 (transcribed by Brenda Preyer).

70 Goldthwaite 1993, pp. 224–36.

71 ASF, Archivio Gherardi-Piccolomini d'Aragona 137, f. 63, credit account.

72 For the difficulty of defining *spalliera* paintings, see note 79 below.

73 The attachment of the Courtauld chests to their present two *spalliere* is a later configuration, probably dating from the mid nineteenth century. See cat. 1 and 2 below.

74 Archivio di Stato, Florence, Magistrato dei Pupilli avanti il principato, 181, f. 148r; Kress 2004, pp. 257–58, identifies the Fitzwilliam panels as for chests, but this seems unlikely given their quite exceptional state of preservation.

75 Schiaparelli 1908, pp. 212–15, 298; Thornton 1991, p. 47, pl. 53 and p. 48.

76 Vasari 1550 and 1568, 'Life of Dello Delli' (1568), p. 38.

77 See Fahy 1976, p. 181.

78 For Apollonio di Giovanni and Marco del Buono's precedent, see Callmann 1974, cat. 46 and 47, pls. 196, 197, 255, 257, pp. 71–72.

79 For the argument that a *spalliera* was a distinct type of painting with its own narrative demands, see Barriault 1994, pp. 11 and 19, and in general pp. 11–49, 57–94. For a more questioning view, see Syson and Motture 2006, pp. 274–75; also Nelson 2007.

80 See Franklin 2005, pp. 104–05.

81 Vasari 1550 and 1568, 'Life of Dello Delli' (1568), vol. 3, pp. 37–38.

82 Preyer 2006–07, p. 42.

83 Preyer 2006–07, pp. 42–44.

'Many different things':[1] Transforming Stories into Painted History

'And the stories which they made on the front [of the chests] were for the most part tales taken from Ovid and from other poets, or stories recounted by the Greek and Roman historians; and also hunts, jousts, novelle of love, and other similar things, according to what each one liked best.'[2]

Giorgio Vasari, 'Life of Dello Delli', Florence, 1568

Writing in the mid sixteenth century, Giorgio Vasari was the first to comment on the extensive narrative repertoire of paintings made for chests and other types of furniture in fifteenth-century Florence. His account accords well with the material evidence of the several hundred paintings which survive today. As Vasari wrote, these do 'for the most part' represent tales from ancient poetry (including fig. 12), particularly Ovid's *Metamorphoses*, Greek and Roman history (including cat. 1, 2, 7, 9 and 10), as well as more contemporary subjects, drawn both from the poems of Boccaccio and Petrarch (cat. 3 and 4 and fig. 5) and (occasionally) from recent Florentine history (fig. 23) or chivalric imaginings (fig. 19). One other major source of inspiration for *cassone* panels, the Old Testament (see cat. 5 and 6), is excluded from Vasari's quick survey.

Despite this major lacuna, Vasari's account is worth examining further. Rather than being off-the-cuff remarks, Vasari's comments, made in the re-written 'Life of Dello Delli' in the second edition of his *Lives*, are based on a good knowledge of furniture paintings (see below, 'Creating *Cassoni*'). One feature of his survey is of particular interest because it elides the ancient and contemporary narratives represented on painted chests under the heading of *favole* or tales. Vasari felt that both ancient and modern sources were of merit for this art form, because they offered the artist the same material of jousts, tournaments, festivals and love stories, which he considered most appropriate for painted furniture.[3] Regardless of their subject matter and the workshop that produced them, the same details of costume, architecture or urban setting were employed

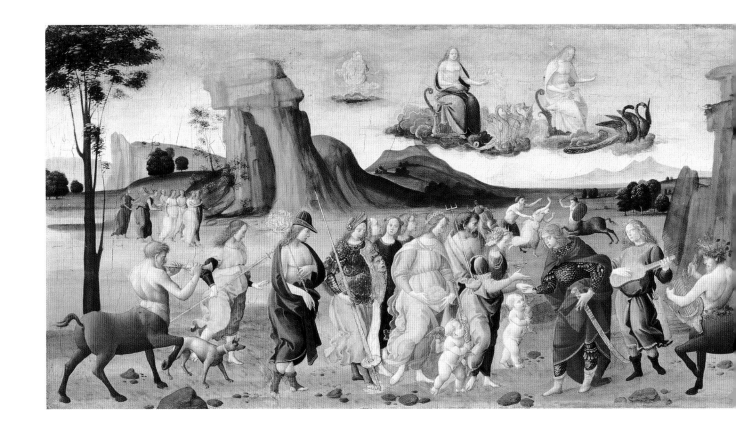

to depict ancient and modern stories, so that they seemed to belong to one world. Furthermore, Vasari's remarks concur with the surviving material evidence to suggest that subjects were chosen for *cassoni* because there was a clear sense of what was acceptable for depiction on this art form. We will find that unsuitable stories had to be edited and amended – in most cases by the painter as much as by the patron – in order to conform with their setting in a patrician home.

The narrative range of *cassone* panels was influenced enormously by their physical placement within the household and their common association with marriage. Painted chests were normally placed in a man's chamber (*camera*), and often commissioned as part of widespread changes to this room at the time of marriage, although evidence suggests they could also – sometimes – be found in rooms specifically designated for the women of the household.[4] A man's *camera* played a highly significant role in the activities of each nuclear family group within the extended family palace.[5] This was a multi-purpose space, which could be used both for private and public functions. Here the husband would rest and also, it was hoped, conceive with his wife the next legitimate generation of the *casa*. Appropriately virtuous and worthy images were believed to aid the successful production of children, and in particular of sons and heirs.[6]

The *camera* also regularly played host to gatherings of household members, including children and servants, as well as outside visitors. As a result it – and the objects it contained – were of great significance to heads of households, their heirs and other family members.

Lorenzo Morelli's chests (cat. 1 and 2) were re-used by his eldest son, in the same space, when he married.[7] Similarly, as recounted by Vasari, Margharita Borgherini (née Acciauoli) remained attached to her husband's bedchamber, commissioned by her father-in-law Salvi. She refused to divest it of its painted decoration (including fig. 10) 'from memory of him and love for my husband'.[8] Art commissioned for the *camera* was a key site of family identity. To separate it from the room it was designed for was to diminish its worth in economic terms, as well as its significance for genealogy and family history.

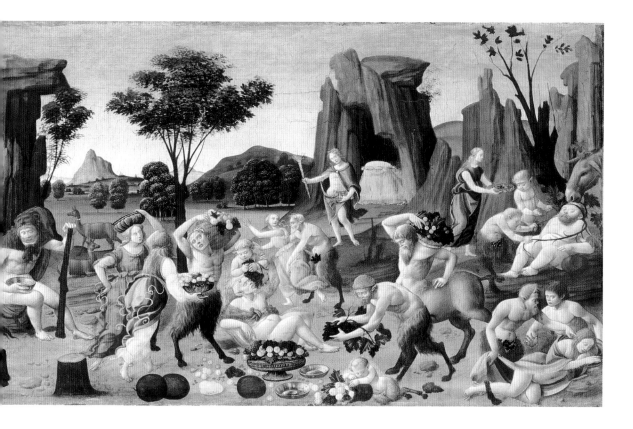

Fig. 12
Bartolomeo di Giovanni, *The Marriage of Peleus and Thetis*, 1490–1500
Musée du Louvre, Paris

31

Image as History?

In a passage made famous by Ernst Gombrich, the humanist poet Ugolino Verino eulogised the painter Apollonio di Giovanni, who specialised in *cassoni*, for producing erudite and moving depictions of ancient history (such as fig. 7) which were 'better' in their evocation of 'burning Troy' than the epics of Homer and Virgil.[9] Verino compared Apollonio directly to the ancient Greek artist Apelles, the paragon of painters. This 'Tuscan Apelles' also exploited his charm and skill as an interpreter to make history vividly present for those who used his paintings.

Adorned with coats of arms, painted chests embodied family identity, memory and history (see cat. 1 and 2). The stories they told were edited so that they conformed to the moral and exemplary significance with which, for Florentines, history was endowed. There is thus a sense in which these paintings can be considered as visual parallels to the contemporary writing, reading, and understanding of history.

The workshops that produced pictures for the domestic setting were also familiar with the production of cycles of sacred histories in churches. They had access to sophisticated means of pictorial exposition, and were able to compose coherent narratives in which several sources might be amalgamated. It can further be argued that in some of the techniques they used they were influenced by contemporary historians. Upon examination it emerges that secular paintings for the domestic setting were deliberate syntheses of different retellings of the tales they narrated, rather than simply visualisations of a single text.

This selection process produced painted histories which were compatible with wider assumptions about the content and use of history. They could at once furnish the more highly educated members of the household with subjects befitting their status and aspirations, allied with the most prestigious classical texts, while doing so in a manner familiar from more accessible vernacular sources. Ancient histories or poems may have been the first source for the artist and patron whose dual efforts and demands led to the production of these images, but the painted history was never intended to be a surface for the display of textual references. It was a field for an amalgamation of diverse sources in one setting. From these it created new and distinctive visual histories appropriate and relevant to patrician households. They were required to fulfil the primary function of history – that of instruction – in this case for a diverse audience in a single space.

Painters were not historians, and the formal connections between visual interpretations of ancient history and written histories can be overstated. However, a case can be made in support of the argument that painted domestic histories were influenced by new attitudes towards the writing and use of history, conceived by Brunetto Latini, augmented by Petrarch and Coluccio Salutati in the late fourteenth century, and expanded by Leonardo Bruni, Poggio Bracciolini, Donato Acciaiuoli and others during the Quattrocento.[10]

Bruni and his contemporaries recreated ancient history in the image of their own world, reviving the Roman historian Livy's methods to write their own history. Like Livy, they intended their readers to model themselves on the heroes their histories contained. Bruni, whose Latin *History of the Florentine People* was rendered into the *volgare* by Donato Acciaiuoli, was very significant for the diffusion of new approaches to history in fifteenth-century Florence.[11] He was indebted above all to Livy, Sallust and the philosopher and orator Cicero for his approach to the historian's craft, as well as the factual information he provided about ancient Etruria, the territorial antecedent of the Florentine Republic.[12] In general, Bruni followed Livy – even if in an important deviation he expressed muted praise for Mucius Scaevola (see the Nerli *spalliera*, cat. 2), who had frightened the Etruscan king Lars Porsenna into believing that all Romans would act as courageously as he. Bruni considered that the Romans' refusal to follow the normal rules of military engagement had prevented Porsenna and his men from capturing Rome.[13] Although on this occasion he rejected Livy's pro-Roman bias, he did so using Livy's historical

methods, weighing up a range of primary sources to reach a balanced conclusion.

The painters of visual histories at times used a comparable technique of selective argumentation and combining sources. For example, the paintings of Dido and Aeneas and Ulysses made by Apollonio di Giovanni and his workshop (see fig. 7) have hitherto been discussed simply in terms of their relationship to the modern canon of the *Aeneid* and the *Iliad* and to works of humanist history, when in fact they depend on a variety of textual traditions – ranging from the ancients Virgil, Homer and Ovid through to modern authors – Dante, Boccaccio, Petrarch, Brunetto Latini and Guido delle Colonne.[14] A large, although not quite so extensive, range of different interpretations informed the telling of other stories in the domestic painting repertoire, such as the narrative of Susanna and the Elders interpreted by artists as diverse as Zanobi Strozzi (fig. 18) and the Master of Apollo and Daphne.[15]

This diversity of sources means that the argument of a painted furniture narrative is not always immediately clear to a modern viewer. However, it is likely that the paintings' capacity to incorporate a number of different interpretations formed part of the attraction they held for their fifteenth-century users. Familiar stories could be told in a way which permitted a variety of diverse meanings.

'According to what each one liked best': the requirements of *cassone* panels

The visual diversity and multiplicity (even confusion) found on the average *cassone* panel must have been introduced in response to the potentially different requirements of those people who were intended to see and make use of them. They were intended to convey exemplary moral messages akin to those provided by written history to men, women, children, and other household members. Their potential role of providing models of appropriate behaviour was greatest for those – the women[16] and servants – whose literacy (as readers and writers) was uncertain, or even in certain quarters considered undesirable. In addition, certain ensembles were intended to provoke intellectual discussion and debate. And although their educative and prescriptive role was crucial, they were also meant to contain the power to divert and entertain.

The very little that we know of fifteenth-century responses to pictures confirms the significance of the visual diversity and complexity of furniture painting. Lorenzo de' Medici's brief comments on painting, inserted as part of his commentary on his own sonnets (which ultimately argues that a portrait of the beloved is the best of all), reveal an awareness of how different might be the requirements of each individual for a picture:

'Because, although the picture is perfect, it might be that the quality of what is painted might not be suited to the nature of who ever is obliged to see it, conscious that some people are delighted by happy things, others by animals, orchards, balls and feasts, and the like; others would wish to see battles, either on land or sea, and similar martial or fierce things, others countries, windows, views and proportions of perspective; others something different; and thus, if one wishes a picture to be entirely pleasing, one needs to add this requirement, that the thing painted is delightful in itself.'[17]

Visually, the bustling contents of paintings for *cassoni* accord well with this comment, as well as Vasari's remark that they depicted 'whatever each one liked best'.[18] *Cassone* panels had to achieve this difficult brief in one united visual space. Lorenzo Morelli's selection of specific episodes from early Roman history to adorn his chests and *spalliera* was surely a result of such multiple demands. He could enjoy the martial exploits of Camillus defeating the Gauls (cat. 1) and the town of Falerii (cat. 2). At the same time, his wife was exhorted not to follow the bad example of the schoolmaster of Falerii, who offered his charges to the Romans as hostages (cat. 2). The chest which bears this front panel is framed by the virtues of Prudence and Temperance, particularly appropriate to women. This conjunction urged Vaggia Nerli to look after her

and her husband's children to the best of her ability. In turn, these children would be encouraged to model themselves on the virtuous pupils who helped to punish their treacherous teacher. Nor did the paintings simply contain exemplary messages. Richly decorated with gold and silver, they contained many details parallelled in Lorenzo de' Medici's commentary – beautiful landscapes and fine townscapes, the excitement of battles, the pleasures of perspective and views of Rome.

Manuscript compendia and *cassoni*

The ability of *cassone* panels to enable their user to pick what he or she wanted from a range of visual possibilities is parallelled in another significant group of contemporary story collections, the chapbooks (or manuscript compendia and scrapbooks) created by Florentines for their private instruction and enjoyment. Instructive connections can be drawn between Florentine paintings for *cassoni* and these narrative collations, which survive in considerable numbers (there are several thousand in the libraries of Florence alone).[19] They demonstrate the varied cultural influences and interests of fourteenth- and fifteenth-century Florentines, but they have been ignored in general by historians because they do not fit into the canon of either literary or artistic respectability. They are unprepossessing visually, and thus of little interest to the art historian who studies manuscripts, while the stories and poems they contain are rarely of sufficient calibre to attract the serious literary scholar.

Many of the surviving compendia are largely religious in content, and contain lives of the saints as well as versions of biblical stories.[20] However, an equally large number combine these with mythological tales, ancient and modern history, and modern poetry.[21] Not only do the contents of these chapbooks parallel the repertoire of *cassone* paintings. The versions of the stories they tell also bear striking similarities to those found on furniture painting. Stories from ancient poetry and history were rewritten, often with moral or Christian glosses, so that they fitted the needs of their fifteenth-century Florentine users.

These books are fascinating for their narrative range and their tendency to combine versions of related texts, even those which might contradict each other. This is strongly reminiscent of the ability of *cassone* panels to convey multiple messages in one pictorial space. The narrative conjunctions found in these manuscripts seem strange to readers of printed books, accustomed to unadulterated and agreed versions of a text. However, the sheer quantity of surviving manuscript compendia, as well as their endurance as a genre well into the sixteenth century, suggests that their diversity pleased their original audience, and was the reason for their continuing success.

Lorenzo Morelli, the commissioner of the painted chests and *spalliera* now in the Courtauld (cat. 1 and 2) owned at least one (possibly two) of these manuscript compendia. The manuscript he described as 'a book of Ovid's letters and other things' in his expense account of 1465 survives in the Biblioteca Nazionale Centrale in Florence. It cost him four large florins.[22] On a fly leaf, Morelli stated his ownership, and also described the book as a chapbook 'because it tells of many different things'.[23]

The unassuming appearance, contents and lack of illustrations of this chapbook, purchased from 'Zanobi Deleicha', make it very typical of surviving manuscripts of this type. Its contents mirror the core genres of stories depicted on *cassone* frontals: Roman poetry, contemporary Tuscan verse, ancient Greek, Roman, biblical and modern history. As such it provides a good framework for exploring the subjects depicted on *cassoni* and *spalliera* panels, and decoding their meanings.

Lorenzo Morelli's book begins with a version of Ovid's *Heroïdes* – generally called the *Pistole* ('Letters') in Tuscan – translated by Domenico da Montichiello. This series of eighteen letters was purportedly written by heroines of ancient mythology, including Medea and Helen, to their generally unreliable lovers (replies by three errant men are also included). This loosely connected body of poems, together with the *Ovidio maggiore* (the 'Big Ovid', or the *Metamorphoses*),[24] is recorded in many fifteenth-century inventories of book

collections.[25] Such references are generally to vernacular versions of these verses, normally in a translation accompanied by a Christian moralisation, like that owned by Lorenzo Morelli.[26]

These glosses enabled Ovid's often salacious and always entertaining stories to be used by *cassone* painters because they could now – if required – hold a moral message appropriate to their context on a chest. The majority of Greek and Roman mythologies depicted on *cassoni* are indebted to such reinterpretations of Ovid rather than to his original Latin verse. A panel in the Courtauld from around 1430 (Appendix, no. 2) depicts Apollo's pursuit of the nymph Daphne, and how her father Peneus transformed her into a laurel to preserve her chastity. Ovid's account emphasises Apollo's musings on the various beauties of Daphne's form,[27] while the painting – like the moralised versions of Ovid – concentrates on Daphne's (fully clothed) virtue and purity.

Florentines were exposed to looser derivations of Ovidian narratives in the works of Giovanni Boccaccio, Francesco Petrarca (Petrarch) and others. Both Boccaccio and Petrarch were key authors for the *cassone* repertoire,[28] and Lorenzo Morelli's chapbook includes selections from Petrarch's *Canzoniere* as well as Boccaccio's poem the *Ninfale fiesolano*, which tells of the love of the hunter Africo for Mensola, one of Diana's nymphs.[29] The *Ninfale* is based on Ovid's tragic story of Callisto, raped by Jupiter, abandoned by Diana and almost murdered by her son Arcas.[30] Yet Boccaccio's poem imaginatively 'florentises' and modernises Ovid. Callisto becomes Mensola, the titular nymph of a river which flows down from Fiesole to Florence. Africo is an adaptation of Ovid's Actaeon, another victim of Diana's cruelty, who in the form of a stag was killed by his own hounds. So is another Boccaccian hunter, Ameto. The *Ninfe fiorentine* tells of his epiphany when he stumbled upon a group of bathing Florentine nymphs, and is transformed into a better man by love for Lia, one of their number.[31] A considerable number of painted versions of the related stories of Actaeon, Callisto, Ameto, Lia, Africo and Mensola were made around 1420 to 1450, and they are are hard to disentangle from

each other.[32] For example, Ameto in a birth tray of *Scenes from the 'Commedia delle Ninfe fiorentine'* (New York, Metropolitan Museum of Art)[33] approaches his saviour Lia in the same manner as Actaeon moves towards Diana in a panel of *Diana with Actaeon and Meleager* by Lorenzo di Niccolò di Martino (Warsaw, Muzeum Narodowe).[34] In dress and attitude he also resembles both Jupiter and the young Arcas in Paolo Schiavo's *The Myth of Callisto* (Springfield, Museum of Fine Art).[35] It is possible that these figures derive from the same pattern-book drawing, or a painted prototype, knowledge of which was diffused through this stylistically related group of artists.[36] However, it seems more likely that these narratives found popularity because they merged the world of antiquity with that of Trecento Tuscany so that visually they appeared to share a single Florentine setting. These stories' ability to be at once ancient, modern and Florentine found them a significant place in the domestic painting repertoire.[37]

The inspiration Boccaccio derived from Ovid is also evident in his great collation of stories the *Decameron*, which provided one of the most constant elements of Florentine manuscript compendia and book collections.[38] Ovid's tales of 'bodies being changed into new bodies'[39] become a new grouping of equally fabulous narratives, reaching happy endings by the most convoluted means. Boccaccio's tales of the patient Griselda and Nastagio degli Onesti were deemed suitable subjects for domestic painting.[40] Griselda's unquestioning obedience of her callous husband made her a model wife, while Nastagio's haughty beloved was frightened into learning the error of her ways.[41] Reunited in this exhibition are two chest frontals by Giovanni Toscani depicting the ninth *novella* of Day 2 of the *Decameron* (cat. 3 and 4). Like the stories of Nastagio and Griselda, they were re-edited for pictorial display on wedding chests, so that their exemplary and 'historical' message became evident.

These panels tell of Ginevra, a model of female constancy and virtue, and Ambrogiuolo, an example of behaviour a man should avoid. Like the ancient Roman heroine Lucretia this Genoese wife was the unwitting

victim of her husband Bernabò's enumeration of her beauty and virtue. He laid a huge bet with Ambrogiuolo that her virtue was incorruptible, but, while Lucretia was raped by Tarquin, Ginevra's suffering was less immediate. A corrupted maid smuggled Ambrogiuolo into Ginevra's room in a chest (cassa). At night, he crept out to find Ginevra asleep. Pulling back the covers, he noticed a tiny mole under her left breast (cat. 3). Hearing this detail from Ambrogiuolo, Bernabò imagined the worst, and ordered his wife's assassination.

The second panel (cat. 4) begins with the murder, which the assassin could not bring himself to execute. Six years passed, spent by Ginevra (disguised as the youth Sicurano) working for the Sultan in Alexandria. The panel reprises the tale at the moment of the first meeting of Bernabò, Ambrogiuolo and Sicurano/Ginevra. Sicurano's real identity is revealed before the Sultan as 'the miserable unfortunate Ginevra'.[42] Bernabò kneels in supplication to beg Ginevra's forgiveness. It is deliberately unclear whether he is meant to be viewed as a supplicant of Ginevra, or of the Sultan, who had given Bernabò into Ginevra's hands to be dealt with as she wished. Man and wife returned with their fortune to Genoa, while the final section of the panel depicts the hideous punishment of the traitor Ambrogiuolo. Tied to a stake, his naked body was smeared in honey, and he was left to be stung to death.[43] Toscani's detailed depiction of Ambrogiuolo's fate was intended as a warning to traitors inside the household, as well as further afield.

The examples of history

Chapbooks, like furniture painting, had a strong exemplary quality. Their contents tended to concentrate on questions of leadership, which could be applied by men to their activities at home and abroad. For instance, Lorenzo Morelli's manuscript compendia included a letter ascribed to Saint Bernard on household governance, and chapters from Brunetto Latini's *Tesoro* (Treasure of Gifts) about Solomon and Seneca.[44] Other manuscript chapbooks invariably attempted to connect the events and virtues of the ancient world

to contemporary Florence. This was manifested most openly in the practice of binding contemporary and ancient *dicerie* (speeches) together.

In such a collection of speeches one would most commonly find Leonardo Bruni's 'Speech to Niccolò Tolentino' or some of the fifteenth-century Florentine Captain Stefano Porcari's exortations to the Florentines on justice bound with Cicero's speeches *Pro Marcello* and *Pro Ligario* (made on the occasion of the Catilinarian Conspiracy), and Catiline's speech to his men before entering into battle.[45] The 'modern' speeches were filled with ancient *exempla*: for example, these are scattered throughout Porcari's speeches to the Florentine Signoria on the administration of justice, where they are presented as precursors of Florentine virtue.[46] Such an admixture of the ancient and modern is also seen in furniture painting, such as fig. 21, where the Wooden Horse enters Troy accompanied by chivalric knights, and decorative ensembles could combine ancient and contemporary history. For example, the documented (but lost) *spalliera* by Lo Scheggia depicting Lorenzo de' Medici's 1469 joust is recorded in the 1492 Medici inventory in the '*camera di monsignore, dove sta Giuliano*', hung above a pair of chests showing the victory of Marcus Marcellus in Sicily.[47]

The historical frameworks found in most manuscript scrapbooks placed the history of all civilisations – Israel, Egypt, Babylon, Greece, Rome and Christendom – within a unified structure of six ages, which also incorporated the stories of the pagan gods and chivalric heroes. These were normally found in the vernacular, such as the many anonymous 'Histories of the World from the Creation', Guido da Pisa's *Fiorità d'Italia* or Boccaccio's 'Letter to Messer Pino de' Rossi'.[48] Petrarch's 'Triumphs of Love, Chastity and Death' (depicted by Pesellino in fig. 5) employ a similar blanket approach to world history: figures like Julius Caesar, Achilles, Venus, Judith, Ahasuerus and Lancelot happily rub shoulders.[49] A visual expression of this is found in the so-called *Florentine Picture Chronicle* (London, British Museum), where a liberal mix of tales from the Old Testament and the classics are organised in several ages of historical

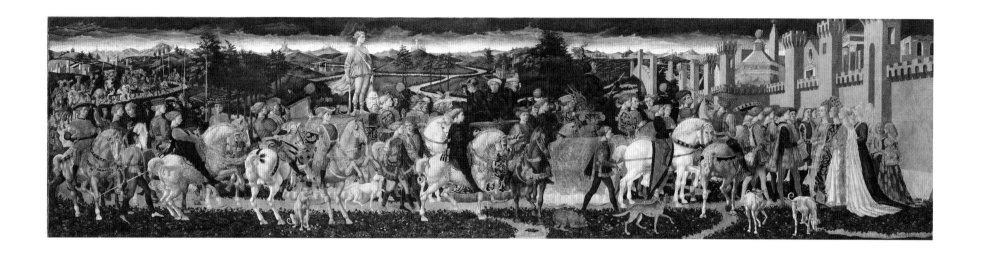

Fig. 13
Francesco Pesellino, *The Triumph of*
David and Saul, 1445–55
The National Gallery, London

development.[50] It is within this context that the depiction of ancient histories on *cassone* panels – whether those of the Old Testament, like David and Saul and Esther (figs. 13 and 8), or of Rome, such as the Rape of the Sabine Women (cat. 9 and 10 and fig. 1), should be seen. They all belonged to the same historical universe, and equally could provide Florentine patricians with behavioural lessons. David's unexpected victory over Goliath made him an exemplar of the power of right (however puny), while Esther was a model for women thanks to her virtue and ability to please her natal and marital families.[51] The Sabine Women submitted to their cruel treatment, and as a result were able to effect a reconciliation between their fathers and husbands.[52]

Study of Florentine manuscript compendia reveals a particular concern with the affairs of Rome, which is paralleled on *cassone* and *spalliera* panels. Greek rulers and kingdoms were represented as tyrants – even Alexander the Great. Their corruption was seen to have met its just rewards in the conquest of the Greek city states by Republican Rome.[53] The Romans were shown time and time again as the precursors of the Florentine Republic and of Florentine liberty. A small group of figures populated the Florentine view of the Roman past – Julius Caesar (cat. 8), Cato the Censor, Cicero,

Catiline, Hannibal of Carthage and Scipio Africanus (cat. 7) – although there was a special fascination with the period between the collapse of the Republic and the Civil Wars, the establishment of Julius Caesar as dictator of Rome, and the aftermath of his assassination.[54]

The manuscripts most commonly concentrated on Brunetto Latini's 'translations' of Cicero's speeches *Pro Ligario* and *Pro Marcello*, accompanied by prologues which gave a resumé of the background to the speeches, so that every reader would be able to understand this pragmatic statement of the political compromise of republicanism and despotism, and to make by themselves the choice between these forms of government.[55] Individuals like Caesar and Pompey the Great (cat. 8), Cato and Cicero were often mentioned with little explanation, the assumption being that they were familiar to everyone.[56]

This can be paralleled in the *cassone* repertoire, which had an important subsection of stories from the late Republic, including the triumphs and assassination of Julius Caesar[57] and the death of Pompey.[58] A panel of this subject, bequeathed by Lord Lee to the Courtauld (cat. 8), is typical in its concentration on the details of the battle at Pharsalus (in Thessaly) and on the murder of Pompey by Ptolemy of Egypt

(at Alexandria). Although these events took place on opposite sides of the Mediterranean, the painter has elided them into one single episode. The paintings, like the manuscript compendia, give a surprisingly neutral view of the rights or wrongs of the collapse of the Roman Republic.

Both furniture panels and manuscript collations could exist as 'ready-mades' as well as specific commissions. Analysis of these textual and visual sources reveals that Florentines were meant to subscribe to the belief that the great men of Rome and Greece prefigured the Florentine Republic.

Florence, 'the ancient and modern city'

The manner in which these manuscripts and paintings interpret antiquity is reflective of the particular historical environment in which fifteenth-century Florentines lived. The boundaries we now perceive between history and modernity and between the sacred and secular worlds did not exist. In fact, they would have held such attitudes to be inconceivable. The elision of ancient and modern customs and culture in a contemporary setting was so normal that it did not merit discussion or comment. Florence was a Christian city, but with a very significant ancient past. Florentines claimed descent from several Roman notables – Julius Caesar and Sulla, as well as the righteous opponents of Catiline, whose rebellion against the late Roman Republic had been crushed near Pistoia.[59] Children formally began their lives with baptism in the city's Baptistery, which was widely believed to be an ancient temple of Mars.[60] They were exhorted by their parents to follow the morals and rectitude of the ancients, which corresponded to those of the godly family.[61]

Their fathers might enter the Sala dei Gigli (Hall of Lilies) in the seat of the city's government, the Palazzo della Signoria, where images of the Roman worthies Cicero, Brutus, Mucius Scaevola, Decius Camillus and Scipio surrounded Florence's patron saint, Zenobius, and told them how to conduct their affairs.[62] Triumphs could be staged in emulation of those recorded of ancient worthies, such as Julius Caesar and Aemilius

Paulus.[63] Motifs taken from the ancient world were found in prominent places throughout the city, and played an important role in articulating civic identity – from the representations of Hercules on the Campanile and the Porta della Mandorla of the Duomo to Michelangelo's colossal statue of David, installed outside the Palazzo Vecchio in 1504.[64]

Making antiquity modern

Such attitudes even informed those artistic commissions in which we know the painter or patron had a demonstrable interest in classical scholarship or ancient texts and sculpture, such as Bartolomeo di Giovanni's *The Argonauts at Colchis* (fig. 14) and *The Marriage of Peleus and Thetis* (fig. 12) or the many depictions of Aeneas and Ulysses by the shop of Apollonio di Giovanni and Marco del Buono (such as fig. 7). More often than not patrons and painters made use of versions of these classical tales which were widely diffused in vernacular texts, and even perhaps in oral culture,[65] and this made them more appropriate for their setting in domestic decorative schemes. For example, we know that when Lorenzo Tornabuoni married Giovanni degli Albizzi in 1486 (see fig. 14) his selection of the history of Jason and Medea to decorate his *camera* was influenced by his personal study of the ancient Greek versions of this story.[66] Yet these stunningly beautiful panels have a more obvious relationship with chivalric retellings of Jason and Medea's love, in particular Guido delle Colonne's compendious *History of the Destruction of Troy*, which transformed the story of the Trojan War into an epic of courtly love.[67] Guido – and Lorenzo Tornabuoni's artists – reinterpreted this tragic tale as a happy union between equal participants. The *History of the Destruction of Troy* was probably the most significant of all late medieval narratives.[68] Arguably it, rather than Virgil or Homer, formed the taste for depictions of the wanderings of Aeneas and Ulysses, and of subjects like Peleus and Thetis (described by Homer as being represented on their son Achilles' shield), the arrival of the Wooden Horse at Troy (fig. 21) and the death of Hector (fig. 15).

Fig. 14
Bartolomeo di Giovanni
The Arrival of the Argonauts in Colchis, 1487
The Mari-Cha Collection Ltd

Knowledge of the ancient world was not restricted to the classically educated, but part of the common currency of life.

How did painters articulate the close relationship between the ancient past and the contemporary world on furniture panels, so that their users could imagine antiquity in their world? One of its clearest manifestations is in their urban and landscape settings and the costume and fashions they depict. No differentiation between the specifics of the architectural and landscape settings exists in depictions of Old Testament forerunners of Christ, virtuous pagans, and fourteenth- and fifteenth-century Italy (for instance compare fig. 13 and cat. 4). They show similar collections of hills and rocks, punctuated by the occasional walled town. Arguably this similarity was intentional. It might derive from their membership of one imaginative realm – a visual Universal History where exemplary figures from the present and the past were treated as part of one world order.

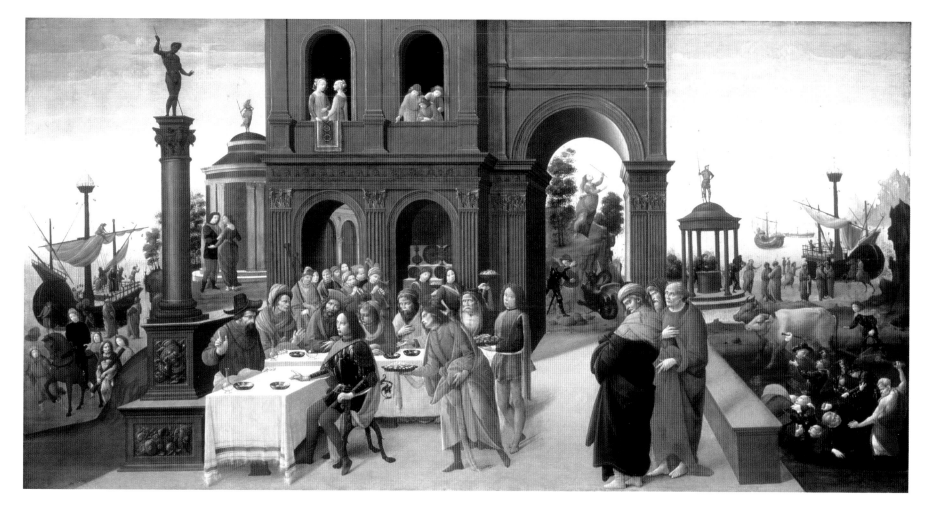

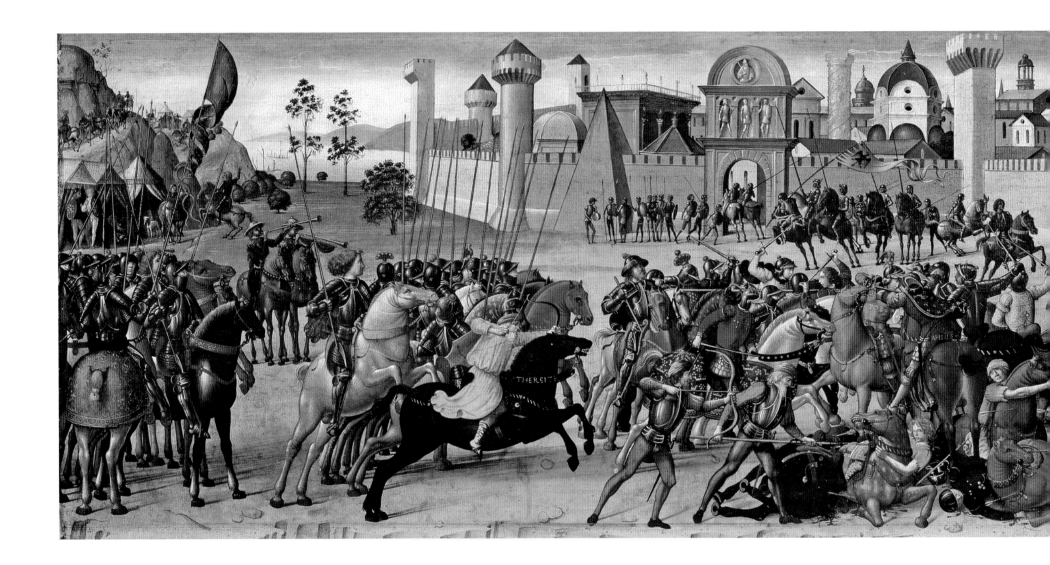

Fig. 15
Biagio di Antonio, *The Death of Hector*,
around 1495–1500
Fitzwilliam Museum, Cambridge

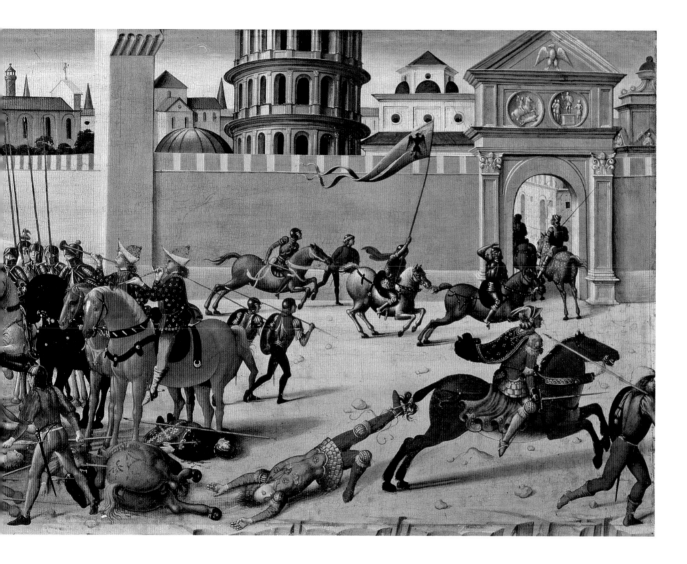

Just as Florentines remembered ancient Rome in the fabric of Florence, their painters depicted Rome as a quasi-Florentine city. The workshop of Apollonio di Giovanni and Marco del Buono was the first to represent actual Roman buildings in paintings for the domestic setting. Their visualisations of Rome are based on a compendia of several of the city's most notable monuments and features – the Pantheon (often labelled as *sca. maria ritonda*), the Aracoeli (*capitolino*), the Colosseum, the Column of Trajan or Marcus Aurelius (*colonna*), and the Castel Sant'Angelo (*chstel.s.agholo*).[69] They were present as easily understood symbols of the ancient world, of Rome's historical importance as the capital of Western Christendom, and of the setting for exemplary actions by pagans and Christians.

Apollonio's compendia views were detailed. They melded the manuscript tradition of the 'Marvels of Rome' (*Mirabilia Urbis Romae*), a description of Rome composed for pilgrims in the twelfth century,[70] with a concern to represent Rome and her monuments with some degree of topographical accuracy. They also influenced the depiction of Rome in *cassone* painting until the demise of the genre in the late fifteenth century, although these are notably less accurate. They were intended as mnemonic evocations of a city which symbolised the intersection of the virtuous pagan and Christian pasts, but which their painters and patrons might never have visited.

By such devices ancient history was made relevant and immediate. Biagio di Antonio's depiction of Rome on the front of the Morelli chest (cat. 1), where the Pantheon abuts Trajan's Column and the Campidoglio, with the Castel Sant'Angelo jammed in behind, and the Pyramid of Cestius placed in the city walls, is a very typical compression of the composite Roman views devised by the Apollonio shop. It is parallelled in his *The Death of Hector* (fig. 15), as well as in the Master of Marradi's *Rape of the Sabine Women* at Harewood House (cat. 9). Similarly, ancient Roman battles were refashioned so that they could appear Florentine. Some of the soldiers in the Morelli-Nerli chests (cat. 1 and 2) wear doublet and hose, and others, like the hero

41

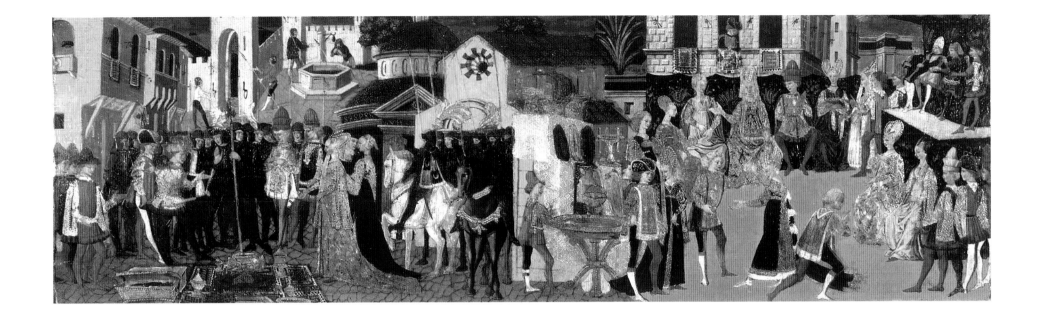

Camillus, wear approximations of fifteenth-century armour. Such modernisation is perhaps most evident in the *Siege of Carthage and Continence of Scipio* (cat. 7), where the latest technology, cross-bows and even cannons, is used to bombard the walls of Carthage by Romans wearing approximations of Florentine armour. These conflicts, at once ancient and modern, should probably be viewed in relation to contemporary ritual 'battles' performed on Florentine streets, such as those of the Florentine *condottiere* Roberto da Sanseverino, which staged violence peacefully within the city walls, or the re-enactment of classical entries into the city.[71]

Another means of rendering painted histories immediate was through the dress of the participants. The costume of ancient heroes or heroines on furniture can resemble that worn by virtuous fifteenth-century patricians. The more Florentine a figure looked, the more intentionally he or she provided a behavioural model. The young Carthaginian woman returned by Scipio Africanus to her betrothed (fig. 16) wears an elaborate golden dress, probably a *cioppa*, with long, open sleeves. Her *gamurra*, a dress with sleeves, can be seen underneath this. Her head is covered with a *balza*,

decorated with pearls, and a small veil covers her hair. Relatively little distinguishes this outfit from those which patrician women might wear on special occasions, such as marriage. These were sensationally expensive ensembles. For example, the '*suntuosa cioppa*' which Francesco Castellani had made in 1448 for Lena Alamanni, his betrothed, of kermes cloth, with pearls, gold and silver thread, cost approximately 300 florins, although Lena seems to have never worn it.[72] This was five times greater than the sum Lorenzo Morelli expended on his great chests.[73]

By the same token, it appears that the more exotic a character's dress, the greater potential he or she had to behave in an unorthodox, non-Christian or evil manner. This made it easy to identify un-exemplary figures in domestic paintings. For instance, the Romans who were going to accede to the Gauls' ransom demand and the Etruscan king Mucius Scaevola (respectively on the Morelli chest and the Nerli *spalliera*, cat. 1 and 2) wear togas over contemporary Greek costume, and they are bearded not clean-shaven. Their beards and hats are *capricci* on those worn by the Byzantine Emperor John VII Palaiologus (see also cat. 5 and 6), who had visited Florence during the Ecumenical Council

Fig. 16
Apollonio di Giovanni and
Marco del Buono Giamberti,
The Continence of Scipio, around 1460
Victoria and Albert Museum, London

of 1438–39.[74] It is particularly interesting to look at those more liminal characters, who could provide limited – but not absolute – models of good behaviour in a domestic setting. For example, the figure of Judith played a significant role in articulating Florentine republicanism. In the household, with its large female constituency, the independence of mind she expressed in killing Holofernes was far less praiseworthy. This is conveyed in paintings (like fig. 17) by clothing her in a pointed golden hat as an ancient heroine of at best partial merit, such as Dido in the Apollonio shop's depictions of Dido and Aeneas.[75]

Although Judith's fellow Jewish heroes and heroines, Solomon, Sheba, Susanna and Esther, were biblical exemplars, they inhabited the same pre-Christian world as Alexander and Aeneas, and were subject to the same moral sanctions and limits to their virtue. In the many surviving versions of Solomon and Sheba (such as cat. 5 and 6), Sheba wears elaborate costume, a fantastic riff on fashionable 'courtly' dress of the 1420 and 1430s. Her head is always covered with a complicated head-dress, while she wears a golden dress with elaborate sleeves and a train. Similar costumes are worn by mythological heroines, such as the virtuous nymph Daphne (Appendix, no. 2).

The men's costume also conveyed moral messages. King Solomon is portrayed in the long robe and crowned hat – derived from the dress of the secular Greek participants in the Council of Florence[76] – in which Apollonio di Giovanni, Lo Scheggia and their followers dressed venerable pagans including the ancient gods (fig. 7), King Darius of Persia, Scipio Africanus (fig. 16) or Ahasuerus, the husband of the Jewish 'fair young virgin' Esther (fig. 8).[77] As non-Christians they could never have the moral repute or exemplary force of a saint. A specific type of costume seems to have evolved to bridge this difficulty, and to portray unilaterally virtuous, exemplary pagan women and men such as Susanna (fig. 18). This distinguished them from more ambivalent figures such as Dido, Aeneas and Judith. Their clothing was closer to normal forms of contemporary Florentine dress than any exotic model, or at least to those extraordinarily expensive

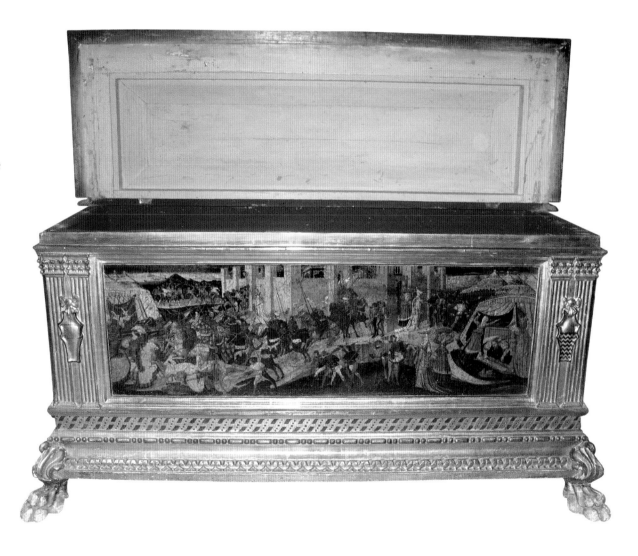

Fig. 17
Florentine
Chest with Judith and Holofernes, around 1460
The Abercorn Heirlooms Settlement

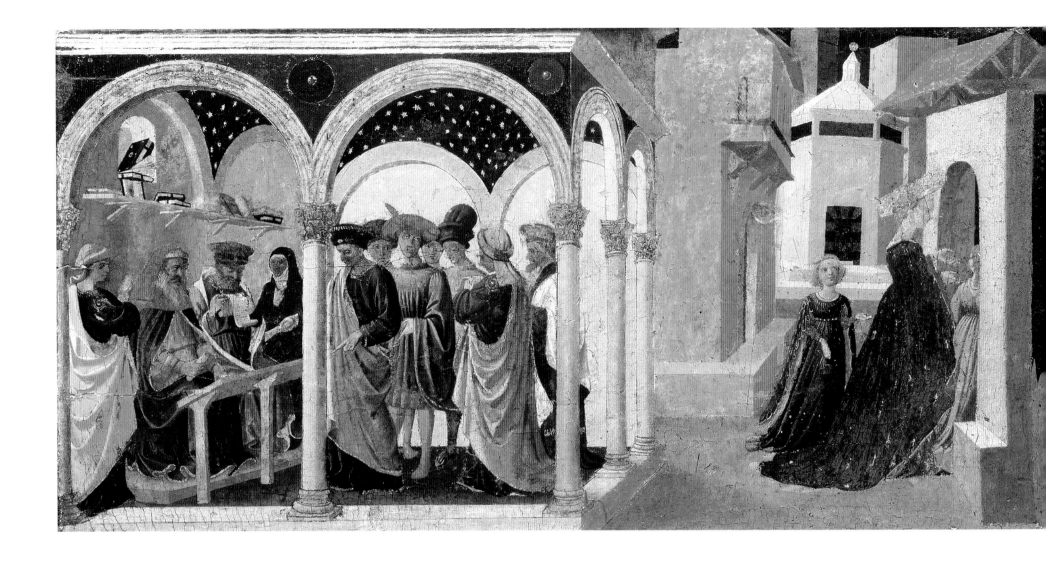

and unusual costumes commissioned in association with betrothal and marriage.

For instance, in the depictions of the Sabine Women at Harewood House (cat. 9 and 10) the men wear the common fifteenth-century doublet and hose covered by a tunic (a *gonella* or *cioppa* with sleeves).[78] They are dressed in armour which makes no effort to appear fantastic or chivalric. The women wear costume which is simpler and more conventional than those depicted by Apollonio di Giovanni and Lo Scheggia's workshops. At the end of the fifteenth century a more classical form of dress was sometimes used to denote virtue. Painters involved in or familiar with the first decorative scheme in the Sistine Chapel (1481–82) used *all'antica* versions of contemporary female costume for exemplary females in their furniture paintings, such as Thetis in fig. 12 and Medea in fig. 14. They wear the conventional *gamurra*, *camicia* and an overdress, but their over-dresses are gathered round their waists and thighs.[79] Yet although fashions of dress may have changed, their moral implications and meaning did not.

Throughout the fifteenth century, the modes of storytelling employed in paintings for chests and other forms of furniture painting were closely aligned to the concerns of their intended viewers. From the study of commonplace books and painted histories it seems incontestable that Florentines believed that they combined the virtues of their Judeo-Christian and pagan 'ancestors' to the benefit of their Christian actuality and future. This was not merely expressed using

Fig. 18
Zanobi Strozzi, *Susanna and the Elders*, around 1440
Musée du Petit Palais
(Campana Collection), Avignon

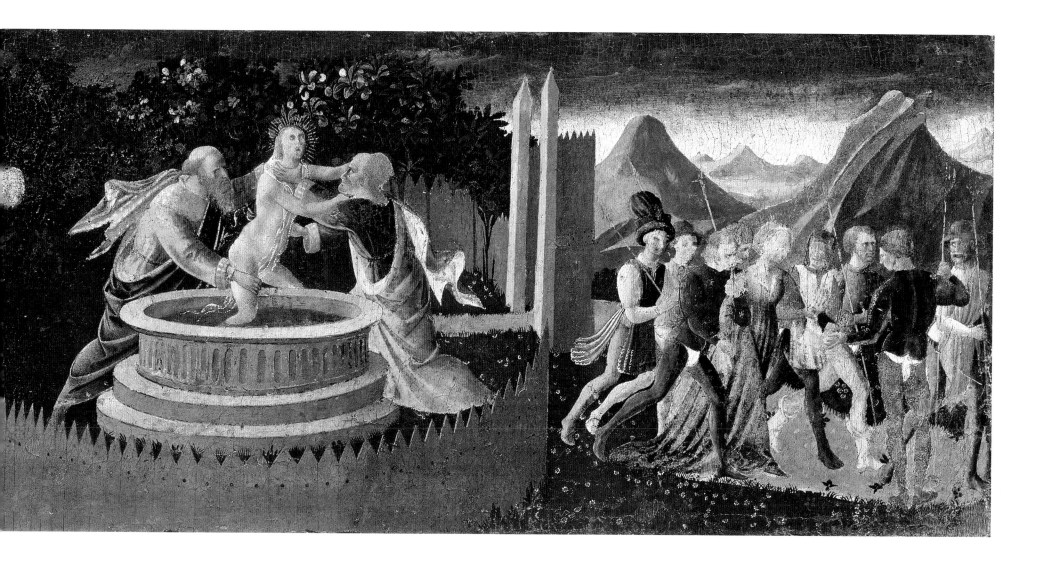

public, formal and scholarly means of communication, but through the most intimate level of contact and association within the household. The settings and clothing of domestic paintings gave the visual expressions of these stories eloquence and utility. The melding of different civilisations – both ancient and modern – produced a palatable and easily understandable vision of a unified past seen retrospectively through contemporary eyes. It was also one which was intended to justify and glorify Renaissance Florence.

In spite of Ugolino Verino's rhetoric, Apollonio di Giovanni was no more a historian than was any other fifteenth-century painter of furniture panels. However, these painters transformed the great variety of sources at their disposal into painted narratives which were intended, like written histories, to provide examples of good and bad behaviour for their viewers to follow or to avoid. This was particularly important for those Florentines whose literacy was limited: some women, servants, and very young children. Of course furniture painting had further purposes beyond imparting moral lessons. It was intended to divert, and to give a variety of pleasurable experiences, transporting its viewers into quasi-imagined worlds, in which the past and present were viewed through a Christian lens. Yet in the final analysis it had to be able to convey some sort of exemplary lesson to its viewers. Dangerous tales of unrequited power, love and passion were edited so that they could be incorporated in furniture ensembles celebrating deeds worthy of inclusion in history.

1 Commonplace book of Lorenzo Morelli: Biblioteca Nazionale Centrale di Firenze (henceforth BNCF), Palat. 359, fly leaf VIII: *'Questo libro è di Lorenzo Moregli, chiamato un zibaldone perchè tracta di più chose diferenziate'* (This book belongs to Lorenzo Morelli, called a *zibaldone* because it tells of many different things').

2 *'E le storie che nel corpo dinanzi si facevano, erano per lo più di favole tolte da Ovidio e da altri poeti; ovvero storie raccontate dagli storici greci e latini: e similmente caccie, giostre, novelle d'amore, ed altre cose simiglianti, secondo che meglio amava ciascuno'*: Vasari 1550 and 1568, 'Life of Dello Delli' (1568), vol. 3, p. 38.

3 Considerable work has been done (and is being done) on the relationship of *cassone* panels to contemporary triumphs, festival and processions (see Ventrone 1992a; Pacciani 1992, Baskins 2008–09, pp. 47–65). This essay will concentrate upon the intersection of past and present in paintings for chests.

4 For example, in the Gianfigliazzi Palace (Preyer 2004, pp. 80–81), and the Boni-Antinori and Pazzi Palaces (Preyer 2006–07, p. 371, n. 34).

5 Preyer 2006–07, p. 46.

6 Musacchio 2006–07, pp. 128–32.

7 Lydecker 1987, p. 187.

8 Vasari 1550 and 1568, 'Life of Iacopo da Pontormo' (1568), vol. 5, pp. 317–18: *'. . . per memoria di lui e per amore di mio marito, et il quale io intendo col proprio sangue e colla stessa vita difendere'*.

9 Verino 1940, Book II, no. 8, translated by E.H. Gombrich in Gombrich 1985, p. 11.

10 For an introduction to Florentine twelfth- and thirteenth-century historiography, see Del Monte 1950. For an opening into the complicated world of fourteenth- and fifteenth-century historiography, see Cochrane 1980, pp. 3–9; Jacks 1993, pp. 74–86; Hankins 1995, pp. 1–30.

11 See Ianziti 1998; Hankins 1997, vol. 1, p. 259; Bessi 1990.

12 La Penna 1968, App. I, pp. 9ff.

13 Cabrini 1990.

14 Schubring 1915, pp. 179–203; Gombrich 1985.

15 Baskins 1991, pp. 329–41.

16 For the appropriateness of female viewing and learning, see Tinagli 1997, pp. 162–64.

17 *'Perché, ancora che la pittura fussi perfetta, potrebbe essere di qualità quello è depinto, che non sarebbe seconda la natura di chi debbe vedere, conciosia che alcuni si dilettano di cose allegre, come è animali, verzure, balli e feste, [e] simili; altri vorebbono vedere battaglie o terrestre o maritime, e simili cose marziale e fere; altri paesi, casamenti e scorci e proporzioni di prospettiva; altri qualche altra cosa diversa; e però, volendo che una pittura interamente piaccia, bisogna adiungervi questa parte, che la cosa dipinta ancora per sè diletti'*: see Medici 1991, pp. 136–39 (translated by James Cook in Medici 1995, with some emendations).

18 Vasari 1550 and 1568, 'Life of Dello Delli' (1568), vol. 3, p. 38.

19 See Campbell 2000, p. 53. The genre of Florentine manuscript compendia or scrapbooks has also been studied by Dale Kent (see Kent 2000, ch. 6).

20 Campbell 2000, p. 52.

21 These manuscripts have not been studied comprehensively. For the most detailed studies of them to date, see Kent 2000, ch. 6, and Campbell 2000, ch. 2. The sample of 115 studied in Campbell 2000 mixed the sacred and the secular.

22 *'1° libro di' pistole d'Ouidio e d'altro'*; Lorenzo Morelli, 'Spese di più chose di Lorenzo Moregli' 1465 (Florence, ASF, Archivio Gherardi-Piccolomini d'Aragona 137, fol. 13).

23 BNCF, Palat. 359, fly leaf VIII; see above, note 1.

24 Campbell 2000, p. 193.

25 Bec 1984, pp. 28–30, 42–44, 150, 154.

26 See Guthmüller 1989, App. F.

27 Ovid 1955, Book I, ll. 444–570, pp. 41–44.

28 Watson 2003, pp. 44–53.

29 Boccaccio 1971.

30 Ovid 1955, Bk. II, ll. 401–535, pp. 61–64.

31 Boccaccio 1971a.

32 These paintings include Master of 1416, *Episodes from the 'Commedia delle Ninfe Fiorentine'* (New York, Metropolitan Museum of Art); Giovanni Toscani, *The 'Ninfale fiesolano'* (location unknown); Circle of Mariotto del Nardo, *Diana with Actaeon and Africo* (Warsaw, Muzeum Narodowe); follower of Domenico Veneziano, *The Myth of Actaeon* (Williamstown, Williams College Museum of Art); Paolo Schiavo, *The Myth of Callisto* (Springfield, Museum of Fine Arts).

33 Reproduced and discussed by Musacchio in Bayer 2008–09, cat. 68, pp. 151–52.

34 Spyschalska-Boczkowska 1968.

35 See Campbell 2000, pp. 206–07 and Campbell (forthcoming). The Callisto panel is reproduced and discussed in Simmoneau 2007, figs. 1–4.

36 Kirkham and Watson 1975, pp. 42–44.

37 Campbell 1995, chs. 1 and 2.

38 Campbell 1995, table 1a; Bec 1984, pp. 31–32, 44–45.

39 Ovid, Metamorphoses, Book I, l. 1.

40 Boccaccio 1966, Day 10, *novella* 10, pp. 659–69; Day 5, *novella* 8, pp. 362–67.

41 See Callmann 1974, p. 86; Allen 1977; Olsen 1992; Rubin 2007, pp. 229–35; Syson 2007, p. 230.

42 *'la misera sventurata Zinevra'*; see Boccaccio 1966, p. 168.

43 Boccaccio 1966, p. 169.

44 Florence, BNCF, Palat. 359, ff. 94v–95v; ff. 113r–114v.

45 For an example of this see Florence, Biblioteca Riccardiana di Firenze, 1156; for further discussion see Campbell 2000, ch. 2.

46 Stefano Porcari, *Oratione dimessere stefano porchari di/nanzi a signori* (Florence, BNCF, Naz., II, II, 87, ff. 194r–206 v).

47 *'Una spalliera di br. xiii lunga e alta br. una e ½ sopra a' detti forzieri et chassone, dipintovi drento la storia della giostra di Lorenzo con cornicie e collonette messe d'oro, divisa in 3 parte, di mano dello Scheggia'*: Spallanzani and Gaeta Bertelà 1992, p. 72.

48 This letter is filled with references to exemplary classical heroes and historical figures. See Campbell 2000, p. 64, and Appendix, 2, 10, 36, 53, 57, 75, 76, 79, 87, 90, 104, 107, 110.

49 Petrarch 1996, pp. 47–626.

50 Colvin 1898.

51 Baskins 1993, pp. 31–54.
52 Gordon 2005, p. 288; Baskins 1993 and 1998, ch. 4; Campbell 2000, ch. 5, pp. 135–42.
53 For example, see Biblioteca Medicea Laurenziana di Firenze (henceforth BMLF), Plut. 43, 17 (Campbell 2000, Appendix, 108), a comparison of Alexander, Hannibal and Scipio written by Giovanni Aurispar, in which Alexander is vilified for the ease with which he gained his kingdom, compared to Scipio's conquest of Africa for Rome, not himself – achieved through hard struggle and 'pietà'.
54 Campbell 2000, pp. 73–76.
55 Campbell 2000, pp. 74–75.
56 Campbell 2000, pp. 72–73.
57 See cat. 8 below, note 13, and Callmann 1974, cat. 52, 53, 56, 57, pls. 205, 211, 213, 214, 229, for depictions of the assassination and triumph of Caesar.
58 See cat. 8 below, note 12, for depictions of the death of Pompey.
59 Ettlinger 1972, p. 121.
60 See, for example, Verino 1790, unpaginated.
61 Campbell 2000, pp. 45–47.
62 Rubinstein 1995, pp. 62–65; Hegarty 1996, pp. 264–85.
63 Trexler 1980, p. 451; Carew-Reid 1995, pp. 91–92; Ventrone 1996.
64 See Ettlinger 1972; Plazzotta in London 2008–09, p. 226.
65 Kent 2000, chs. 5 and 6.
66 Campbell 2007, pp. 4–6; Bayer in Bayer 2008–09, cat. 140a–c, pp. 303–06.

67 See Campbell 2007, pp. 12–14.
68 Delle Colonne 1974, p. xi; Güthmuller 1989, p. 339.
69 The three most significant 'Roman' views by Apollonio di Giovanni are *The Triumph of Scipio Africanus* (Fitzwilliam Museum, Cambridge); *Scenes from the 'Aeneid', Part II* (New Haven, Yale University Art Gallery) and *The Triumph of Julius Caesar* (private collection). They are reproduced in Callmann 1974, pls. 55, 144 and 205.
70 See Nichols 1986 and Miedema 1996.
71 The remarks on Roberto da Sanseverino are indebted to Scott Nethersole's PhD thesis (Courtauld Institute of Art, University of London) on battle imagery in fifteenth-century Florence (chapter entitled 'Staged Violence', pp. 2–4, 10–11). In 1443, when Alfonso II conquered Naples, his triumphal procession was staged by Florentines on the basis of ancient practice (as they perceived it): see Brilliant in Baskins 2008–09, cat.15, pp. 150–53.
72 Frick 1995, pp. 248–9; Randolph 1998, pp. 182–200.
73 Lydecker 1987a, pp. 286–88.
74 Campbell 2000a; Chong in Campbell and Chong 2005–06, cat. 14, p. 66.
75 See Callmann 1974, pp. 165–66, pls. 43 and 44; Campbell 2000, p. 178.
76 For painted representations of Solomon and Sheba in fifteenth-century Florence, see Callmann 1974, pls. 145–52.
77 Esther 2: 2.
78 Herald 1984, pp. 53–56.
79 Campbell 2000, pp. 182–84.

Creating *Cassoni*

Vasari and *cassoni*

The first comprehensive description of painted wedding chests was made retrospectively, after they had ceased to be a living art form in Florence. This account, by Giorgio Vasari, the father of Florentine art history, has proved enormously important. It determined both the terms of their preservation and their subsequent rehabilitation following centuries of neglect.

Wedding chests began to be incorporated within collecting and art history in the mid nineteenth century, at the same time that the Renaissance itself was delineated as a historical phenomenon. For nineteenth- and early twentieth-century art historians, the value of painted wedding chests lay in what they revealed of the lives and customs of Renaissance Italians. Collectors rushed to acquire objects associated with the 'Golden Age' of Lorenzo de' Medici.

Vasari's comments on *cassoni*, written in the mid sixteenth century, have been much criticised. It has been argued that his damning judgement on painted chests as a 'minor' art is responsible for their relative neglect by historians until the second half of the twentieth century.[1] Vasari's study of *cassoni* did not simply shape their critical reputation and historiography. More fundamentally, it was responsible for their identity and survival – even their name (see above, 'The Wedding Chest'). There is no doubt that Vasari's analysis of painted chests has been of enormous significance; however, a careful and contextualised reading of his comments on furniture painting reveals a more nuanced and interesting story than the familiar narrative of Vasari's misunderstanding and under-appreciation.

Vasari mentions paintings for the domestic setting at various points in his *Lives of the Most Excellent Painters, Sculptors and Architects* (first published in 1550, with a much revised edition in 1568).[2] His explicit purpose was to convey great honour upon them as an art form of considerable importance for fifteenth-century Florentine painting. For example, in the 'Life of Botticelli' he referred to the rooms of painted decoration Botticelli undertook for members of the Vespucci and Pucci families, and in the 'Life of Piero di Cosimo' he elaborated on the room Piero painted for the Vespucci.[3] Equally extensive are the *tour de force* accounts of the 'Borgherini Bedchamber' discussed above (fig. 10) and the paintings made by Paolo Uccello (see fig. 19) for many Florentine houses 'to decorate the sides of couches, beds and so forth'.[4] None of these descriptions of commissions of artistic and cultural importance produced for members of the social elite give the impression of an insignificant art. This is confirmed by Vasari's most extensive discussion of furniture painting, which is concentrated in the 1568 version of the 'Life of Dello Delli'.[5] It is a great irony that not one of the surviving paintings for chests can be connected with Dello Delli (whose real name was Dello di Niccolò di Dello).[6] It would be tempting to characterise him as a convenient figment of Vasari's historical imagination, but there is no doubt that a painter of this name did exist, and those details of his career – except for his supposed speciality as a furniture painter – which survive accord with the basic information given in Vasari's 'Life'.[7]

Between 1550 and 1568 Vasari rewrote his life of Dello so that it became the first historical analysis of painting for chests and other types of furniture. The first version of Dello's 'Life' condemned the 'evil of jealousy' (*la maladizzione della invidia*) to which Dello was subject from his erstwhile Florentine friends once he had tasted wordly success at the court of the King of Spain.[8] The 1568 'Life' was enlarged, and almost completely transformed, into a concise history of furniture painting in Florence. The work of Dello, an artist of the early fifteenth century, was conflated with that of artists later in the century, in order to represent the varied production of Florentine furniture painters as one coherent body of work. Yet Vasari's description of their output was accurate, and his analysis suggests that he had seen a large number of furniture panels. He described their insertion into the front and sides of chests, beds, and the panelling of chambers.[9] He pointed to their prestige, by commenting that the chamber of Giovanni di Cosimo de' Medici was filled with a complete decorated scheme (by Dello Delli).[10] He implied their connection with marriage, saying that

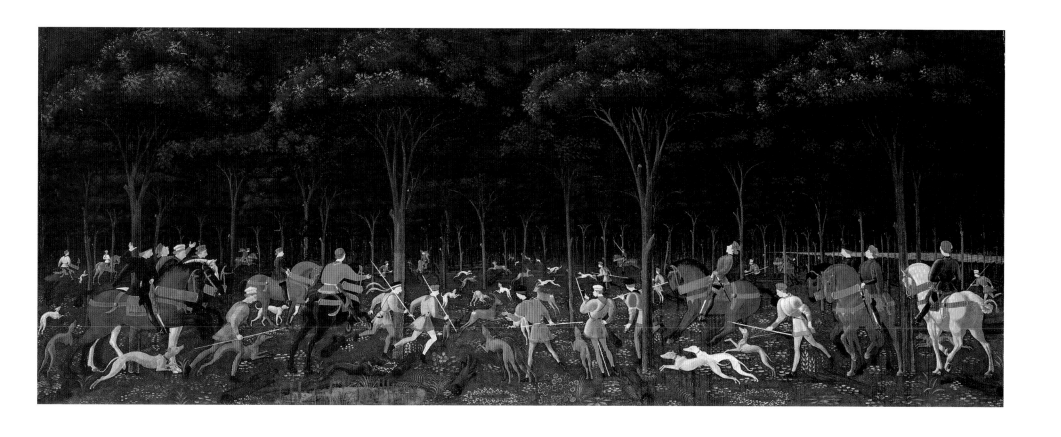

Fig. 19
Paolo Uccello, *The Hunt in the Forest*,
around 1470
Ashmolean Museum, University of Oxford

they often bore the coats of arms or insignia of married couples. And, as we have seen above ('"Many different things"'), his description of the range of subjects these paintings depict, and their classification, conforms broadly with the surviving paintings.[11]

Vasari's purpose in describing furniture painting was to confer great honour upon it. He made explicit references to the flowering of this art form in the 'Golden Age' under the patronage of the Medici family. Dello Delli is said by Vasari to have worked extensively for Cosimo de' Medici, and is thus placed in the company of such respected artists as Filippo Lippi, Benozzo Gozzoli and even Donatello (who was alleged to have made decorations in low relief to accompany paintings by Dello).[12] However, central to Vasari's panegyric of fifteenth-century Florence was the figure of Lorenzo de' Medici, in whose time the city was 'truly a golden age for men of talent'.[13] At many points throughout the Lives Vasari presented Lorenzo as the epitome of the enlightened patron of artists on the model of his grandfather Cosimo il Vecchio, continued on a more lavish scale by his descendant (and Vasari's patron) the Grand Duke Cosimo.[14] In this 'Golden Age' Vasari indicated the high status of furniture painting by commenting that one could still see in his day 'certain cassoni, spalliere and cornici[15] in the chamber of the Magnificent Lorenzo de' Medici the Elder on which were painted – not by bad artists but by excellent masters – with judgement, invention and marvellous skill all the jousts, tournaments, hunts, festivals and other spectacles of his times'.[16] Not only could these be seen in Duke Cosimo's palace, the old Medici palace on the via Larga, and the family's former dwellings, but in 'all the most noble houses of Florence'.[17] Vasari himself had ensured that several cassoni by 'Dello' were preserved in the Grand Duke's palace. He commented that even those who – unlike him – did not esteem such paintings for their artistic merit must value them for their historical importance, since they showed the 'style of dress of that time for men and women'.[18]

Nevertheless, Vasari's praise for Dello and other painters of furniture was tempered by the difficulties of placing their work within his conception of art

history as a progressive narrative of biography and taste, culminating in artists of supernatural genius – Leonardo, Raphael and Michelangelo. The work of many domestic painters was not easily accessible, being placed in the private rooms of the greatest Florentine households. They belonged to an art form which was already obsolete.[19] By centring his analysis of domestic painting in the 'Second Age' of artistic development Vasari made it clear that, although he recognised the historical significance of furniture painting, he did not consider it important to the artistic practice of his own time. It was also significant that his expanded account of domestic painting formed part of the more complete historical account of the arts and artists in Italy undertaken in the 1568 edition of his Lives.[20]

The reinstatement of cassoni

Despite Vasari's measured analysis of cassone painting as a historical phenomenon, the tradition of art history as biography and taste which he initiated was responsible for its detachment from the art historical canon. The process of reinstatement began gradually in the early nineteenth century. Significantly, the first individuals responsible for this, including the Liverpuddlian William Roscoe (1753–1831) and the Parisian Alexis-François Artaud de Montor (1772–1849), were also among the earliest serious acquirers of such paintings. They collected and wrote on the models established by Vasari.

William Roscoe, the son of a market gardener and innkeeper, became a lawyer and subsequently a banker. Although he spent the majority of his life in Liverpool, and never left England, he researched and published the first biography in English of Lorenzo de' Medici.[21] Roscoe admired Lorenzo because he believed he represented a worthy exemplar for men of his time and rank. He put his rhetoric into practice, and deliberately tailored aspects of his life to mirror Lorenzo de' Medici's career: for example, he retired from his practice as a solicitor at the age at which he believed Lorenzo had also left public life. As Washington Irving commented during Roscoe's lifetime, 'Like his own

Lorenzo de' Medici, on whom he seems to have fixed his eye, as on a pure model of antiquity, he has interwoven his life with the history of his native town, and has made the foundations of its fame the monuments of his virtues'.[22]

Following publication of his celebrated biography, Roscoe set out to form a collection of paintings which were 'original and authentic sources' of the 'rise and progress of the arts in modern times as well in Germany and Flanders as in Italy'.[23] The phraseology is highly reminiscent of Vasari, as was Roscoe's intention that these paintings (the majority of which are now in the Walker Art Gallery, Liverpool) be 'subservient to some objects of public utility'.[24] Several were purchased because they shed light on the 'Golden Age' of Lorenzo de' Medici, including a *cassone* panel by a late fifteenth-century follower of Apollonio di Giovanni depicting *The Adventures of Ulysses* (Liverpool, Walker Art Gallery, no. 2809). Most interestingly, Roscoe acquired the *predella* painting of *San Bernardino preaching*, now attributed to the studio of Vecchietta (Liverpool, Walker Art Gallery, no. 2758),[25] because he believed it portrayed the Medici family leaving church – Cosimo, the 'Pater Patriae', with his son Piero, preceded by his grandsons Lorenzo and his brother Giuliano, followed by a retinue of friends and servants. Roscoe attributed it to Pesellino, famed in nineteenth-century England and France for his production of paintings for the domestic setting.[26]

The diplomat, historian and translator Alexis-François Artaud de Montor formed his pioneering collection of one hundred and fifty early Italian paintings along principles similar to those which had animated William Roscoe. His 'Remarks on the State of Painting in Italy in the Four Centuries which preceded that of Raphael' were first published in Paris in 1808 (and subsequently revised at least once).[27] In 1843 they were republished to accompany the catalogue of his considerable collection.[28] Artaud de Montor's remarks, which are found in their fullest form in the 1811 edition, represent the first post-Vasarian attempt at a full art historical analysis of Florentine domestic painting, although they are greatly indebted

to the 'Life of Dello Delli', notably in their terminology. He introduced the painters of 'chests' (*caissons*, or *cassoni*), who included Orcanga, Starnina, Filippo Lippi and Pesellino, as worthy predecessors of Raphael. The qualities he praised in their work recalls Vasari's assessment of *cassoni* as visual records of a bygone age: 'Here one also finds a great freshness of colouring, a skilful consummate brush accompanied by no repainting; well-formed draperies, elements of architecture properly lit by daylight, and even enough learning to demonstrate that these masters were aware of the costume of the different nations, the customs, animals, and plants of the climate where the scene was set.'[29]

The catalogue proper of Artaud de Montor's collection opens with some remarks on 'those paintings known under the name of CASSONI or chests'. Like Vasari, he connected (although far more explicitly) 'the custom of painting the external part of chests' to marriage,[30] and alleged that this was brought to Tuscany by 'Greek' painters, thus giving them an honourable – although 'primitive' – role in his neo-Vasarian chronology of thirteenth- to sixteenth-century Italy.[31] He was also keen to demonstrate that talented artists produced *cassoni*, stating that 'they attached as much pride in making a beautiful *cassone*, as they did to painting a handsome portrait'.[32] His remarks on their function, as safe places to store objects under lock, and his comment, '. . . one can discern the location where the lock was placed', suggest that the panels in his collection, which included *Scenes from the Story of Joseph* (Cambridge, Fitzwilliam Museum), were already removed from their original setting in chests when they entered his possession.[33]

Artaud de Montor's comments build on Vasari's analysis in the 'Life of Dello Delli', although he makes several assertions apparently based on his study of his own objects. For example, he claimed that although most fourteenth-century chests were small in size, some were not, notably those painted by Andrea Orcagna. Those of the fifteenth century were larger still, particularly those of Filippo Lippi and 'Pesellino Peselli' which he praises for their delicate (*soigné*) work, 'which one cannot see without experiencing a

feeling of pleasure and astonishment'. He suggested that the painters of *cassoni* had particular specialisms, for instance claiming that Dello Delli was renowned for historical subjects.[34] Most significantly, he argued that the production of *cassoni* had an important social purpose, and he ended with a plea that the custom of decorating wedding chests with painting should be introduced into France. As a result, 'imperceptively, the spirit and discernment of the populace would be improved' and 'the taste for painting would enter into the spirit of the nation'.[35]

Artaud de Montor was highly unusual in his passion for *cassoni*, and mid-nineteenth-century art historical literature tended to make only the most cursory references to them. Crowe and Calvacaselle, for example, in *A History of Painting in Italy* (1864), mentioned Vasari's praise for Dello Delli, but remarked that 'it would be hard to point out any works of this kind [for chests and furniture] at the present day'.[36] These writers and others gave a developmental history of the arts in fifteenth-century Florence *à la* Vasari, and the role of *cassoni* – if they were mentioned at all – was to encourage contemporary society to model itself on the age of Lorenzo the Magnificent. For instance, Luigi Lanzi, whose *Story of Painting in Italy* was translated into English in 1852 by William Roscoe's son Thomas, wrote of the Medici house as 'a lyceum for philosophers, an arcadia for poets and an academy for artists', whose customs were copied by many Florentine private citizens, and thus improved the whole city.[37] The writings of James Jackson Jarves (1818–1888), one of the first two significant American collectors of fourteenth- and fifteenth-century Italian art (the other, Thomas Bryan, had purchased many of the domestic paintings in Artaud de Montor's collection, including fig. 9),[38] also emphasised the moral improvements which the examination of these paintings in a public gallery would bring to society,[39] including its poorest members, such as the creation of 'an intelligent public opinion' and 'the instruction and enjoyment of the people'.[40] Paintings for chests were included among the collection which Jarves had formed in Florence for this purpose,[41] and as Alan Chong has demonstrated, Jarves clearly understood their original function as a 'front of a bridal chest, used to contain the wardrobes of rich and noble brides'.[42] But North America was not ready for Jarves's enterprise, and he found no direct buyer,[43] although Yale's subsequent acquisition of his paintings (he had initially deposited them at New Haven as surety for a loan) meant that they were displayed ultimately for purposes close to his original intentions.[44]

A rigorously historical, but essentially similar, attitude to the 'industrial arts' as those of Jarves and Artaud de Montor can be found in the great Swiss historian Jacob Burckhardt's *The Civilisation of the Renaissance in Italy* (first published in 1860, and translated into English in a widely read version by John Addington Symonds in 1878). Burckhardt's cultural history played a crucial role in the introduction of the word 'Renaissance' as a descriptive term for fifteenth and sixteenth-century Italy, replacing references simply to the 'rebirth' of the arts. His conception of the arts was rooted in Vasari, but it was more profoundly shaped by the rigorous Berlin school of history and the methods of Ranke and Kugler, with whom he had studied.[45] Burckhardt argued that material comfort (as he and his contemporaries understood it) first appeared in Renaissance Italy. For this purpose, 'art ennobles luxury, not only adorning the massive sideboard or the light brackets with noble vases . . . but absorbing whole branches of material work – especially carpentering – into its province.'[46] The ennoblement of domestic objects was part of the 'spirit of the Renaissance', which transformed domestic life itself into a 'work of deliberate contrivance'. In Burckhardt's exceptionally influential conception of the Renaissance, the use of beautiful, well constructed objects in everyday life meant that art entered into life, and made life itself into a work of art.[47]

William Blundell Spence and the creation of the *cassone* market

Burckhardt was writing just as *cassoni* were beginning to be considered as art objects by more than a few

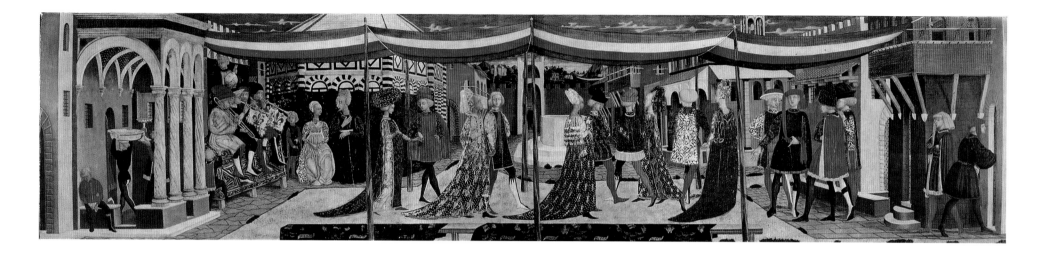

unusual individuals. Within thirty years painted wedding chests were an integral part of any collection of Italian Renaissance art, rather than curiosities. A painting such as Lo Scheggia's *Dance Scene* (fig. 20) went from being wholly unappreciated to an essential document of fifteenth- and sixteenth-century life (in a twist of irony, this panel, one of the first '*cassone*' panels to be universally lauded, was not actually made for a chest).[48] The development of this market was fast and furious. Until the 1850s *cassone* panels were only purchased as examples of the Italian 'primitives', interest in which was restricted to a few specialist collectors such as Giovanni Pietro Campana (1808–1880) – who owned figs. 18 and 21)[49] – William Roscoe, the Revd Walter Davenport-Bromley (1787–1863) and the diplomat and nobleman William Thomas Horner Fox-Strangways, 4th Earl of Ilchester (1795–1865).[50] At this date, no collectors in Britain (or elsewhere) were consciously purchasing paintings for furniture, or from domestic decorative schemes. For instance, the pair of paintings of Solomon and Sheba exhibited here (cat. 5 and 6) were bought by Lord Lindsay as Crivelli in 1849.[51]

What had been responsible for this sudden change? One cause can be found in the new museums of decorative art which were in the process of being established throughout Europe. Their purpose was to collect the applied arts as examples of industrial design to inspire the production of present and future generations. Britain's decorative art museum, the South Kensington Museum (later to be known as the Victoria and Albert Museum), was among the first to purchase paintings for chests as such, rather than as 'primitive' paintings, and six were bought by Frederick Cole and J.C. Robinson between 1858 and 1863 (including figs. 3 and 16).[52] Even more chests and paintings associated with them were acquired for the Prussian state collections by the extraordinary Wilhelm von Bode (1845–1929), largely though the Florentine artist and dealer Stefano Bardini (1836–1922). As a result the Berlin museums have exceptionally strong holdings of fifteenth- and sixteenth-century Italian paintings and furniture for the domestic setting.[53]

An even more extensive market for wedding chests developed among European and North American collectors of Italian painting and furniture.[54] Many of these extraordinarily wealthy individuals – some aristocrats, others businessmen – wished to be seen as re-inventions of the Italian merchant princes whose possessions they acquired so avidly,[55] including Robert (1810–1892) and May Holford (d. 1901), Nathaniel de

Rothschild (1812–1870), Edouard (1833–1894) and Nélie Jacquemart-André (1841–1912),[56] Lord Somers (1819–1883)[57] and Lord Lindsay, Earl of Crawford and Balcarres (1812–1880), author of the influential *Sketches of the History of Christian Art* and a great collector of both early books and the Italian 'primitives' (including cat. 5, 6, 9 and 10). In 1861 he wrote to his son Ludovic concerning these activities:

'I little thought in my boyhood when Cosimo and Lorenzo [de' Medici] were the subject of my worship at Eton, that I should one day . . . point to my son a parallel and a moral from their history. The parallel is this: what commerce did, directly, for the Medici in the fifteenth century, commerce has done indirectly for our own family in the nineteenth . . . the growth of trade has, by a strange recompense, afforded us . . . the means of doing what our more powerful ancestors, the contemporaries of Cosimo, could not have compassed – of building up our old Library after the example of the Medici, and in the mode they would themselves have acted upon had they been now living.'[58]

It is evident that Lord Lindsay considered his picture and book collecting to be a direct continuation of the Renaissance tradition of private patronage established by the Medici and others in fifteenth-century Italy, intended as a whole to 'illustrate the progress and history of painting'.[59] So, it seems, did his peers, but none expressed it as cogently and clearly as he.

The role of one individual, the Anglo-Florentine painter, *dilettante* and dealer, William Blundell Spence (1814–1900), seems to have been key to the development and exploitation of this market. Spence's significance can be over-stated. He was not the only dealer to sell *cassoni*, and following his father's death in 1860 dealing was no longer a financial imperative, although it remained a passion. He dealt largely and most satisfactorily with English *milordi* – including Lord and Lady Lindsay, their sister and brother-in-law the Holfords, Thomas Gambier Parry (1816–1888),[60] and the Sackville-Wests of Knole – but he was not the only dealer to sell to these clients. Torello Bacci, for instance, sold at least five paintings for the domestic setting (including cat. 9 and 10) to Lord Lindsay.[61]

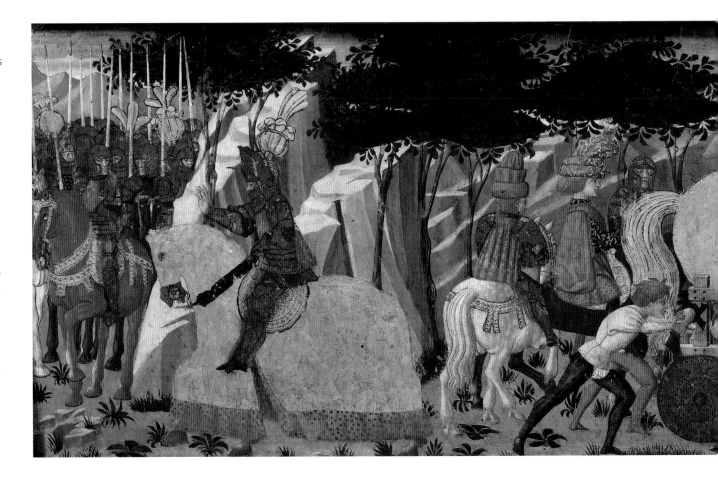

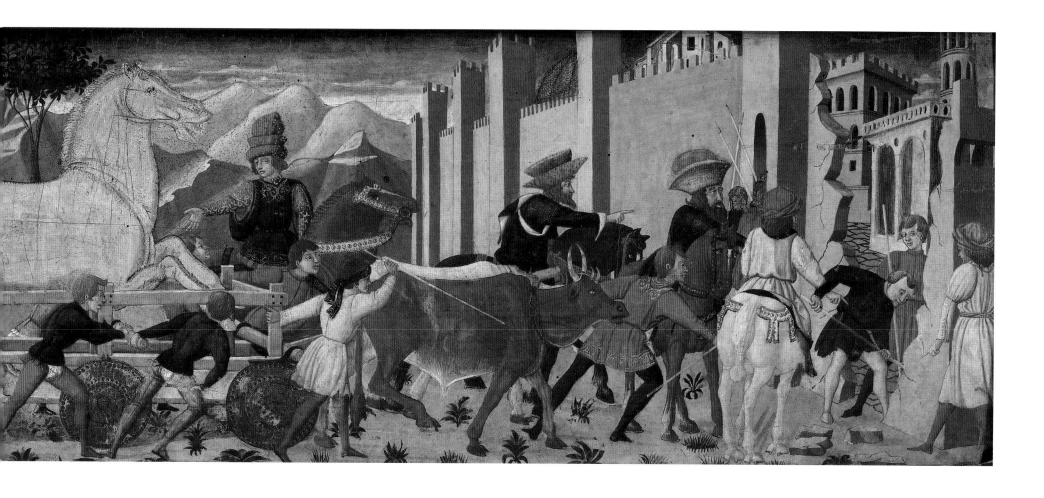

Fig. 21
Giovanni di Ser Giovanni (Lo Scheggia),
The Arrival of the Wooden Horse in Troy,
1460–65
Musée National de la Renaissance, Ecouen

Spence did not, as far as it can be ascertained, have substantive business with many German or French clients. These, if buying *cassoni*, tended to use Stefano Bardini, who was not active on a grand scale until the 1870s.[62] Bardini sold *cassoni* extensively,[63] and two of his main clients – Nélie Jacquemart-André and Wilhelm von Bode – bought in a spirit of competitive but friendly rivalry.[64]

However, it is hard not to conclude that William Blundell Spence created the general market for *cassoni*, and that British collectors, thanks to Spence, were the earliest to purchase *cassoni* as chests rather than detached panels. Writing to his father in 1843, he commented, 'The early *quattrocento* pictures are just coming into vogue but, except for a very fine specimen are certainly not very dear and customers are rare'.[65] By the late 1850s the tide was beginning to turn, influenced partially by his efforts. In 1857 a *cassone* panel was numbered among three pictures he sent on approval to Queen Victoria and the Prince Consort.[66] The following year he sold this painting to Thomas Gambier Parry for £40 (cat. 7).[67] It seems to have been the first painting to enter a British collection specifically as from a *cassone*.[68]

Cassoni, and paintings for them, numbered heavily among the fifteenth-century paintings Spence urged on

55

his clients, and the rise of this market was swift. Two selections from the large correspondence which still survives between Spence and some of his clients illustrate this. In a letter to Thomas Gambier Parry (21 July 1859) he bemoans: 'I have purchased two fine *cassoni* by Dello for £90 which might have been had for £40 three years ago'.[69] Thirteen years later another client, Sir William Drake, wrote to Spence about a recent purchase in Florence: 'I think that on the whole I was right in giving the 1550 francs for the *cassone* but compared with what one used to give the price is large.'[70]

It seems likely that the overwhelming majority of chests or panels identified as being from a chest to enter British collections from Italy during the nineteenth century passed through William Blundell Spence's hands.[71] Certainly, there is no evidence to the contrary. Where documentary evidence does not survive, the chests themselves can provide proof of this hypothesis. For instance, nothing is known for certain about the whereabouts of the Morelli-Nerli chests (cat.1 and 2) between 1680 and their appearance in the collection of Sir Herbert Smith, Witley Park, Worcestershire in 1938.[72] However, the recent discovery of what may be William Blundell Spence's handwriting on the back of the Nerli chest (cat. 2) suggests that he possibly acted as agent for their sale to England.[73] A chest at Knole, purchased in Florence in June 1876, bears a card stuck to its inside lid which is also in Spence's characteristically fluid script.[74] And in addition (as will be examined below), the physical structure and appearance of chests also provides likely proof of Spence's ownership.

Spence's display and sale of *cassoni* appears to have been influenced by their discussion by historians, particularly Vasari. Spence hung his collections, which he often referred to as 'gems' or 'jewels'[75] with which he would not part (rather disingenuously, given that he sold many of them) in a gallery in Palazzo Giugni on Florence's via degli Alfani.[76] Two small paintings, perhaps by Spence, of rooms in this gallery show his paintings and chests displayed as if in a seigneurial mansion, newly refurbished in the neo-Renaissance

style with coffered ceilings and heavy cornices.[77] Paintings were grouped around chests, giving a sense of ponderous, impressive grandeur and prosperity. The chests thus took on the appearance of visual documents of Renaissance Florentine life, made by important artists. Presumably this was intended to show his wealthy and well-connected clientèle how easily their new possessions would integrate into their existing houses. Certainly, the views of Spence's gallery resemble the interiors in which most of these chests found homes after leaving Spence's hands (such as fig. 22).

Spence's Vasarian marketing of *cassoni* as visual evocations of Renaissance Italy is further revealed in his correspondence with clients. His panels or chests were almost inevitably and invariably attributed to Dello Delli, Paolo Uccello or Pesellino.[78] They were either described, in partial echo of Vasari, as representing scenes from ancient history or – more commonly – events from fifteenth century Florence. The characteristics of his approach are well documented in his surviving letters to Thomas Gambier Parry (most of whose collection now belongs to the Courtauld Gallery). The first chest panel which Gambier Parry bought from Spence in July 1858 (cat. 7) was described by the dealer as 'Part of a marriage chest painted by Pier della Francesca for the Casa Rucellai. It represents the betrothal of a Rucellai to a Neapolitan noble – and the Siege of Siena by the Rucellai, Vettori and Corsini Families. From the Rucellai it was inherited by the Ginori.'[79] The object did not just therefore have a good provenance, and an attribution to a great name, but it represented high politics of the age, and was closely related to marriage. Five months later, he tried to sell Gambier Parry 'a splendid marriage chest complete[80] On the front is a battle and tournament very like the one you bought of me as to treatment – and nearly as well preserved –.'[81] In January 1859 Spence attempted to interest Gambier Parry in 'a small picture part of the *cassone* by Dello; the subject the Zatto delle spose Venete'. He was not successful on this occasion, but managed to sell the painting six years later, still as 'the brides of Venice', to the Earl of Southesk.[82] The

same letter mentions another 'smaller marriage chest which I saw today and which I think could be had for about £50 that might suit you, it is about 4 feet and a half long, the subject very particular and the costumes mainly women very quaint.~'[83] Spence mentioned a further six *cassoni* in his regular correspondence with Gambier Parry during the first half of 1859 alone – either because they were chests in a 'wonderful' or remarkable state of preservation, inevitably 'very fine',[84] or because they were by Uccello, by whom his client was actively seeking a *cassone* painting.[85] Ultimately, the *cassone* which satisfied these criteria for Gambier Parry was one whose front panel was described by Spence as representing Scipio Africanus (reproduced fig. 22), and 'on hearing from him [Mr Spence] that there was a first rate *cassone* to be sold I sold two small watercolour drawings by Barret and Copley Fielding for about double what I gave for them and sent Spence the money – just the price of the *cassone*'.[86]

The objects sold by Spence and other dealers were often 'improved' before they left Florence for their new homes in wealthy private collections and museums. As a result hardly any of the chests which survive today are simply fifteenth-century objects.[87] Although the value placed on painted chests as memorials of important alliances meant that many had been retained by the families for whom they had been made, they had become outmoded and had been relegated to store rooms. Some had even been disassembled in the sixteenth century, to create new pieces of furniture from older components.[88] The ravages of neglect and the passage of time were hidden under new structures and additions which transformed surviving chests (such as cat. 8) into more convincing manifestations of the nineteenth century's ideals of Renaissance objects.

Spence, who considered himself an artist first and a dealer second, held picture restorers in abhorrence. He castigated them as 'daubers' who 'work for people who know nothing about it and often on pictures that are only fit for fuel'.[89] Yet he evidently made considerable use of them[90] – or at least the 'one person here to whom I would entrust a picture of value'.[91] Spence

was much less reticent in his praise for Florentine craftsmen who were able to restore fifteenth century furniture to its former glory. The carpenter and carver Luigi Frullini is documented as having made reproduction Renaissance furniture for Spence in the 1870s,[92] and it is possible that he may also have restored his *cassoni*.[93] Ellen Callmann has demonstrated the resemblances between a reproduction *cassone* made by the Florentine Antonio Ponziani in 1861 (now in the Galleria d'Arte Moderna, Palazzo Pitti, Florence)[94] and the chests which came through Spence's hands, such as the two *cassoni* now in the National Gallery, London (including fig. 23).[95]

These chests, displayed across a room in the National Gallery's Sainsbury Wing, look like a pair, but this is impossible since the painted panels set inside them are by different workshops and separated in date by at least thirty years. However, the bodies of the *cassoni* themselves are incredibly similar. Both National Gallery

chests stand on four lion's feet, attached to the chests with wooden battens. Their exteriors suggest that they are complete 'Renaissance' fabrications, based on fifteenth-century sources such as several woodcuts (including fig. 24) which accompanied Girolamo Savonarola's *Art of Dying Well*, published in Florence in 1496. In contrast, those exceptionally rare objects which have undergone less substantive alteration, such as the body of the Trebizond chest (fig. 25)[96] and the chest with a wedding procession in the Victoria and Albert Museum (fig. 3) stand on simple battens or a *predella*. Each of the National Gallery chests is covered with an elaborately raised gilded lid, decorated with intricate foliate carving, and a lion's head. The heavy cornicing (particularly on the lids) is almost identical on both. In addition, the front panels of each chest are framed by pillars, topped by extremely unusual composite capitals. They are decorated above and beneath the central panel with very uniform coloured

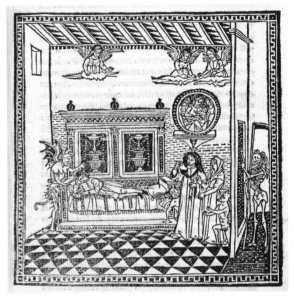

Fig. 24
Woodcut illustrating Girolamo Savonarola's *Predica del arte del ben morire*, Florence (Bartolomeo de' Libri), 1496
The British Library, London

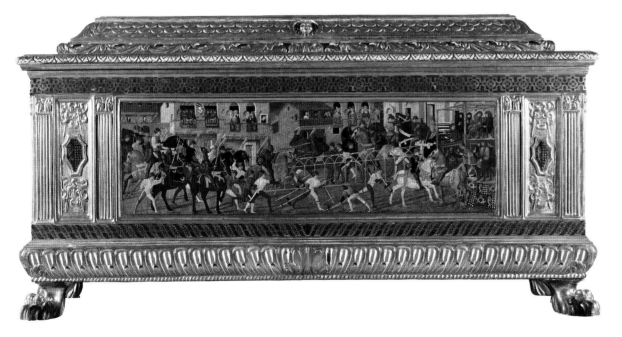

Fig. 23
Follower of Apollonio di Giovanni, *Chest with a Tournament Scene*, around 1465
The National Gallery, London

Fig. 25
Apollonio di Giovanni and Marco del
Buono Giamberti, *Chest with the Conquest
of Trebizond*, after 1461
The Metropolitan Museum of Art,
New York

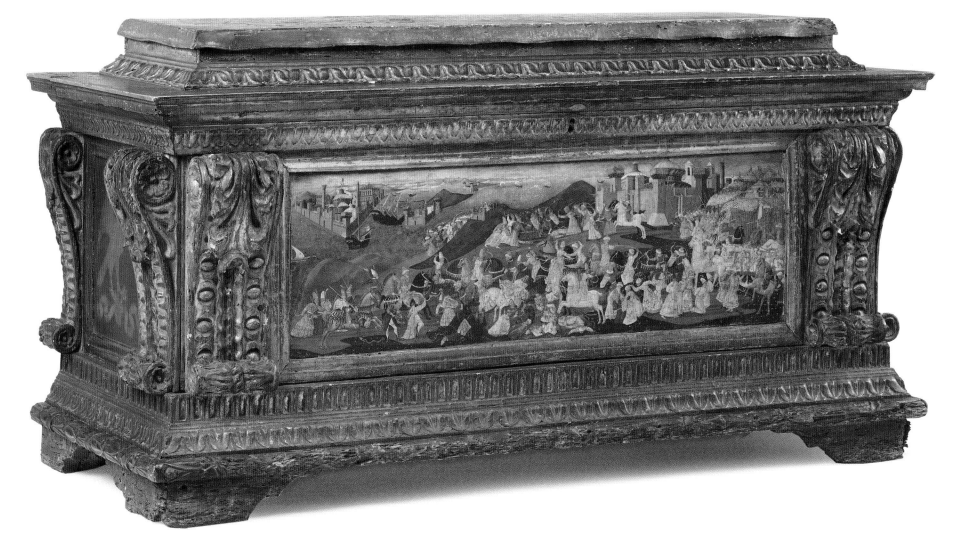

stencilling and punching, seemingly produced by a machine-made punch. Old pieces of wood, indeed parts of old chests, were used in their construction, but their appearance today is primarily that of nineteenth-century objects.[97]

Many of the chests which passed through Spence's hands share such characteristic details.[98] The pioneering research of Ellen Callmann first drew attention to the extent to which Spence and others remade *cassoni*.[99] Not every chest was a total reconstruction, and it is probable that the level of intervention depended on the condition of the object in question. For instance, the Courtauld's Morelli-Nerli chests (cat. 1 and 2) underwent less alteration than the two National Gallery *cassoni*. Some substantial changes were made, such as the addition of two decorative mouldings beneath the front panels, and each chest's placement on four lion's feet. Yet the basic structure of the body of these chests is probably relatively intact, although they were substantially regilded: certainly they retain more of their original structure than has been suggested recently.[100]

In contrast, Thomas Gambier Parry's 'Uccello' (illustrated fig. 22) is a prime example of Spence's reconstructive tendency. Spence praised it to Gambier Parry as 'a very fine *Cassone* a short one by Paolo Uccello intact, representing . . . Scipio Africanus very fine indeed as to condition'.[101] Gambier Parry was by all accounts delighted with his purchase,[102] yet not a single aspect of Spence's description seems correct to the modern observer. The front panel is certainly not by Uccello, although the battle scene it depicts is indebted to his popularisation of these subjects. Nor is the subject Scipio Africanus, but the battle of Pharsalus (Pompey's head is handed on a platter to Caesar at the far right; compare cat. 8). Moreover, the condition does not seem 'very fine' but rather enormously restored and compromised. Gambier Parry's chest, which was sold in 1971[103] and subsequently dismembered, contained panels by a number of different artistic personalities. The front panel was by a Florentine painter of around 1460, probably associated with Lo Scheggia. The *testate* (representing two allegorical

female figures, one with a lyre and the other with a dove) were perhaps North Italian, and their style and iconography suggest a date of around sixty years earlier. The back of the chest consisted of a panel representing two *putti* seated on dolphins. This was painted for the inside of a *cassone* made by Apollonio di Giovanni for the marriage of Giovanni di Antonio de' Pazzi and Beatrice di Giovanni de' Borromei in 1461 (now in the Indiana University Art Museum, Bloomington).[104]

Thus, rather than being an intact fifteenth-century chest, Gambier Parry's prized possession was a confection of disparate panels, placed in a new *cassone* constructed from fragments of old furniture and modern wood. The same can be said of the chest presented by the Misses Lindsay to the National Gallery in 1912. The Lindsays' chest contains a front panel representing *The Schoolmaster of Falerii*, probably by the Master of Marradi, and dating from the 1490s. However, the *testate* of *putti* with seed pods are reminiscent of Lo Scheggia's *intarsia* designs for Florence Cathedral (see above, 'The Wedding Chest'). The configuration of the painted panels is quite fictitious, as they were probably made about forty years apart, and by different workshops. The levels of all these interventions seem unsuitable today. Chests were not simply repaired, but restructured and repainted to house fifteenth-century panels.

The boundary between a fake and a heavily restored object is very fine indeed – so it is hard to categorise a painting like *The Triumph of Chastity* (Appendix, no. 3), which Thomas Gambier Parry bought from Spence for £200 in 1875.[105] Today, this looks entirely like a nineteenth-century work. The pigments used include Prussian blue, unknown before the eighteenth century, and the gold background (which is under parts of the painted surface) cannot be original. However, the x-radiograph reveals the ruined ghost of an earlier painting beneath the surface of some areas.[106] The repainting was not necessarily undertaken with nefarious intentions. Spence has been criticised for his 'fakery', but this is perhaps to misunderstand and simplify what is a very complicated story.[107] It appears

that neither Spence nor other dealers at this date intended to deliberately deceive their clients, who did not feel that they had been victims of trickery and chicanery.[108] What they got were objects that looked as they thought great Renaissance marriage chests should – bright with gold and colour and depicting important events from history. As Ellen Callmann remarked, the confusion only set in with the next generation, who were not aware of the extent to which their Renaissance *cassoni* had been remade.[109]

How the market shaped historiography

Those who bought *cassoni* wanted to be informed about their new possessions. Their presence as a commodity on the art market created a new art historical interest in them, as representations of Florentine life 'as it was' and the 'spirit' of the Renaissance identified by Burckhardt. What remain the two most significant studies of *cassoni* were published in the early twentieth century as a result of this new impetus: Attilio Schiaparelli's *La casa fiorentina ed i suoi arredi nei secoli XIV e XV* and Paul Schubring's catalogue *Cassoni: Truhen und Truhenbilder der italienischen Frührenaissance*.[110] The market for these publications was based on the large number of paintings for chests and other types of furniture in circulation during the late nineteenth- and early twentieth-centuries. Schubring commented that he had examined more than eight hundred chests while researching his book. Of these, over two hundred (presumably including fig. 25) were in an enormous room owned by Stefano Bardini, encompassing every possible variety of the object.[111]

Schiaparelli's intention was to provide a detailed description of the architecture, function and decoration of the Florentine house, concentrating on the palaces of the elite. Within this functional context he dedicated a section of his chapter on furniture to painted furniture because they represented 'the most typical moments of contemporary life in its most picturesque forms (feasts, battles, jousts, hunts, games, processions, ceremonies of every sort, types of armour, of painted cloth, of

magnificent clothing)'.[112] They were of 'great importance for the history of dress and culture'. Among other things 'they show how interweaved were the tales of mythology and history and the fanciful world created by story-tellers and poets'. In addition, 'they place under our gaze genuine particularities, which we can only understand in an incomplete and indirect form from other sources – these being the life of the period, its characteristic atmosphere, with its unfamiliar types of dress and curious customs, both public and private, of the elite and of the people'.[113]

The resemblance of these and other passages to Vasari's 'Life of Dello Delli' is striking, and it was surely intentional. The terms in which Schiaparelli discussed *cassoni* also recalled the comments of dealers like Spence and Bardini. Schiaparelli, like Vasari, singled out furniture painting as a 'minor art' on which the 'major themes' of fifteenth-century Florentine life and history were played out. His account of furniture painting was elegiac, and tinged with regret for the widescale destruction of 'old' Florence during his lifetime. The purpose of his book was 'to offer to those spirits who love the past some help to evoke in its entirety the domestic environment in which the contemporaries of Dante, Boccaccio, Brunelleschi, and Botticelli lived'.[114] Consequently, he considered that it was his duty to list as many of these important documents of fifteenth-century culture as possible, as well as giving their locations in European and North American collections to facilitate the work of the historian.[115]

Schiaparelli's work on painted chests, and that of others including Wilhelm von Bode and Count Lanckoronski,[116] was somewhat superseded by Paul Schubring's *Cassoni* of 1915 (republished with a supplement in 1923). Schubring's status as a distinguished art historian, who had proved himself with books on 'respectable' subjects like Donatello, and a study of early Renaissance tombs, helped further to legitimise the academic status of furniture painting.[117] His impressive catalogue, with over nine hundred objects,[118] is preceded by a study of the subjects represented on *cassone* panels. This appears to have been the primary

intention of his book, which is subtitled 'An Historical Essay on Secular Painting in the Fifteenth Century' (*Ein Beitrag zur Profanmalerei im Quattrocento*).

Schubring's monograph remains the most valuable reference work on the subject, the only comprehensive attempt to date, survey and illustrate the majority of extant Italian decorated chests from the fourteenth to the early sixteenth centuries. Although Schubring was sensitive to the various furniture forms into which paintings were inserted, including beds and *cornice* and *spalliera* panels, he still demonstrated his dependence on the traditional narrative of furniture painting established by Vasari by calling his book 'Cassoni'. For Schubring, 'cassone' remained the generic term for a painting of a secular subject in a private setting, regardless of its form and dimensions. His employment of this blanket term obscured the complexity of function within the varieties of domestic painting, because other art historians followed his lead as the acknowledged expert on this art form.

The production and reception of Schubring's work were intertwined with the art market. Although his primary intention was to study the subjects of *cassoni*, his book was used predominantly as a monographic catalogue of furniture painting. He published many chests which were for sale, notably those belonging to Bardini. The inclusion of other objects, particularly those in British private collections, made their where-abouts known, and gave them a showcase where they could be seen by the next generation of *cassoni* collectors, in the main Americans such as Samuel Kress (1863–1955).[119] Schubring's book – like Berenson's 'Lists' – legitimated attributions, as well as acting (unintentionally) as a potential shopping list.

With hindsight, we can say that Schubring's *Cassoni* was first published at the highwater mark for the collection of painted furniture. The crash of 1929 marked the end of their period as objects of great desire to the majority of collectors and museums. Those still in private collections declined considerably in value. In September 1938, the London dealer Tomas Harris (1908–1964) bought the Morelli-Nerli chests (cat. 1 and 2) for £150 each from a house sale in

Worcestershire (they had failed to find a buyer at auction). The following April he offered them to the Museum of Fine Arts in Boston as 'the most important pair in the world',[120] but to no avail.[121] Only in 1947 did Harris find them a permanent home in the collection of Lord Lee of Fareham (1868–1947), who purchased them for the astonishing sum of £10,000 shortly before his death as part of the collection he intended to bequeath for the use of students at the young Courtauld Institute.[122] The further bequest of Thomas Gambier Parry's collection by his grandson Mark in 1966 furnished the Courtauld with a significant group of Florentine furniture paintings, including *cassone* panels detached from chests, partially intact chests and chests and paintings which had been heavily restored.[123]

For much of the last sixty years, *cassoni* have been relegated to display under what are considered more important paintings, tolerated in museums for their ability to give context to the work of the great artists of the Vasarian biographical tradition. The position is now changing. Thanks once more to historiographical trends, painted furniture has been the subject of intense study by a generation of scholars (many of whom have been influenced by social and gender history), predominantly interested in what it might reveal of fifteenth- and sixteenth-century customs, behaviour and *mentalité*.[124] Although much of this work was undertaken in reaction to the Vasarian canon, it can in a sense be seen as a further reinvention of Vasari's categorisation of domestic paintings as vehicles for the conveyance of social *mores*. *Cassoni* and other types of furniture paintings are also more voraciously collected by public and private collectors than at any point since the late 1920s. But we should recognise *cassoni* both for what they are – highly significant art objects made for the Renaissance home – and for what they have become. No other category of object bears the weight of its history and historiography so heavily. Art history has not just framed the context in which *cassoni* have been discussed. It has transformed their appearance, and determined the shape they bear today. This intersection between art objects, collecting and scholarly writing gives *cassoni* a unique place in

the discussion of the historiography of the Italian Renaissance. It is only by appreciating the dual character of these chests as both Renaissance and modern objects that we can fully comprehend them, and savour their intent. This catalogue represents an attempt to see these important items as furniture, paintings, and as objects which cross both the categories of art and the boundaries of time.

NOTES

I would like to acknowledge the work of Alan Chong and the contribution of the Isabella Stewart Gardner Museum, Boston, towards the development of this essay. Alan and I have worked independently on this material for several years. I am extremely grateful to him for sharing both his thoughts and research on this subject with me.

1 For example, see Barriault 1994, p. 3.
2 Rubin 1994, p. 193.
3 Vasari 1550 and 1568, vol. 3, p. 514 ('Life of Sandro Botticelli', 1568); vol. 4, pp. 68-69 ('Life of Piero di Cosimo', 1568).
4 See Vasari 1550 and 1568, 'Life of Andrea del Sarto' (1568) and 'Life of Iacopo Pontormo' (1568), vol. 4, pp. 363-64, vol. 5, pp. 317-18; 'Life of Paolo Uccello' (1568), vol. 3, p. 69.
5 Vasari 1550 and 1568, 'Life of Dello, Florentine Painter' (1568), vol. 3, pp. 37-41.
6 Jacobsen 2001, p. 544.
7 Jacobsen 2001, pp. 544-45. Dello matriculated in the Arte dei Medici e Speziali in January 1432 (modern style). His painting speciality is not indicated. His mother's *catasto* return of 28 February 1446 (modern style) records that he had been in Spain for fourteen years.
8 Vasari 1550 and 1568, vol. 3, pp. 38-39 (1550).
9 Vasari 1550 and 1568, vol. 3, p. 38 (1568).
10 Vasari 1550 and 1568, vol. 3, p. 38 (1568).
11 Vasari 1550 and 1568, vol. 3, p. 37 (1568).
12 Vasari 1550 and 1568, vol. 3, p. 38 (1568).
13 Vasari 1550 and 1568, 'Life of Sandro Botticelli' (1568), vol. 3, p. 511.
14 Rubin 1994a, pp. 432ff.
15 For a recent analysis of this passage see Syson and Motture 2006-07, p. 274.
16 Vasari 1550 and 1568, vol. 3, p. 38 (1568). *'E che ciò sia vero, si è veduto insino a' giorni nostri, oltre molti altri, alcuni cassoni, spalliere e cornice nelle camera del magnifico Lorenzo Vecchio de' Medici, nei quali era dipinto di mano di pittori non mica plebei, ma eccellenti maestri, tutte le giostre, torneamenti, cacce e feste et altri spettacoli fatti ne' suoi tempi, con giudizio, con invenzione e con arte maravigliosa'.*
17 Vasari 1550 and 1568, vol. 3, p. 38 (1568): *'in tutte le più nobili case di Firenze'.*
18 Vasari 1550 and 1568, vol. 3, p. 39 (1568): *'nel palazzo del signor duca Cosimo n'ho fatto conservare alcune e di mano propria di Dello, dove sono e saranno sempre degne d'essere considerate, almeno per gl'abiti varii di que' tempi così da uomini come da donne che in esse si veggiono'.*
19 Vasari 1550 and 1568, vol. 3, p. 37 (1568).
20 See Rubin 1994, pp. 193-94.
21 Roscoe 1796.
22 Irving 1819, p. 24.
23 Roscoe (?) 1816.
24 Roscoe (?) 1816, p. 1.
25 Morris and Hopkinson 1977, pp. 212-13 (no. 2758).
26 Roscoe 1822, p. 89.

27 See Artaud de Montor 1808; Artaud de Montor 1811, Artaud de Montor 1843. This material was first presented in an unpublished paper delivered at the Association of Art Historians Conference, Oxford, 2001. Alan Chong has also worked independently on Artaud de Montor: I am very grateful to Alan for discussing this with me, before his work (Chong 2008-09) went to press.
28 Artaud de Montor 1843.
29 Artaud de Montor 1811, p.39: *'avant lui [Raphael], Orcagna, Starnina, Dello, Frà-Lippi, Pesellino Peselli, avoient peint, sous le nom de caissons, d'énormes tableaux sur bois, où l'on voit les arabesques que, suivant plusieurs auteurs, Raphaël n'auroit vues nulle part; où l'on trouve une grande fraîcheur de coloris, une assurance de pinceau, qui n'est accompagnée d'aucun repentir; des draperies raisonée, des morceaux d'architecture éclairés du jour convenable, et même assez d'érudition pour prouver que ces maîtres ont connu les vêtements respectifs des nations, les usages, les animaux et les plantes du climat où la scène se passe ?'*
30 Artaud de Montor, 1811, p. 54: *'Je veux parler des tableaux connus sous le nom de CASSONI ou coffres. L'usage de peindre la partie extérieure des coffres dans lesquels on enfermoit les présens de noce données aux jeunes mariés.'*
31 Artaud de Montor 1811, pp. 54-55.
32 Artaud de Montor, 1811, p. 56: *'ils attacheroient autant d'amour-propre à faire un beau cassone, qu'à peindre un beau portrait'.*
33 Artaud de Montor, 1811, p. 55: *'On voit meme que les coffres peuvent se fermer, puisqu'on distingue la place où l'étoit serrure.'*
34 Artaud de Montor, 1811, p. 55: *'qu'on ne peut les voir sans éprouver un sentiment de plaisir et d'étonnement'.*
35 Artaud de Montor, 1811, pp. 55-56: *'Comme il seroit hereux qu'un semblable usage se renouvelât ! Nous avons aujourd'hui tant de talens à employer ! L'art de la peinture ne pourroit faire que des progress plus éclatans, s'il étoit consacré à embellir nos fêtes de marriage ; à l'époque d'une noce, on est toujours généreux, il faut même presque paroître prodigue. Les premiers artistes pendroient les cassoni destinés aux personnes riches; chaque femme d'ouvrier voudroit avoir son cassone . . . les artistes de tous les rangs, de tous les talens seroient dignement recompenses . . . il naîtroit aussi de grands peintres dans nos départemens ; le peuple perfectionneroit insensiblement cet esprit et ce discernement qu'on surprend dans tous les jugemens spontanés qui lui échappent, et le gout de la peinture entreroit dans les habitudes de la nation.'*
36 Crowe and Calvacaselle 1864, vol. 2, p. 301.
37 Lanzi, vol. 2, p. 72.
38 For Bryan (1800-1870) and a full account of his collection, which included eighteen paintings bought at Artaud de Montor's Paris sale in January 1851, see Chong 2008-09, pp. 67-71.
39 Jarves 1861, p. 13.
40 Jarves 1861, p. 12.
41 Currently catalogued as Workshop of Apollonio di Giovanni, *The Story of Aeneas, I and II* (1871.34 and 35), *The Tournament in Piazza Santa Croce* (1871.33) and ?Follower of Paolo Schiavo (1871.67).
42 Jarves 1860, p. 49, no. 55. See Chong 2008-09, p. 72, n. 33.
43 Callmann 1999, p. 339.

44 Seymour 1970, pp. 1–2; Chong 2008–09, pp. 73–74.
45 Burckhardt 1990, p. 1.
46 Burckhardt 1990, p. 239.
47 Burckhardt 1990, p. 254. A similar idea is expressed in Ajmar-Wollheim and Dennis 2006–07, p. 18.
48 Bellosi and Haines 1999, p. 81.
49 For Campana's collection, see Simmoneau in Erlande-Brandenburg, Simmoneau and Benoît 2004, pp. 15–16, and most comprehensively Sarti 2001.
50 Lloyd 1977, p. xx (letter of W.T.H. Fox-Strangways to Henry Fox-Talbot, 5 February 1827).
51 Christie's, London, 30 March 1849 (Thomas Blayds's sale), lots 161 and 162.
52 Kauffmann 1973, cat. 9, 120, 121, 122, 124; also Victoria and Albert Museum inv. 8974–1863.
53 For the paintings, see Nützmann 2000. Achim Stiegel is currently working on a catalogue of the Italian furniture of the Kunstgewerbemuseum Berlin.
54 This essay concentrates on the British collecting of wedding chests and furniture painting; for some aspects of the wider European and American story of the market in these objects see in particular Scalia and De Benedictis 1984; Fahy 2000; Di Lorenzo 2002–03. The North American collecting of *cassoni* has been analysed admirably by Chong 2008–09.
55 Pavoni 1997; Ajmar-Wollheim and Dennis 2006–07, p. 19; Penny 2005; and (for the later American collectors) Brown 2003, p. xiii.
56 Di Lorenzo 2002–03.
57 Fleming 1979b, p. 571, n. 20.
58 Barker 2000, p. 15.
59 Brigstocke 2000, pp. 27, 31.
60 For Thomas Gambier Parry's collection see Farr 1993. A post-graduate research project supervised by Alexandra Gerstein under the auspices of the Courtauld Institute Research Forum (2006–07) studied the general patterns of Gambier Parry's collecting of the decorative arts. I am indebted to Alexandra Gerstein for permitting me to study unpublished papers from this project.
61 Brigstocke 2000, p. 30. Apart from the panels now at Harewood, these were two panels (possibly *spalliere*, and certainly not for *cassoni*) of Lucretia and Virginia by Jacopo del Sellaio and a *desco* of Diana and Actaeon (reproduced in Weston-Lewis 2000, cat. 17 and 26).
62 Scalia and De Benedictis 1984, pp. 13–15.
63 Schubring 1915, esp. p. vii.
64 Di Lorenzo 2002–03, p. 17, also nn. 24–29.
65 Fleming 1979a, p. 497.
66 Letter from William Blundell Spence to Thomas Gambier Parry, July 1858 (undated), p. 3. I am grateful to Thomas Fenton for permitting me to quote from Spence's letters to Gambier Parry. Mr Fenton has kindly deposited a copy of these in the Courtauld Gallery Archive.
67 Letter from William Blundell Spence to Thomas Gambier Parry, July 1858 (undated), p. 1.
68 In the same year, Spence sold his first painted *cassone* to a British collection (for £80). This object, which remains in the

Victorian and Albert Museum (inv. 4639–1858), is discussed by Callmann 1999, pp. 346–47, nn. 45 and 48, fig. 20, and Kauffmann 1973, no. 124, pp. 111–12.
69 Letter from William Blundell Spence to Thomas Gambier Parry, 21 July 1859, p. 2.
70 Fleming 1979b, p. 571, n. 27.
71 Callmann 1999, p. 348, asserts that all such paintings came from Spence, but Lord Lindsay also bought from Torello Bacci (see cat. 9 and 10).
72 Smith sale 1938, day 3 (29 September 1938), lots 576 and 577 (unsold).
73 The handwriting is on the back of the Nerli chest.
74 'Florence. 24 June 1876. / *Un Cassone da Matrimonio intagliato e / dorato con pitture / del celebre Dello Delli / Pittore Fiorentino del 400.*' I am grateful to Robert Sackville, and to Helen Faubert of the National Trust for enabling my examination of the *cassone* at Knole.
75 See for instance, William Blundell Spence to Thomas Gambier Parry, letter of 3 February 1859, p. 1; letter of 21 July 1859, p. 2.
76 Fleming 1979b, p. 570; initially Spence had lived (and sold from) an apartment in the Palazzo Corsi, subsequently the home of another English *marchand-amateur*, Herbert Horne (Fleming 1979a, p. 499).
77 They are reproduced in Callmann 1999, p. 339, figs. 14 and 15.
78 Fleming 1979b, pp. 578–80.
79 Letter from William Blundell Spence to Thomas Gambier Parry (undated, but annotated by Gambier Parry 'July 1858. Spence. The Pictures'), p. 2.
80 Underlined by Thomas Gambier Parry.
81 William Blundell Spence to Thomas Gambier Parry, Siena, 17 December 1858, p. 3.
82 James Carnegie (1827–1905) became 9th Earl of Southesk (by reversal of the Act of Attainder) in 1855. The painting is now in the National Gallery of Scotland, attributed to Apollonio di Giovanni. See Fleming 1979b, p. 575, n. 19, pp. 78–79.
83 William Blundell Spence to Thomas Gambier Parry, Florence, 17th January 1859, p. 4.
84 For example, William Blundell Spence to Thomas Gambier Parry, Florence, 8 April 1859, p. 1; Florence, 21 July 1859, p. 2.
85 William Blundell Spence to Thomas Gambier Parry, Florence, 17 January 1859; Florence, 8 April 1859; 28 April 1859; Florence, 21 July 1859.
86 Gambier Parry List 1863, nos. '23.4.5'. The chest is first mentioned in a letter from Spence to Gambier Parry from Florence of 21 July 1859, p. 2. It appears in Gambier Parry's 1860 'List' of his collection (Gambier Parry List 1860, nos. 67, 68, 69), and in the 1863 'List' he describes it as costing £70.
87 A *pastiglia* and painted 'Chest with a Wedding Procession' (fig. 3) has one of the best claims to be a largely unreconstructed fifteenth-century object. I am indebted to Éowyn Kerr, former Kress Fellow in Conservation, Victoria and Albert Museum, for sharing the results of her largely unpublished research with me. For the interventions made to the Morelli-Nerli chests and the Metropolitan Museum's Trebizond chest, see below, cat. 1 and 2, and Krohn 2008–09, cat. 56, pp. 129–33, n. 1.

88 Matchette 2006, p. 711, nn. 40-42.

89 William Blundell Spence, Letter to Thomas Gambier Parry, Florence, 21 July 1859, p. 1.

90 Callmann 1999, p. 347. Many panels which went through Spence's hands exhibit extremely heavy nineteenth-century restoration, such as: Florentine, around 1470, *cassone* panel with the Triumphs of Love, Chastity and Death (London, Victoria and Albert Museum, 4639-1858); Florentine, around 1450, *A Triumphal Procession* (Courtauld Gallery; App. no. 4); and in particular the Courtauld *Triumph of Chastity* (App. no. 3) which is an almost totally mid-nineteenth-century painting on top of a ruined painted panel.

91 William Blundell Spence, Letter to Thomas Gambier Parry, Florence, 21 July 1859, p. 1. This person may have been Signore Bacci, who is described as 'Mr Spence's restorer' by Henry Cole of the South Kensington Museum in his annotated copy of Murray's *Handbook for Travellers in Northern Italy* (see Wainright 1999, pp. 180 n. 32, 184).

92 Fleming 1979b, p. 571, n. 27.

93 Callmann 1999, p. 340.

94 Callmann 1999, pp. 340-41; Chiarugi 1995, p. 85 and fig. 503.

95 London, National Gallery, NG 3826 and NG 4906. See Davies 1961, pp. 189-90, 192-94 (both as Florentine School). NG 3826 was presented by the Misses Lindsay in 1912, while NG 4906 was bequeathed by Sir Robert Samuelson in 1937. For their purchase through Spence by both sets of donors' parents see Fleming 1979b, pp. 578-80.

96 Recent technical examination of the Trebizond chest suggests that the front panel was set into the body of the chest at a later date. I am grateful to Charlotte Hale for this information.

97 I am most grateful to Larry Keith for having examined these two chests with me in 2001, as well as to Nicholas Penny for having introduced me to the complexities of looking at these chests in 1996, while I was a PhD student.

98 A small and unscientific sample of such chests includes Lo Scheggia, *The Triumph of David* (ex-Cook collection, Richmond); *The Battle of Pharsalus* (Lee Collection, Courtauld Gallery); Lo Scheggia, *The Triumph of Aemilius Paulus* (National Trust, Knole); Florentine, around 1460, *Judith and Holofernes* (The Abercorn Heirloom Settlement); Florentine, around 1450-60, *Camilla in Battle and the Triumph of Aeneas* (Musée du Cinquantenaire, Brussels); Florentine, 1460-70, *Triumph of a Roman General* (ex-Sarah Campbell Blaffer Foundation, Houston); Florentine, around 1460, *Triumph of a Roman General* (private collection).

99 See Callmann 1974, 1978, 1999.

100 Callmann 1999, pp. 342-44; Partridge 2006, p. 103; Baskins 2008-09, p. 5.

101 William Blundell Spence to Thomas Gambier Parry, Florence, 21 July 1859, p. 2.

102 See note 86 above.

103 Highnam Court sale 1971, lot 1282.

104 Callmann 1977; Krohn in Bayer 2008-09, cat. 58a, pp. 134-36.

105 William Blundell Spence, Receipt from Thomas Gambier Parry, 16 November 1875.

106 I am grateful to Tilly Schmidt, Aviva Burnstock and Graeme Barraclough for sharing their (as yet unpublished) full technical study of this work with me.

107 Baskins 2008-09, p. 5; Krohn in Bayer 2008-09, p. 136, n. 11.

108 For a later, different attitude, see Mazzoni 2004.

109 Callmann 1999, p. 348.

110 Schiaparelli 1908; Schubring 1915. Roberta Bartoli is preparing a new edition of Schubring's corpus.

111 Schubring 1915, vol. 1, p. vii; Scalia and Benedictis 1984, pls. xxvii, lv.

112 Schiaparelli 1908, pp. 273-74: '*La rappresentazione della vita contemporanea ne' suoi momenti più tipici e nelle sue forme più pittoresche (feste, battaglie, giostre, caccie, giuochi, cortei, ceremonie d'ogni specie; sfoggio di armature, di drappi variopinti, di vesti magnifiche)*'.

113 Schiaparelli 1908, p. 278: '*ci mettono sott'occhio ne' suoi particolari più genuini ciò che solo in modo incompleto e indiretto potremmo conoscere da altre fonti, cioè la vita del tempo col suo ambiente caratteristico, con le strane sue fogge di vestire, colle sue curiose costumanze pubbliche e private, signorili e popolari.*'

114 Schiaparelli 1908, p. ix: '*Porgere agli spiriti amanti del passato un qualche aiuto a rievocare nella sua interezza l'ambiente domestico in cui vissero i contemporanei di Dante e del Boccaccio, del Brunelleschi e del Botticelli*'.

115 Schiaparelli 1908, p. 27.

116 Bode 1902; Lanckoronski 1905.

117 Schubring 1904; Schubring 1907.

118 Schubring 1915 and 1923.

119 See Brown 2003, pp. xiii-xv.

120 Letter of Tomas Harris to W.G. Constable, 27 March 1939 (Museum of Fine Arts, Boston, Archives, Director's Correspondence).

121 The chests were offered by Harris to the Museum of Fine Arts in April 1939 for £18,000 (letter of Tomas Harris to W.G. Constable), a price which Harris asked the Museum to 'treat . . . as personal' because they had (according to Harris) been valued previously at £30,000. They arrived in Boston on loan from Harris on 22 December 1939 (see labels on the backs of both chests). In 1940, the impetus for their acquisition shifted from the paintings to the decorative arts department. Their high price had always been a problem, and on 10 December 1940 the Museum told Harris that they could not acquire them owing to lack of funds: however, because of the war they remained at the Museum of Fine Arts until 1945. This hitherto unpublished correspondence is held in the Museum's archives. I am extremely grateful to Victoria Reed and Frederick Ilchman for locating and studying it on my behalf.

122 See Courtauld Gallery Archive, file F.1947.LF.3-4, transcript of Lee's red account book.

123 Blunt 1967; Farr 1993a.

124 The literature, which is vast, is detailed in the Bibliography (for an adept bibliographical summary see Rubin 2007, pp. 360-65). See, for example, Olsen 1992; Baskins 1998; Musacchio 1999; Barriault 1994; Ajmar-Wollheim and Dennis 2006-07; Randolph 2008-09; Baskins 2008-09, Krohn 2008-09.

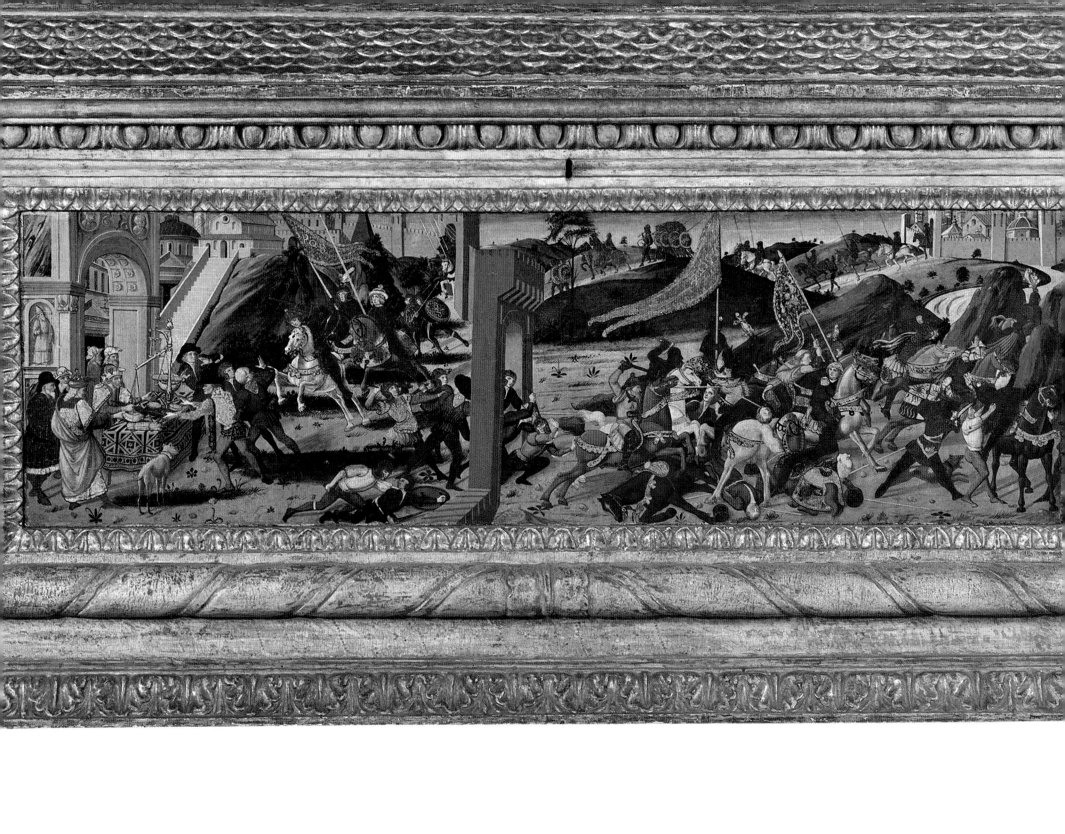

Catalogue

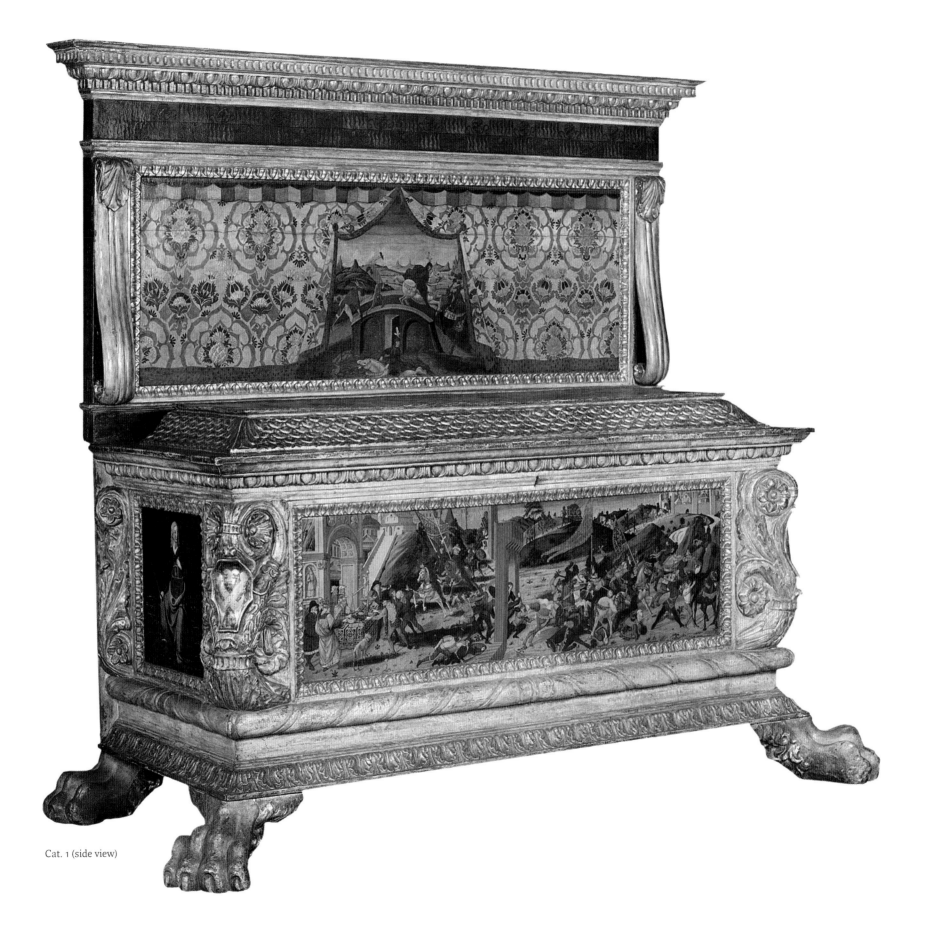

Cat. 1 (side view)

Biagio di Antonio (1446–1516), Jacopo del Sellaio (1441–1493) and
Zanobi di Domenico (active *c*. 1464–74)

1 Chest and *spalliera* with the arms of Lorenzo Morelli and Vaggia Nerli (The Morelli Chest), 1472

Front panel: *Camillus chases the Gauls from Rome*
Side panels: *Justice* and *Fortitude*
Spalliera: *Horatius Cocles*

Wood, gesso, tempera, oil and gilding, 205.5 × 193 cm (overall)
Front panel 40.5 × 137 cm
Side panels 40.5 × 35.5 cm
Spalliera panel 54.5 × 162.5 cm

The Courtauld Gallery, London
(Samuel Courtauld Trust), F.1947.LF.4

PROVENANCE

Lorenzo di Matteo Morelli, by December 1472; Leonardo di Lorenzo Morelli (1507); by descent in the Morelli family until at least 1680;[1] probably William Blundell Spence (1814–1900), Florence; Sir Herbert Smith, by 1938; his sale, Witley Court, Worcs., 29 September 1938, lots 576 and 577 (unsold, at suggested price of £175 each); purchased some time before April 1939 by Tomas Harris for £150 each;[2] from whom purchased by Lord Lee of Fareham, a few days before his death in 1947, for £10,000; by whom bequeathed, 1947

EXHIBITION HISTORY

Birmingham 1955, cat. 13a and b; London 1999–2000, cat. 78 and 79

LITERATURE

Fra Ildefonso 1785, p. 164: 103; Smith Sale 1938, p. 45 (Florentine, sixteenth-century); Birmingham 1955, p. 11, no. 13a and b (Florentine, fifteenth-century); Sutton 1958, p. 1120 (Florentine, fifteenth-century); Lee 1967, no. 60, pp. 30–31 (Florentine, 1472); Callmann 1974, pp. 26 n. 10, 29, 86 (Florentine, 1472); Troutman 1979, p. 31 (Florentine, 1472); Gombrich 1985, p. 17 (Florentine, fifteenth-century); Lydecker 1987, pp. 112–23, 161, 167, 286–88 (Biagio di Antonio and Jacopo del Sellaio); Callmann 1988, pp. 8–9, 14, n. 25 (Biagio and Sellaio); Thornton 1991, p. 195 (Biagio and Sellaio); Barriault 1994, p. 34, 36, 45–46, 64–65 n. 29, 71–72, 84, 108–10, 125, 133, 141–42 (Biagio and Sellaio); Hughes 1997, pp. 17, 47, 50, 64–65, 176, 209, 223 (Biagio and Sellaio); Davies 1995 (Biagio and Sellaio); Davies 1995a (Biagio and Sellaio); Callmann 1999, pp. 342–44 (Biagio and Sellaio with nineteenth-century Florentine restoration); Welch 1997, pp. 283–85 (Biagio and Sellaio); Bartoli 1999,

2 Chest and *spalliera* with the arms of Vaggia Nerli and Lorenzo Morelli (The Nerli Chest), 1472

Front panel: *The Schoolmaster of Falerii*
Side panels: *Temperance* and *Prudence*
Spalliera: *Mucius Scaevola and Lars Porsenna*

Wood, gesso, tempera, oil and gilding, 205.5 × 193 cm (overall)
Front panel 40.5 × 137 cm
Side panels 40.5 × 35.5 cm
Spalliera panel 54.5 × 162.5 cm

The Courtauld Gallery, London
(Samuel Courtauld Trust), F.1947.LF.5

pp. 147, 151–53, 185–86 (Biagio, Sellaio and the Argonaut Master); Haines 1999, p. 60 (Biagio and Sellaio); Morley 1999, p. 91; Rubin and Wright 1999–2000, pp. 314–15, cat. 78 and 79, pp. 316–17 (Biagio and Sellaio); Syson and Thornton 2001, p. 76 (Biagio and Sellaio); Partridge 2006, p. 103 (Biagio and Sellaio with nineteenth-century Florentine restoration); Campbell 2007a (Biagio and Sellaio); Baskins 2008–09, p. 5 (Biagio and Sellaio with nineteenth-century Florentine restoration)

In April 1472 the first stage of a marriage between Lorenzo di Matteo Morelli and Vaggia di Tanai di Francesco Nerli was contracted. The bride brought a dowry of 2000 florins.[3] The wedding was finally concluded in November 1472, when Vaggia made the journey from her father's house in the Oltrarno to her new home on the Borgo Santa Croce.[4]

Lorenzo opened a new account in his ledger to record the considerable expenses which were entailed when he 'took my wife home'.[5] These included clothing, items of personal adornment, as well as the furnishings of his palace. By far the most expensive items of furniture were two painted great chests, with the arms of the Morelli and Nerli families (cat. 1 and 2). Remarkably both these objects and the *spalliera* panel which was displayed above them survive in the Courtauld's collection, together with Lorenzo Morelli's detailed documentation of their commission and manufacture (discovered in the Florentine archives

by Kent Lydecker).[6] They are the only pair of extant Florentine painted chests which can be connected securely with the *spalliera* made for them.

The panels set into these chests and the accompanying *spalliera* (which survives in two sections) tell exemplary tales of martial virtue, bravery and rectitude with the variety and diversity pleasing to a fifteenth-century eye. The narratives are taken with great accuracy from Books II and V of Livy's history of early Rome (*Ab urbe condita*), although they are probably also informed by Valerius Maximus's *Memorable Deeds and Sayings*, which ordered ancient histories according to the virtues they exemplified.[7] The side panels of the Morelli chest (cat. 1) represent Justice and Fortitude: Horatius Cocles, who adorns the *spalliera* currently associated with it, is one of Valerius Maximus's *exempla* for the closely connected quality of courage.[8] The Nerli *testate*, of Temperance and Prudence (cat. 2), also relate to the *spalliera* of Mucius Scaevola, whom Valerius Maximus praises for his patience.[9] These representations of the Virtues are related to those which Piero del Pollaiuolo and Sandro Botticelli had painted for Florence's Mercanzia (merchant's tribunal (*Mercanzia*) from 1469.[10] They were as appropriate in a private as in a public setting to a merchant like Lorenzo Morelli.

The hero of the two main painted narratives is Marcus Furius Camillus. One of the chests (cat. 1) depicts him chasing the Gauls from Rome without handing over the ransom they had demanded from the city. Rome had been sacked by the Gauls[11] – all but the citadel, which was under siege. The besieged Romans, weakened by hunger, agreed to ransom themselves to the Gauls for food. At a conference between the tribune Lucius Sulpicius and the Gallic chieftan Brennus, a ransom of one thousand pounds of gold was agreed. To add insult to injury, the Gauls brought dishonest weights, and on the tribune's objecting, 'The insolent Gaul added his sword to the weight, and a saying intolerable to Roman ears was heard – "Woe to the conquered! (*Vae victis!*)"'.[12]

As Livy recounts, 'neither gods nor man would suffer the Romans to live ransomed', and before the

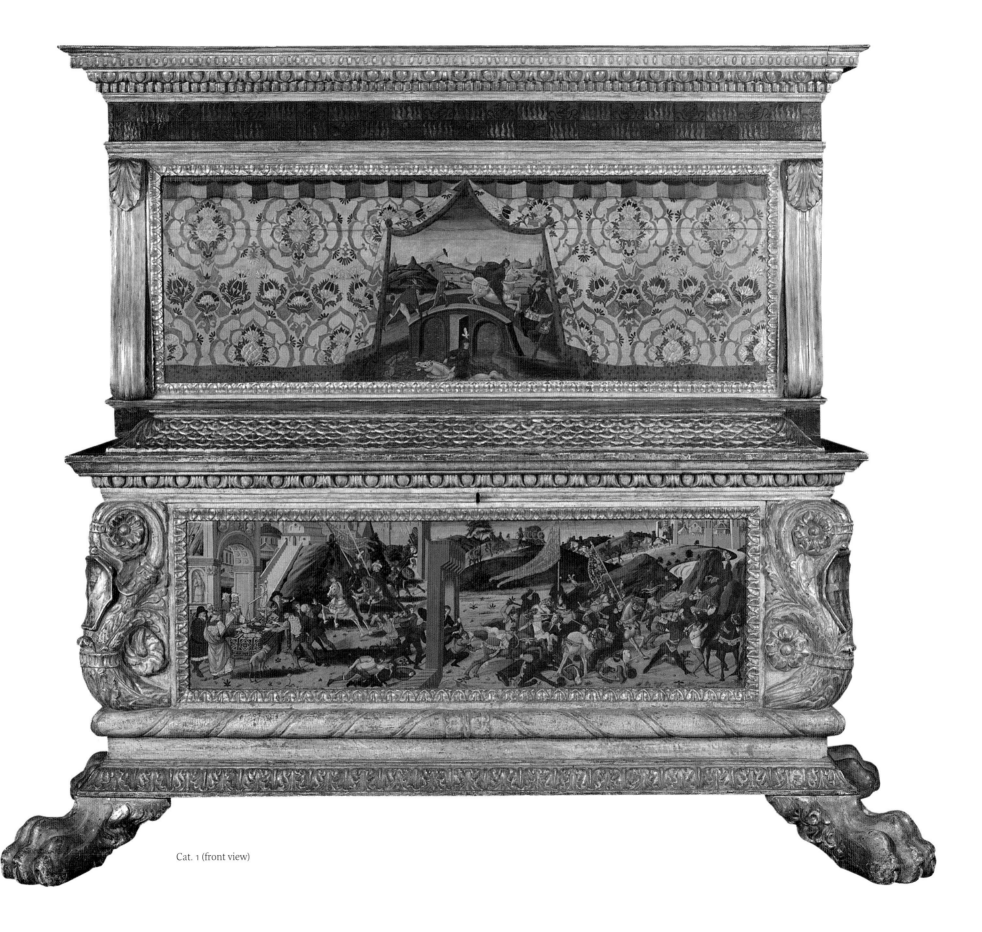

Cat. 1 (front view)

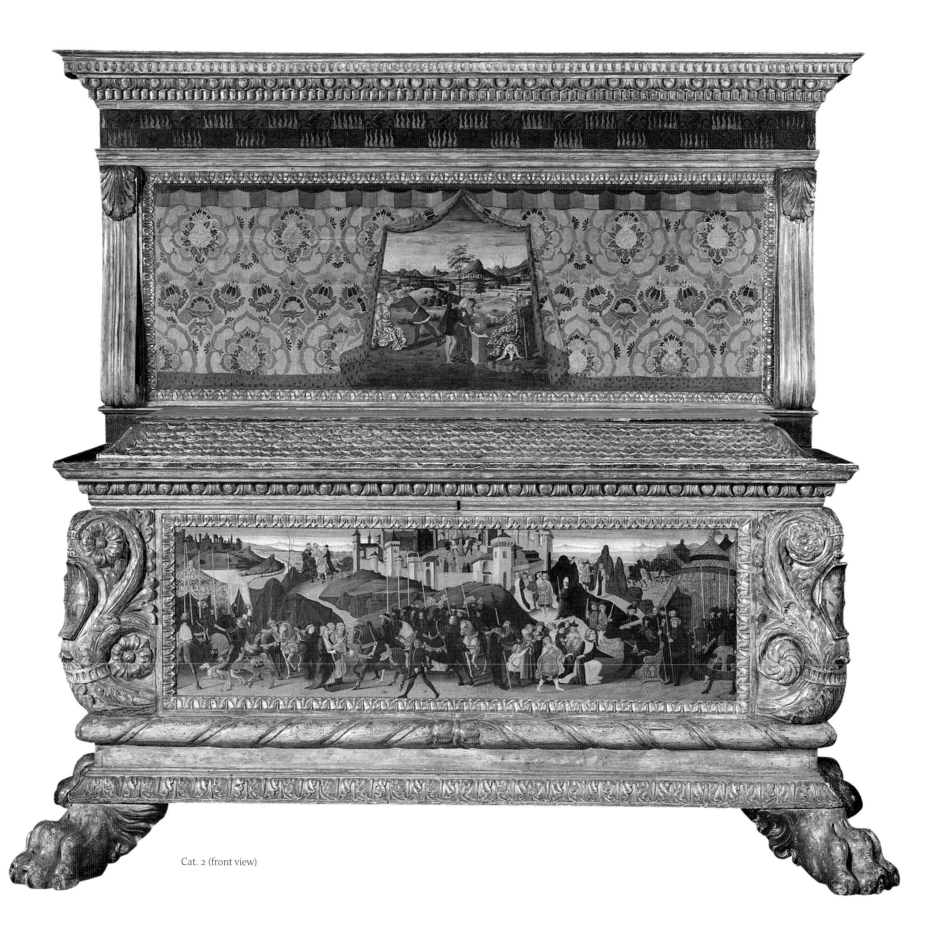

Cat. 2 (front view)

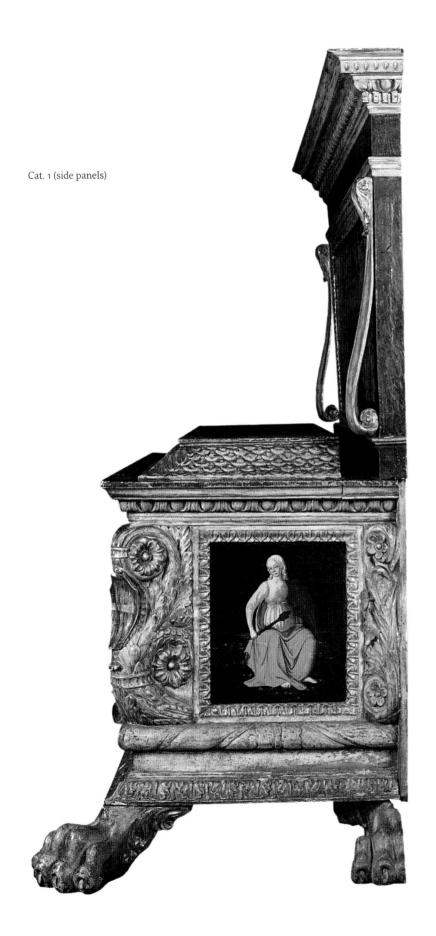
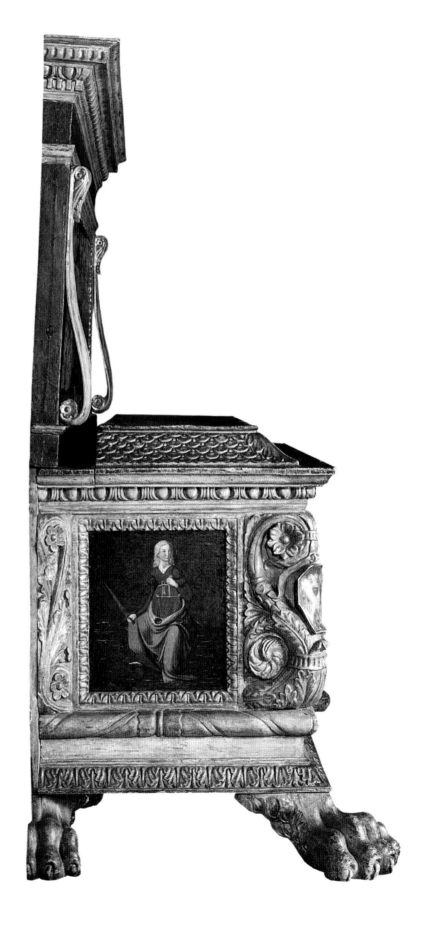

Cat. 1 (side panels)

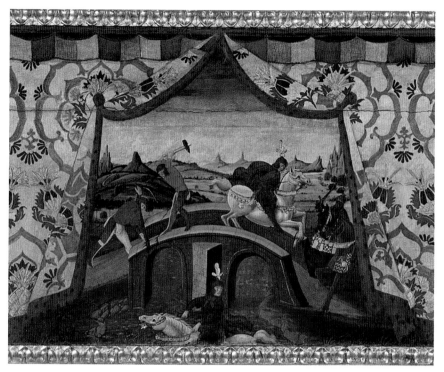

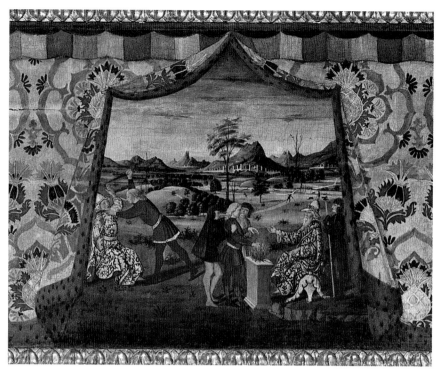

Cat. 1 (*spalliera*, detail)

Cat. 2 (*spalliera*, detail)

payment could be made, Camillus and his men arrived, and commanded the Gauls to leave. They chased them from the city: 'having before their eyes the temples of the gods, their wives and children, the soil of their naked land . . . and all that religion called upon them to defend, recover, or avenge.'[13] Camillus then saved Rome a second time, by preventing the abandonment of the ruined city by her people.[14]

The second chest (cat. 2) shows Camillus's refusal of the treacherous help offered by the schoolmaster of Falerii.[15] This teacher offered his charges to the Romans as hostages, which would enable them to capture the town, but Camillus refused to accept this unfair assistance. He gave the pupils rods with which to beat their duplicitous schoolmaster back to Falerii for further punishment. Meanwhile, the town's elders were so impressed by Camillus's rectitude that they handed over the keys of Falerii without demur.[16] Camillus, Livy writes, had 'conquered his enemies by justice and fair-dealing' – the best form of triumph.[17]

The fictive curtains which decorate the two parts of the *spalliera* have been drawn back to reveal more acts

of Roman patriotic selflessness. Mucius Scaevola is depicted (cat. 2, accompanying the main panel of the Schoolmaster of Falerii) plunging his right hand into a fire to show the Etruscan king Lars Porsenna the sacrifice Romans were prepared to make for their *patria*. Porsenna was so terrified by the prospect that Mucius was the first of three hundred young Romans who had sworn to try to kill him that he immediately sued for peace.[18] The other part of the *spalliera* (cat. 1, accompanying the main panel of Camillus and the Gauls) shows Horatius Cocles, who continued fighting on a bridge while it was being destroyed rather than let the Etruscan enemy pass.[19]

These narrative conjunctions contained possible exemplary lessons for Lorenzo Morelli, his young wife, and the children who were the intended result of their marriage (the flames and pomegranates, split to reveal their seeds within, depicted on the *spalliera* friezes allude to the reproductive hopes for this union).[20] Morelli could see himself as a descendant of Roman heroes like Camillus, fierce in the protection of their family, their city, and also of justice. Vaggia Nerli

was encouraged properly to steward the children in her care, unlike the wicked schoolmaster. In turn, their children would be urged to model themselves on his erstwhile charges, who were instruments of justice. It was to be hoped that the new family could bring the virtues depicted on their painted furniture to life.

We know that this decorative ensemble was intended for Lorenzo Morelli's *camera* (chamber) in the Morelli palace. Following his emancipation in 1461, Lorenzo had largely refurbished this room in 1465. The chests and *spalliera* joined a *lettuccio* (day bed) adorned with three intarsia triumphs by Giuliano da Maiano, a bed by Piero de' Servi decorated with candleholders and more panels of inlaid wood, a mirror in a carved frame, and two images of the Virgin Mary.[21] They were not the only furnishings commissioned for this room in 1472: Lorenzo also ordered a large chest carved with garlands of fruit, coats of arms and lettering on the lid,[22] while it is not clear in what room a bed with chests and a frieze was to go.[23] Moreover, the decorative friezes of Lorenzo's existing bed and day bed were gilded in

1472, presumably so that they and the chests he had just commissioned would look as if they belonged to one ensemble.[24]

Lorenzo Morelli's accounts recount that the chests and their *spalliera*, together with a *predella* (base) were to be constructed by the carpenter Zanobi di Domenico,[25] who made most of the woodwork Morelli commissioned around the time of his marriage.[26] A payment of 21.0.0 florins is recorded to him in September 1472 for 'a pair of great chests and for one *spalliera* and for the base'.[27] It is quite likely that one of Zanobi's specialities was the production of chests for decoration by painters: certainly he also worked for the furniture painter Bernardo di Stefano Rosselli and his master Neri di Bicci.[28] His work would have included carving the framing mouldings.[29]

The next stage was the decoration of the furniture by the painting partnership of Jacopo del Sellaio and Biagio di Antonio. The Courtauld chests and *spalliera* appear to be the only surviving objects to show the close collaboration of these two artists. It seems that the chests were delivered ready-made to the workshop they rented jointly with Lo Scheggia and his son Antonfrancesco in the Loggia dei Pilli.[30] Sellaio and Biagio were responsible for painting and gilding the *forzieri* and their *spalliera*. It is possible that Jacopo Sellaio's long-standing business partner Filippo di Giuliano may have decorated the '*forzerino*' or small coffer that formed part of the contract with Lorenzo Morelli. In 1491 he painted a 'pair of little chests' for Morelli.[31] Roberta Bartoli has argued that another painter, Bernardo di Stefano Rosselli, was also involved in the decoration of the Morelli-Nerli chests. She attributes the *spalliera* panel of Horatius Cocles to him.[32]

Various payments are recorded relating to the chests, which were painted and gilded by 'Jacopo called del Sellaio and Biagio his companion, painters'[33] between 8 November and 10 December 1472.[34] Altogther, the chests and their *spalliera* cost a total of 61.6.10 large florins, of which the considerable sum of 40.16.8 large florins was given directly to the painters. The price was at the high end of the spectrum. As a comparison, the chests produced by Apollonio di Giovanni and Marco del Buono's workshop cost from 28 to 60 large florins (making a rough average of 33.6 large florins).[35]

Lorenzo Morelli's account speaks of '*una spalliera*' while two panels survive with the chests today. Their style is consistent with the front and side panels, and they must be parts of the object commissioned by Morelli, who specifically mentions the *spalliera*'s mimicry of white damask, decorated with flowers, with little stories in the centre.[36] Ellen Callmann argued on the basis of Morelli's record that they originally formed one panel, which ran the whole length of the *camera* wall rather than just the section of the wall above the chests.[37]

Callmann's hypothesis that the two *spalliera* panels were originally one is supported by the physical evidence. Most of their framing sections, carved with egg, dart and acanthus-leaf moulding, seem to be relatively intact. However, all four corners of the current *spalliera* panels have been partially reconstructed and restored, suggesting they were cut down from one panel into two (although the damage is different in each case, and seems to have been sustained on separate occasions, and for distinct reasons).[38] At least one other example of such a configuration is recorded in the 1492 inventory of the Medici Palace.[39]

How were the chests displayed with their single long *spalliera*? For at least seventy years, and probably since they left Florence in the mid-nineteenth century, the two separated panels have been attached to the chests with two battens.[40] This configuration cannot replicate their original appearance (see Technical Notes) as it is impossible to open the chests without damaging the *spalliera* panels. One cannot ascertain with certainty the height at which the *spalliera* was originally hung, but it must at least have been higher than the top edge of the chests' lids when open. It could even have been towards the top of the wall, immediately under or abutting the cornice. Certainly, the rather heavy egg-and-dart moulding of the top framing elements of the *spalliera* recalls corniced decoration. The *spalliera* paintings of Horatius Cocles and Mucius Scaevola also suggest a high display point, as their foreshortening only makes sense when viewed from considerably below.

The chests and *spalliera* panels were still in Lorenzo Morelli's *camera* in 1507 when his son married, and took over use of his father's room. They remained in the family's ownership until 1680,[41] and it is quite possible that they were still in the Morellis' hands until the mid nineteenth century. At this point, they probably entered the possession of the Anglo-Florentine dealer William Blundell Spence, whose handwriting may be on the back of the chest representing the schoolmaster of Falerii (cat. 2). It was most probably Spence who sold them to Sir Herbert Smith (a boot manufacturer), in whose posthumous sale the chests and *spalliera* appear in 1938.[42] The chests, which were unknown to Schubring, were first identified correctly by Harris and Ragghianti in 1939.[43]

Ellen Callmann rightly observed that these chests – like almost every other surviving Florentine wedding chest - had been altered in the nineteenth century. However, recent technical examination (see Technical Notes)[44] largely supports the findings of Arabella Davies's study of 1995.[45] This suggests that Callmann somewhat exaggerated the extent to which the original form of both *cassoni* had been tampered with. From the level of the moulding directly underneath the painted panels upwards the chests are largely fifteenth-century objects, although they have been partly regessoed, regilded and distressed.[46] The lids are in good condition, and are probably all original.[47] Although the textile pattern imitating a cloth lining found in the inner lids looks suspiciously fresh, it contains azurite,[48] and is probably also of fifteenth-century origin.[49] Perhaps most significantly, we can be sure that the paintings were made for these chests. The narrative panels set into the chest frontals play a vital structural role, and thus (unlike the Trebizond chest, fig. 25) they cannot have been slotted into the chests following their manufacture.[50] Instead, they appear to be integral parts of their construction. Although the Morelli-Nerli chests and *spalliera* have undergone considerable adaptation and restoration, they are essentially fifteenth-century objects.

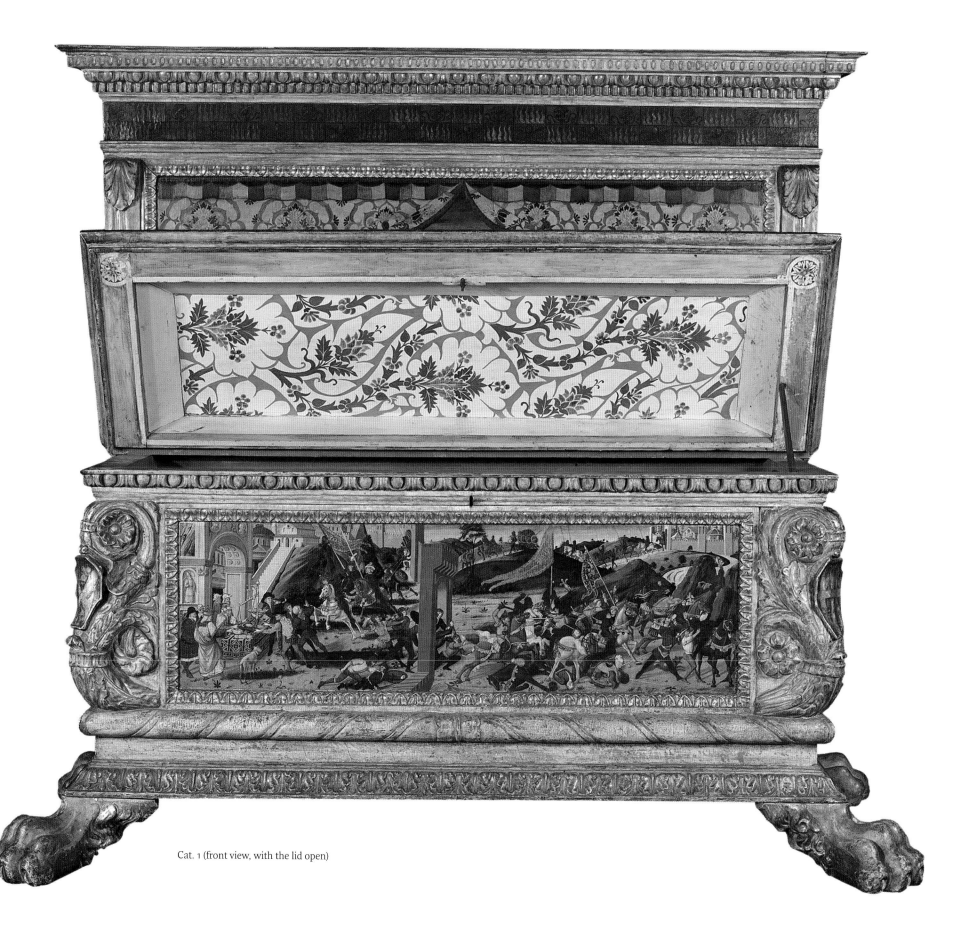

Cat. 1 (front view, with the lid open)

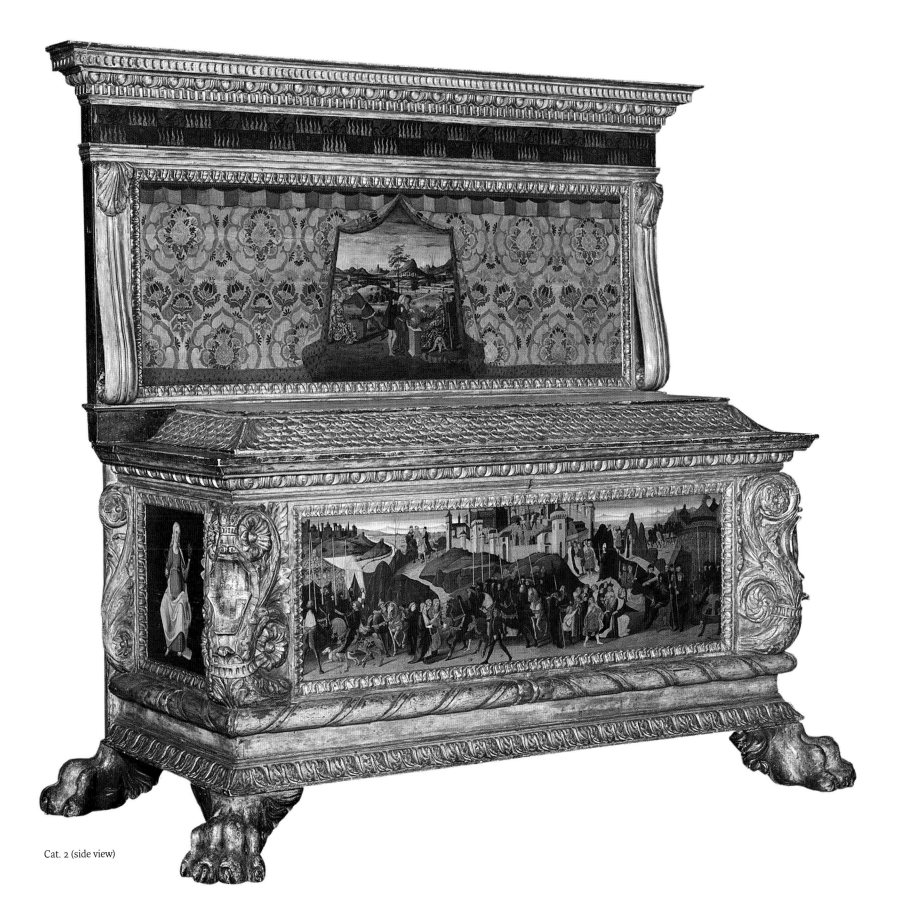

Cat. 2 (side view)

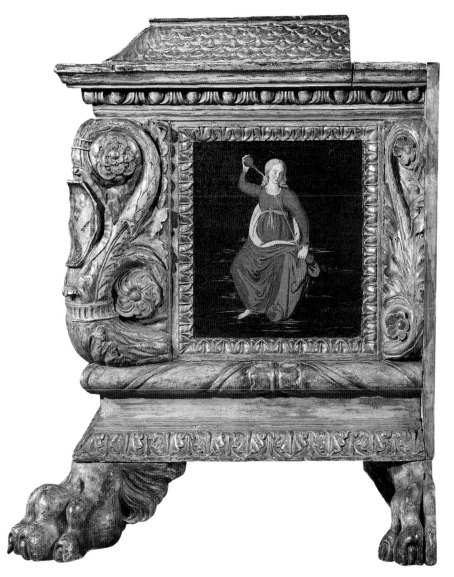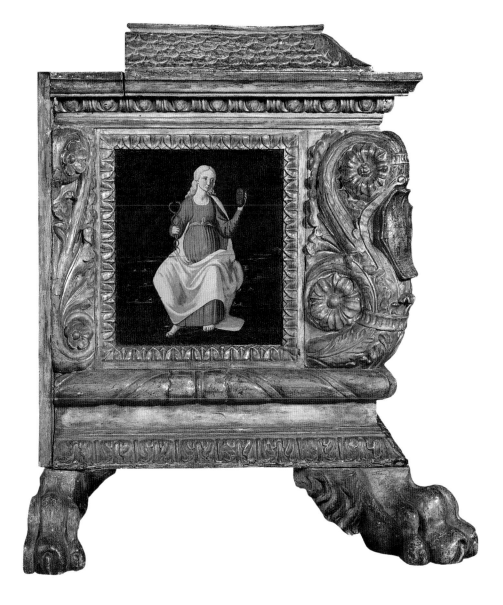

Cat. 2 (side panels)

Technical Notes

GRAEME BARRACLOUGH

Fundamentally, these magnificent fifteenth-century chests survive in their original state.[51] However, in common with much furniture of this type, they have been adapted and restored in the intervening centuries.

The front and back of the main body of both chests consists of a single plank of poplar. Dovetailed into these panels are the side panels, which on the Morelli *cassone* (cat. 1) consist of a single plank, whilst on the Nerli chest (cat. 2) they are made up of two butt-joined planks of poplar. Nailed on to this main structure are the base, which consists of three butt-joined planks of poplar, and the carved mouldings, including the elaborately carved consoles. Whilst the proportions of the *cassoni* – excluding the lion's claw feet – are original, it is likely that the garland moulding and the lower acanthus mouldings are subsequent additions, probably replacing former carved moulded sections.

The acanthus moulding may have been cannibalised from another piece of old carved wood, while the garland moulding is probably later (it recalls late eighteenth- and nineteenth-century Italian mouldings more than any from the fifteenth century). The right corner console of the Nerli chest is at least in part a modern replacement, while the feet, which do not provide adequate support for the chests, and contradict Lorenzo Morelli's payment to his carpenter for a base, are evidently a later addition, found on many *cassoni* which were reconstructed in the nineteenth century (compare cat. 3, 4 and 8).

The lids with their original metal hinges are composed of a series of moulded panels and carved sections. Although the current method of uniting the *spalliera* panels to the *cassoni* (which does not allow the lids to open fully) is likely to be a nineteenth- or earlier twentieth-century arrangement, these panels undoubtedly belong to the *cassoni*. The main body of the *spalliera* panels consists of four thick poplar panels that are butt-joined together and reinforced with a series of original and later butterfly keys. The mouldings that make up the cornice, frieze and other decorative parts of the *spalliere* are planted on to this core.

The painting of these objects occurred after the *spalliere* and *cassoni* were structurally complete. This can be seen from the fact that gesso is present at the junction of panel surfaces and moulding. The techniques of preparation and painted decoration follow closely the methods outlined in Cennino Cennini's *Libro dell'Arte*. In various x-radiographs pieces of frayed and cut fabric are visible, particularly in unstable areas such as along joins and knots. These were applied to even out irregularities in the wood. All surfaces apart from the underside of the chests, and the rear of the *spalliere*, are covered in a gesso ground composed of calcium sulphate and animal glue.

Examination of the painted sections using infra-red reflectography distinguished two basic types of initial drawing. A thin sketchy, rather transparent line was used to outline the figures and horses in the main panels, whereas the figures of the Virtues on the side panels exhibit a bold, fluid outlining, probably executed with a brush and dilute ink. On the side panels the drawing appears more precise, worked up and planned, probably because this area was intended to be painted by workshop assistants. In addition to this drawing, a technique of mechanical transfer by pouncing was employed for the silk curtains of the *spalliere* and most noticeably for the floral designs of the interior of the *cassone* lids.

Incised lines demarcate areas where metal leaf (gold and silver) was to be applied, including around the armour, banners, weapons and the horses' caparisons, and this seems to follow closely Cennini's instructions. Most of the gilding was water gilding, although mordant gilding was used occasionally for areas such as the gilded leather decoration on Horatius's swimming horse (see *spalliera* of cat. 1). The artists made use of a fairly simple punch (giving a rounded-end punch mark of varying sizes) in several ways to gain quite different effects.

The artists also employed a variety of *sgrafitto* techniques. One of these was described by Cennini, whereby a dry thinly

Cat. 1 (back view)

Cat. 2 (back view)

applied paint layer was scraped away from areas of burnished gold to create a rich decorative pattern. However, in other areas, such as the leather doublets, there are tiny nicks in the wet paint as well as a slight indentation into the silver leaf. Elsewhere a thick medium-rich paint was applied on top of the gold to give a more three-dimensional texture.

An *imprimatura* (or base layer) of warm grey was applied to the main figurative panels, but not to the side panels, the *spalliera* silk curtains and frieze, or the inside of the lids. Areas of the surface, particularly the background, were loosely covered with fluid paint to block in the basic forms of the composition. After this initial stage the forms were built up gradually. The foliage and landscape were painted before the draperies. For the flesh paint the artists did not use the traditional *verdaccio* under-painting, but a light base to which they added shadows on top, for example using small amounts of azurite to create cool shadows.

The pigments identified on the *cassoni* and *spalliere* are typical of a fifteenth-century palette. They include lead white, lead tin yellow, iron oxide, earths, vermillion, madder lake, verdigris (used as a glaze with lead tin yellow), charcoal and malachite. Azurite was the only blue pigment used, and no ultramarine is present.

The medium employed was largely egg tempera. However, some staining tests indicated the presence of oil. This suggests that in certain areas an emulsified medium of egg and oil was used. The painting on the inner lid and rear of the chests was executed with a glue binding medium.

NOTES

1 ASF, Archivio Gherardi-Piccolomini d'Aragona 192, booklet entitled 'Inventario delle masserizie della casa di Firenze, 1680': '*Dua cassone dipinti e dorati e storiati con sua spalliera con arme de' Morelli e Nerli*' (Lydecker 1987, p. 287).

2 Tomas Harris attempted to sell these chests to the Museum of Fine Arts, Boston, in 1939-40. For a fuller account of this, see above, 'Creating *Cassoni*' (note 121).

3 ASF, Archivio Gherardi-Piccolomini d'Aragona 194, f. 125 (Lydecker 1987, p. 118).

4 Lydecker 1987, p. 120; Davies 1995, vol. 1, p. 1.

5 ASF, Archivio Gherardi-Piccolomini d'Aragona 137, f. 74, 'Spese per me nello sottoscritte chose quando menai la donna' (see Lydecker 1987, p. 120).

6 Lydecker 1987, pp. 118-19, 286-88.

7 Valerius Maximus 1995-97.

8 Valerius Maximus 1995-97, Book III, ch 2:1, vol. 1, pp. 222-23.

9 Valerius Maximus 1995-97, Book III, Ch 3:1, vol 1, pp. 243-44.

10 Rubin and Wright 1999-2000, pp. 24, 52-53. For Biagio di Antonio's *Justice*, which is related closely to this series, see Bartoli 1999, cat 15, pp. 184-85 and Bartoli in Gregori, Paolucci and Acidini Luchinat 1992, cat. 9.6, p. 243.

11 Livy 1924, Book V, chs. 48-49, pp. 141-47.

12 Livy 1924, Book V, ch. 48, pp. 162-65.

13 Livy 1924, Book V, chs. 48-49, pp. 164-67.

14 Livy 1924, Book V, ch. 49, pp. 166-67.

15 The same subject is depicted on a chest frontal in the National Gallery, London, attributed to the Master of Marradi (NG 3826).

16 Livy 1924, Book V, chs. 27-28, pp. 92-97.

17 Livy 1924, Book V, ch. 28, pp. 96-97. Valerius Maximus also lauds Camillus's act as an exemplar of justice (Valerius Maximus 1995-97, Book VI, ch. 5.1a, vol. 2, pp. 173-74).

18 Livy 1919, Book II, chs. 12-13. p. 254-61. Scaevola asserts 'Look, that you may see how cheap they hold their bodies whose eyes are fixed upon renown!' (p. 259).

19 Livy 1919, Book II, ch. 10, pp. 248-53.

20 Davies 1995, p. 33.

21 Lydecker 1987, pp. 115-17.

22 ASF, Archivio Gherardi-Piccolomini d'Aragona 137, f. 54 (Lydecker 1987, p. 119): '. . . *un chassone di braccia iii chon grillande di frutte e chon l'arme e chon lettere nel choperchio ebbi per in chamera . . .*' (ordered from Luca di Giovanni).

23 ASF, Archivio Gherardi-Piccolomini d'Aragona 137, f. 63 (Lydecker 1987, p. 119): '. . . *una lettiera cho' le chase di braccia 2 choperta di noce e chon fregio straforato da chapo . . .*' (ordered from Zanobi di Domenico).

24 ASF, Archivio Gherardi-Piccolomini d'Aragona 137, f. 73 Lydecker 1987, pp. 119-20): payment of 12 November to Giovanni detto e' rRosso (*sic*) for gilding a '*fregio intagliato a frutte per uno letto e lettuccio per la chamera mia*'.

25 Zanobi di Domenico is recorded in Neri di Bicci's *ricordanze* from 1464 to 1474 (Neri 1976, pp. 233, 234, 299, 352, 362, 363, 375, 382, 408, 409, 413, 414, 424.27).

26 Lydecker 1987, p. 286.

27 ASF, Archivio Gherardi-Piccolomini d'Aragona 137, f. 72: '*1° paio di forzieri e per 1a spalliera e per la predella*' (Lydecker 1987, p. 286).

28 Bartoli 1999, p. 151; Sarti 2002, pp. 125-26.

29 Compare to Bernardo di Stefano Rosselli, *testata* of 'Camilla praying at the temple of Diana', discussed and reproduced in Sarti 2002, pp. 121-26 together with 'Cephalus and Procris', its pendant in Avignon (p. 126, fig. 11). The framing elements of the Sarti and Avignon pictures (attributed also to Zanobi di Domenico) are identical to those around the main panels and *testate* of the Morell-Nerli chests.

30 Haines 1999, p. 60; App., doc. 6, p. 69.

31 ASF, Archivio Gherardi-Piccolomini d'Aragona 137, f. 96 (Lydecker 1987, p. 122) recording a payment to '*Filippo di Giuliano dipintore per dipintura e serratura dun paio di forzeretti*'.

32 Bartoli 1999, pp. 151, 185.

33 ASF, Archivio Gherardi-Piccolomini d'Aragona 137, f. 72, debit account (Lydecker 1987, p. 287), payment of 7 November 1472 to '*Jacopo detto del Sellaio e Biagio suo chompagnio dipintori*'.

34 ASF, Archivio Gherardi-Piccolomini d'Aragona 137, f. 72, debit account (Lydecker 1987, pp. 287-88).

35 Callmann 1974, pp. 76-81.

36 ASF, Archivio Gherardi-Piccolomini d'Aragona 137, f. 72, credit account (Lydecker 1987, p. 288): '. . . *uno paio di forzieri storiati e messi d'oro fine, insieme cho' la spalliera de' detti forzieri lavorata d'un domaschino bianch012 fiorito chon certe storiette del mezzo e chon oro fine . . .*'.

37 Callmann 1988, n. 28. I am grateful to William Clarke, former Head of Conservation at The Courtauld Gallery, for sharing with me his reconstruction of the *spalliera*, drawn up according to Ellen Callmann's model.

38 Davies 1995, p. 26. The Morelli *spalliera* shows signs of physical reconstruction; this is not evident on the Nerli *spalliera*.

39 Spallanzani and Bertelà 1992, pp. 72-73.

40 Smith Sale 1938, lot. 576: 'A 16th century Florentine carved and gilt *cassone* having a tall raised back', and lot 577: 'The companion *cassone*'. The battens are of machine-made wood.

41 See note 25 above.

42 Smith Sale 1938, lots 576-77.

43 Harris identified the commission, and Ragghianti the hand of Biagio di Antonio: letters of Tomas Harris to W.G. Constable, 27 March and 25 April 1939 (Museum of Fine Arts, Boston, Archives, Director's Correspondence).

44 Carried out by Graeme Barraclough, Paul Tear, Tilly Schmidt, Ron Cobb and Caroline Campbell. This technical examination was informed by Arabella Davies's 1995 thesis, and the (still largely unpublished) material she collected for this study.

45 Davies 1995. A greatly summarised version of this thesis was published as Davies 1995a.

46 Luke Syson has observed (verbal communication) that this is reminiscent of the treatment of objects from the Lombardi-Baldi collection.

47 Davies 1995, p. 24.

48 Verbal communication of Stephen Rees-Jones, recorded by Ellen Callmann in letter to Hugh Brigstocke of 27 September 1970 (National Gallery of Scotland Archive, File NGS 1738).

49 The pattern was transferred using a stencil. The brightness of colours can be explained by the chests normally being closed. Very similar patterns have been found on several other lids of chests: including cat. 3 and 4 below. Several more are reproduced in Callmann 1974, pls. 221 and 223 (Trebizond chest, Metropolitan Museum of Art) and 222 (London, National Gallery, NG 3826).

50 Davies 1995, p. 35.

51 Much of the technical information in this section has been informed by an unpublished research project in the Department of Conservation and Technology at The Courtauld Institute of Art (Davies 1995) and by an article by the same author (Davies 1995a).

3 *Cassone*, with scenes from Boccaccio's *Decameron* (the tale of Ginevra, Bernabò and Ambrogiuolo, Part I)

Front panel, 1420–25; the chest is a mid-nineteenth-century reconstruction, using parts of dismembered fifteenth-century chests

Wood, gesso, tempera and gilding
82.5 × 182 cm × 60 cm (overall); 142 × 41.9 cm (front panel)

National Gallery of Scotland, NGS 1738

3 PROVENANCE
'the middle of the eighteenth century in Italy';[1] Captain G. Pitt-Rivers, Hinton St Mary, Dorset, by 1929; his sale, Christie's, London, 2 May 1929, lot 80; bought by Dr John Warrack for 290 guineas; presented by Dr Warrack in 1929 to the National Gallery of Scotland

4 PROVENANCE
British private collection;[2] offered at Phillips, London, 6 July 1999, lot 61; private collection, Florence; private collection

LITERATURE (for both chests)
Antal 1948, p. 367 (Edinburgh: Rossello di Jacopo Franchi); Bellosi 1966, p. 53 (Edinburgh: Toscani); Boccaccio 1966, Day 2, *novella* 9, pp. 159–69; Boccaccio 1966a, pp. 200–01, ill. 228 (Edinburgh: Toscani); Callmann 1974, p. 29, pl. 219 (inner lid of Edinburgh chest); Branca 1985–86, p. 104 (Edinburgh, Toscani); Watson 1985–86, p. 166 (Edinburgh: Toscani); Brigstocke 1993, pp. 188–90 (Edinburgh: Toscani); Callmann 1995, p. 49, n. 53 (Edinburgh: Toscani); Phillips 1999, pp. 74–76, lot 61 (London and Edinburgh: Toscani); Bellosi in Branca 1999, p. 202 and pl. 64 (Edinburgh: Toscani); Bellosi 2000 (Edinburgh: Toscani); Jacobsen 2001, pp. 567–68 (Toscani); Watson 2003, pp. 48–49 (Edinburgh: Toscani). The panels are not mentioned in Schubring's corpus (Schubring 1915)

4 *Cassone*, with scenes from Boccaccio's *Decameron* (the tale of Ginevra, Bernabò and Ambrogiuolo, Part II)

Front panel, 1420–25; the chest is a mid-nineteenth-century reconstruction, using parts of dismembered fifteenth-century chests

Wood, gesso, tempera and gilding
82.5 × 195.5 × 68.6 cm (overall); 142 × 42 cm (front panel)

Private collection

This pair of panels of Ginevra of Genoa (both set into chests made in mid- to late nineteenth-century Florence) are reunited here for the first time in over a hundred years. They are by Giovanni Toscani, who is recorded as a painter on walls, panels and furniture. However, the particular importance of this latter category to Toscani, who called himself a *cofanaio*, or chest painter, is demonstrated by his election as chamberlain of Florence's Carpenters' Guild (the Legnaiuoli) in 1424.[3] In 1966 Luciano Bellosi connected the documented Toscani with the oeuvre which had been associated with the so-called Master of the Griggs Crucifixion, including the Edinburgh *cassone* painting (cat. 3).

Certain features of this pair – such as the fore-shortening of the horses' heads and spectators at Ambrogiuolo's execution in cat. 4, the little boys in the street scene in cat. 3, and the distinctive head-dresses of the merchants in both panels – are typical of works associated with Toscani. In particular, they recall the two panels of the *Palio of Saint John the Baptist* divided between the Cleveland Museum of Art and the Museo del Bargello, Florence.[4] For example, the group of infant bystanders in the Cleveland painting share the same awkward dimensions and strangely stretched limbs as the children in the panel in Edinburgh. Comparison of the Ginevra pair with Toscani's other surviving *cassone* paintings does not bear out Bellosi's classification of the Edinburgh panel (cat. 3) as of considerably lower quality. Cat. 3 and 4 seem entirely consistent with the corpus of *cassone* panels which have been ascribed to Toscani, and there is no reason to doubt their attribution.

The narrative comes from Day 2 of Boccaccio's *Decameron*, which is devoted to tales which reach a happy ending against the odds.[5] Ginevra of Genoa's story is told in the ninth *novella*, narrated by Filomena, and exemplifies the old proverb of the deceived having the better of the deceiver.[6] The narration of the panels is close to Boccaccio, and the artist makes no additions to the text he (or his patron) chose to represent, although some episodes are omitted.

The first panel (cat. 3) begins with the infamous dinner of the Italian merchants in Paris, at which they discussed their wives' chastity. All but Bernabò Lomellin of Genoa agreed that they could not expect them to remain true, as women by nature were more changeable than men. Bernabò's praise of his wife Ginevra as a paragon of every virtue, and particularly chastity, provoked the young Ambrogiuolo of Piacenza to bet that he could seduce Ginevra. Bernabò promised five thousand gold florins (and initially his head) to Ambrogiuolo if his wife was unfaithful. The painting shows the two men confirming their wager in writing, much to the discomfort of their companions, who were sure this could not end well.[7]

Ambrogiuolo, as Boccaccio recounts, travelled to Genoa. It became clear that Ginevra's virtues were as Bernabò had described them, so he resorted to deception. He bribed a poor woman to whom Bernabò's wife had been kind to ask Ginevra to look after a chest (*cassa*) for several days. The painting shows Ambrogiuolo meeting this woman, and the subsequent arrival of the chest (containing Ambrogiuolo) at Ginevra and Bernabò's house. When night came, Ambrogiuolo unlocked the chest, and climbed out into Ginevra's bedroom. He examined the room and Ginevra's person, noting a little mole with six golden hairs under her left breast. Finding that she was as beautiful naked as clothed, he was tempted to join her in bed, but remembering her strictness in such matters, he contented

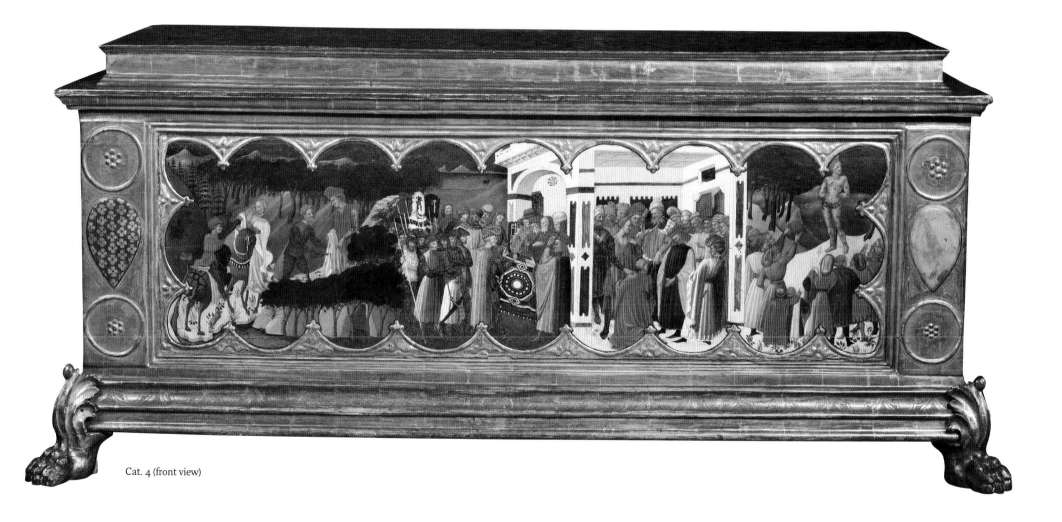

Cat. 4 (front view)

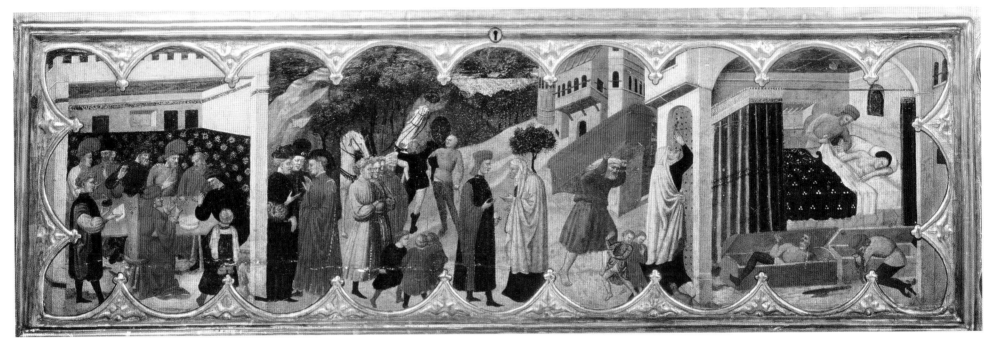

Cat. 3 (front panel)

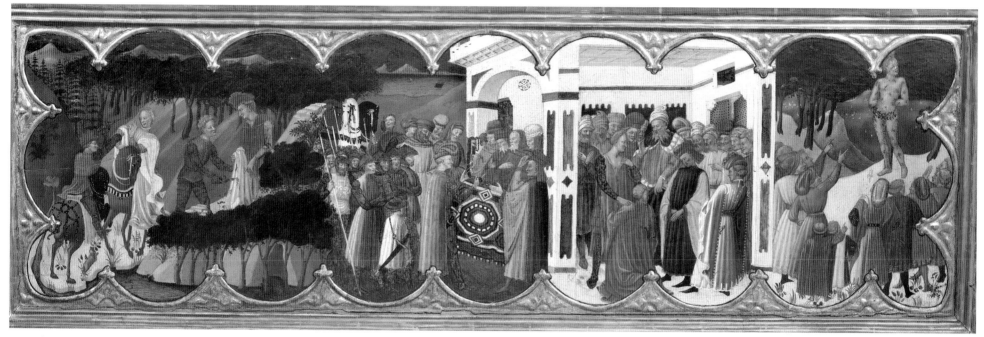

Cat. 4 (front panel)

Cat. 4 (side panels)

himself with removing a girdle, necklace, ring and purse from one of her *forzieri*, before locking himself back into the *cassa*.[8]

Bernabò's reaction to his wife's reported adultery is excised from Toscani's reinterpretation of Boccaccio's tale, which endeavours to make Ginevra and Bernabò look as respectable and normative as possible. The second panel (cat. 4) begins with Bernabò's servant's aborted murder of Ginevra, who tries to protect herself from his dagger with her hand. Subsequently, having assumed male dress, she and the servant tear and smear her dress with blood, so that Bernabò will believe that his order has been obeyed.

Dressed as a man, Ginevra assumed the name Sicurano da Finale and became the servant of a Catalan merchant, who sailed to Acre. The second scene takes place in Africa, where Sicurano has become a much loved servant of the Sultan of Alexandria. Sicurano is shown discovering her trinkets for sale in the market at Acre, while Ambrogiuolo tells his disguised victim that Ginevra had given them to him. In the following

vignette, Ginevra reveals her true identity as Bernabò's unjustly punished wife before the Sultan, her traducer and her husband. Bernabò kneels before the Sultan and Ginevra, begging her mercy, while Ambrogiuolo stands mute, unable to deny Ginevra's truthful statement that she had never slept with him.

The painting ends by depicting Ambrogiuolo's punishment in grisly detail. He was taken outside the city, stripped naked and tied to a post. His body was smeared with honey, and he was left to be stung to death by a swarm of wasps, flies and gadflies. The artist does not depict Ginevra and Bernabò's triumphant return to Genoa.

These are the only surviving paintings of Ginevra of Genoa made for chests, and it is not likely that there were many others. There is often a considerable crossover between manuscript illumination and domestic painting (particularly as many of the same artists worked in both art forms), and this *novella* is not among the regular illustrations of extant manuscripts of the *Decameron*.[9] Only three predate these panels,[10]

and it seems likely that the artist was guided by his knowledge of the text rather than any visual source. Toscani seems to have had a particular affinity with Boccaccio, as five of the eight *cassone* paintings attributed to him represent Boccaccian themes.[11]

One might think that Ginevra's story, which places an emphasis on male and female chastity, would be highly suitable for the viewing context of painted chests. The problem lies in Ginevra's assumption of a male persona – albeit temporarily – as well as her capacity to take independent action. These could not be seen as attractive qualities in a wife, despite her undeniable purity and devotion to her husband. She does not criticise just her traducer Ambrogiuolo, but also her 'cruel and unjust husband Bernabò', who wished her dead body to be devoured by wolves.[12]

Ginevra assumes the masculine role of arbitrator and forgiver in the penultimate scene of cat. 4, where Bernabò kneels before her, and it is interesting that the artist chooses to depict her as a man, although according to Boccaccio she should now be dressed as

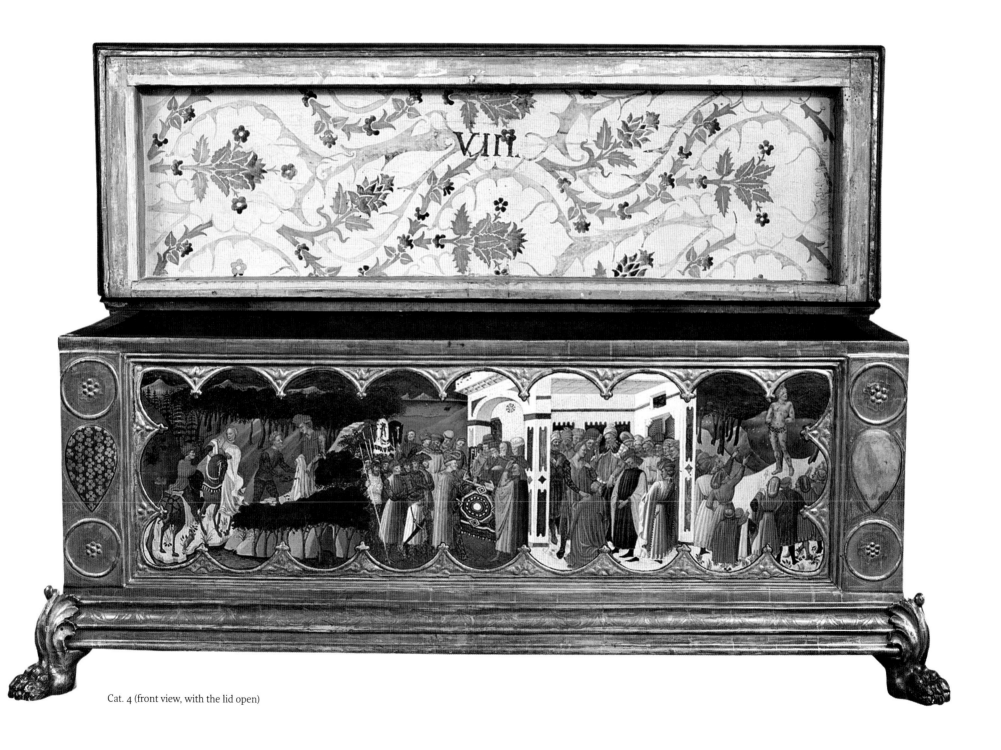

Cat. 4 (front view, with the lid open)

a woman, and surrounded by ladies.[13] In fact, Ginevra is only shown twice as a woman in these panels (in the final scene of cat. 3, and the first of cat. 4), probably to mask the unusualness of her behaviour.

Boccaccio's work provided a rich source of inspiration for paintings for *cassoni* in the early part of the fifteenth century – especially the *Teseide*, the *Ninfale fiesolano* and the *Ninfale fiorentino*, which offered an attractive cross-over with classical mythology, particularly Ovid.[14] From around 1440, Boccaccian tales began to disappear from Florentine domestic painting (Botticelli's Nastagio degli Onesti series is a notable exception to this general tendency). Tales from the *Decameron* never played a major role in the *cassone* repertoire, probably because these salacious, jokey and frivolous stories required more than minimal editing to make them appropriate for the context of the chamber, where the capacity of secular painting to hold a moral message was important. This iconographic shift is partially explained by the change in the commissioning patterns for chests, which became the responsibility

of the groom's family rather than the bride's (as had previously been the case).[15]

Although several different tales from the *Decameron* were interpreted by *cassone* painters, like the story of Ginevra they appear to have been depicted very rarely. The exception is Griselda, who endured patiently all her husband Gualtieri's unnatural and unreasonable trials of her obedience.[16] This serves to highlight the relative spunkiness of Ginevra, who speaks out, although only after six years. One can only hypothesise what circumstances led Toscani or more probably his patron to select this unusual subject for this pair of chests. However, the story of Ginevra has more evident resonances for a bride than a groom. Toscani's depiction of the story highlights this, emphasising Ginevra's chastity and constancy in appalling and testing circumstances, including her attempted murder by her husband. The wife who received these pair of panels would have found in Ginevra's tale an unusual but hopefully inspiring example of how to maintain properly female and wifely virtues, against all the odds.

Cat. 4 (back view)

Technical Notes (cat. 3)

CAROLINE CAMPBELL

The fifteenth-century panel is probably poplar,[17] and was cleaned in 1943. A horizontal split several centimetres from the bottom edge is stable. At an earlier date, probably the mid nineteenth century, it was set into a chest constructed of old and modern wood, and the metal fixings are those consistent with this date (despite Captain Pitt-Rivers's assertion that the chest had a provenance back to eighteenth-century Italy). The sides, and their coats of arms, seem entirely of nineteenth-century date. The lid seems to have belonged to a chest from around 1460–70.[18] It bears a freely painted pattern inside identical to that found on cat. 4, and slightly different to those found inside several other wedding chests of 1450 or later in date.[19] A batten across the centre (removed from cat. 4) obscures all but the first letter ('v') of an inscription (presumably a number in Roman numerals) by the same hand as that on the inner lid of cat. 4.

The back of the chest is of old wood and is decorated with a pattern of grids and crosses identical to that found on cat. 4. Like it, it was probably originally the front of a chest.[20] The edges of the back of the chest and the lid have been covered with fabric (apparently canvas). Metal slats have also been placed on the back of the chest. These are not machine-made, but it is unclear at what date they were attached to the back panel.

Technical Notes (cat. 4)

CAROLINE CAMPBELL

The fifteenth-century panel is in good condition. Its support is probably poplar. The retouchings (in a subtle *tratteggio*) suggest it was cleaned and restored in Italy between 1999 and 2006. The pigments and materials are those customarily found in the fifteenth century, including a gypsum ground, vermillion, red and crimson lakes, green and brown earths and ultramarine. The only less typical pigments are a mix of orpiment and indigo to make a dark green colour. However, this is not unknown in fifteenth-century paintings.[21]

At a later date, probably in the mid nineteenth century, the panel was set into a chest constructed of old and modern wood. The metal fixings are of this date. The short sides with the coats of arms are modern, while the back and the base of the chest are of an old worm-eaten wood, presumably poplar. The sides, decorated with coats of arms, are entirely of nineteenth-century date, as are the claw feet and the raised lid. The inner lid bears a freely painted pattern identical to that found on cat. 3, inscribed across the centre 'vii' in what looks like an eighteenth-century Italian hand (a batten, like that seen on cat. 3, was removed to reveal this). While the top of cat. 4 has been almost wholly reconstructed, the patterning inside both suggests that this lid was perhaps originally the pair of that now belonging to cat. 3.

The back of the chest is of old wood and is decorated with a pattern of grids and crosses identical to that found on cat. 3.[22] The remains of a keyhole can be seen in the centre, and it must have been originally the front panel of an earlier chest. Some of the decoration was reinforced at the time of the chest's construction in the nineteenth century, as parts of the painted pattern continue on the modern gilded sides. The chest has been painted brown inside – a common characteristic of chests reconstructed in the nineteenth century.

NOTES

1 According to Capt. G. Pitt-Rivers, cited in a letter of Colin Thompson to Ellen Callmann (27 December 1968), National Gallery of Scotland archive (file NGS 1738).

2 I am grateful to the present owner for this information.

3 Jacobsen 2001, p. 567.

4 Reproduced in Bellosi 1966, pls. 30a and b.

5 Boccaccio 1966, II, p. 84.

6 Boccaccio 1966, II, 9, p. 159: *'lo 'ngannatore rimane a' piè dello 'ngannato'*.

7 Boccaccio 1966, p. 162: *'. . . conoscendo che gran male ne potea nascere . . .'*.

8 Boccaccio 1966, pp. 162–63.

9 Brigstocke 1993, p. 190, nn. 6–9.

10 Vatican City, Vatican Library, Pal. Lat. 1989; Paris, Bibliothèque nationale de France, Ms Français 12421,f. 97v; Vienna, Österreichische Nationalbibliothek, Ms 2561,f. 90v.

11 Giovanni Toscani, *Scenes from the Filocolo* (Madison, Elvehjem Museum of Art); *Episodes from the Ninfale Fiesolano* (Brunswick, Bowdoin College, and New York, M. Roy Fisher Fine Arts Inc, in 1993), reproduced in Branca 1999, vol. 2, pls. 59, 60, 61. His non-Boccaccian *cassoni* are *The Palio of St John the Baptist* (Cleveland, Museum of Art, and Florence, Museo del Bargello) and an *Outdoor Feast* (Berlin, Staatliche Museen).

12 Boccaccio 1966, p. 168: *'. . . più credulo alle altrui falsità che alla verità da lui per lunga esperienza potuta conoscere'*; *'. . . da questo crudele e iniquo uomo data ad uccidere ad un suo fante e a mangiare a' lupi'*.

13 Boccaccio 1966, p. 169.

14 See Campbell forthcoming.

15 See above, 'The Wedding Chest'.

16 Callmann 1995, pp. 20–21.

17 Visual analysis only.

18 Comments by Ellen Callmann and Hugh Brigstocke (in letters of 27 and 11 September 1970), National Gallery of Scotland archive (file NGS 1738).

19 The others (excepting the Morelli-Nerli chests) are London, National Gallery, NG 3826; New York, Metropolitan Museum, no. 14.39; Cincinatti, Cincinatti Art Museum, no. 1933.9; Brussels, Musée du Cinquantenaire (Schubring no. 301); Boston, Museum of Fine Arts, no. 06.2441.

20 Another very similar pattern is seen on the back of a chest in the Victoria and Albert Museum (317-1894; fig. 4).

21 Report by Libby Sheldon (UCL), dated June 1999, National Gallery of Scotland archive (file NGS 1738).

22 Another very similar pattern is seen on the back of a chest in the Victoria and Albert Museum (317-1894; fig. 4).

5 The Journey of the Queen of Sheba

around 1450

Tempera on panel, 41.7 × 142.3 cm

Private collection

6 The Meeting of Solomon and Sheba

around 1450

Tempera on panel, 42 × 141.7 cm

Private collection

Inscribed on labels on back of each panel:
Carlo Crivelli proveniente delle Eccelentissima Casa Litta

PROVENANCE (of cat. 5 and 6)
?Litta Family, Milan; Thomas Blayds, his sale, Christie's, London, 30 March 1849, lot 161, as by Crivelli; bought for Alexander William, Lord Lindsay (later 25th Earl of Crawford and 8th Earl of Balcarres); private collection

LITERATURE
London 1893–94, cat. 151 and 161 (Florentine School, around 1485); Schubring 1915, cat. 196 and 197 (Cassone Master); Berenson 1963, vol. 1, p. 17 (Apollonio di Giovanni); Callmann 1974, pp. 32, 43, 65, pls. 151–52 (Florentine, 1450–75); Miziołek 1997, p. 18, n. 13; Brigstocke in Weston-Lewis 2000, cat. 10a and 10b, pp. 54–57 (attributed to Lo Scheggia)

EXHIBITION HISTORY
London 1893–94, cat. 151 and 161; Edinburgh 2000, cat. 10a and 10b

The story of the Queen of Sheba, who came to Jerusalem to meet the wise King Solomon in search of answers to 'hard questions' concerning God and faith,[1] is represented on at least twelve surviving fifteenth-century Florentine paintings for chests, many by the two most important workshops specialising in such work, those of Apollonio di Giovanni and Lo Scheggia.[2] The panels exhibited here, which have been attributed convincingly to Lo Scheggia by Everett Fahy,[3] draw attention to the connections between these shops (see above, 'The Wedding Chest') because the distinctive punching of the gold leaf seems to derive from Apollonio and Marco del Buono's workshop.[4] Some of the patterns are also Apollonian in origin, such as the dress of Sheba and the roundels on the side of Solomon's temple.

However, these are interpreted in a very different manner. For example, these roundels contain sculptural figures who hold a garland over Solomon and Sheba's heads. A similar detail appears in another painting of Solomon and Sheba at New Haven which shows the iconographic influence of Apollonio's workshop, although it is by a very different hand.[5] In cat. 6 the suspended garland is intended to look as if it is stone, while the sculpted figures lean out of the arch, as if they have the power of life. Is this an early example of the *paragone*, a conscious comparison between the powers of sculpture and painting? Further features of

the paintings (including the horses, the dog, and the group of boys playing outside the city in cat. 5, and the cityscape in cat. 6) are distinctive characteristics of Lo Scheggia's manner, which was more anecdotal and playful than that of the Apollonio shop.

Sheba's journey to Solomon, and the magnificence with which the Israelite king treated his guest, are first recounted in the Old Testament.[6] However, Lo Scheggia's representation of this subject has relatively little to do with the biblical account. For instance, this makes much of the camels and spices which Sheba brought with her,[7] but neither appear in these paintings (the camels are found, however, in panels by Apollonio di Giovanni and his workshop).[8] Instead, they are much more attuned to the visual tradition of this story found in fifteenth-century Florence, and to several influential vernacular tellings of Solomon and Sheba.

The vogue for this subject in Florence was closely linked to the Ecumenical Council of the Western and Eastern Churches, which had moved from Ferrara to Florence in February 1439 (to avoid the plague). The Greek Emperor John Palaiologus VIII had attended the council with an entourage of over eight hundred, all paid for by the Pope. In August 1439 the theological union of the two Churches was celebrated with a Mass in Santa Maria del Fiore.[9] This was never enforced, and was greeted with horror by the majority of Greeks,[10] although it was much fêted in Italy.

The most important visual expression of the theological union effected in Florence can be found in the sculptor Lorenzo Ghiberti's depiction of Solomon and Sheba for the Gates of Paradise, installed on the city's Baptistry in 1452. The original iconographic scheme, devised by Leonardo Bruni, recommended the Judgement of Solomon. Ghiberti substituted the meeting of Solomon and Sheba in the Temple in Jerusalem,[11] perhaps in response to the Ecumenical Council. This bronze relief was well underway by July 1439, although it was not finished until the summer of 1447.[12]

Ghiberti's *Solomon and Sheba* provided domestic painters with a compelling model, attuned to Florentine wedding conventions, for their depictions of the king and queen's meeting. Lo Scheggia, like Ghiberti,

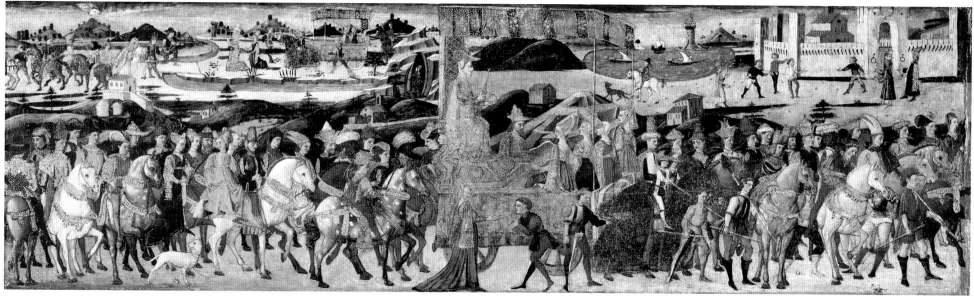

Cat. 5

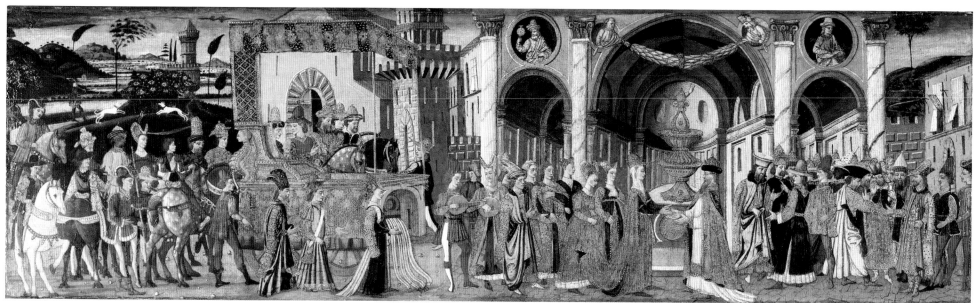

Cat. 6

shows the royal pair clasping hands before a version of Solomon's temple consisting of an apse flanked by two naves (cat. 6).[13] This is an adaption of the final meeting between the two spouses (although without a ring) which was an important part of the Florentine marriage ritual.[14] Like Ghiberti, Lo Scheggia also places urban buildings on either side of the temple. But while Ghiberti's bronze appropriates the solemn sculptural language of classical antiquity to present Solomon and Sheba as Christian worthies,[15] Lo Scheggia, like other painters of chests, revels in the apparently inconsequential details of the scene.

The Byzantine participants in the Ecumenical Council furnished Florentine artists with a repertoire of Greek costumes, which they incorporated in their work to convey otherness and exoticism. Most of Sheba and Solomon's male attendants in cat. 5 and 6 are bearded (which would have identified them to contemporaries as Greek) and wear secular Greek dress. Much of this resembles that worn by Emperor John Palaiologus and his entourage, also recorded by Pisanello in several surviving drawings and a medal.[16] Such details were important: they would both delight viewers, and draw their eyes to the exemplary messages the paintings contained. And, as the Florentine bookseller Vespasiano da Bisticci commented in his life of Pope Eugenius IV, they were not inaccurate: in the East fashions had remained unchanged since ancient times.[17]

While representations of Solomon and Sheba's meeting were inspired by Ghiberti, the depiction of Sheba's journey to Jerusalem was an invention of fifteenth-century Florentine *cassone* painters. It closely resembled their depictions of triumphs (compare fig. 13),[18] as well as being indebted to contemporary processions of the Magi, notably Benozzo Gozzoli's frescoes for the chapel of the Palazzo Medici. The first panel of this pair (cat. 5) depicts Sheba's journey to Jerusalem, shown as a vast, winding processional train, which starts in the top register of the painting and continues, one is meant to imagine, into the meeting of Solomon and Sheba portrayed in its pair. The story begins, slightly to the left of centre, with Sheba's chariot moving through the desert, characterised here as a barren land punctuated

by mountains. At a river, Sheba dismounts, and pauses to kneel in prayer before a plank set across a river.

This significant detail was not an important theme in Italian art before the fourteenth century.[19] It derives from Jacopo da Voragine's *Golden Legend*, which ascribed to the queen the discovery of the wood from which Christ's cross would ultimately be made. She was said to have seen 'in spirit that the Saviour of the world would one day hang upon this very same wood',

and 'would not walk upon it but immediately knelt and worshipped it'.[20] This episode was depicted in Piero della Francesca's Legend of the True Cross cycle at Arezzo,[21] and in Agnolo Gaddi's frescoes of around 1390 in the choir at Santa Croce in Florence – a precedent which would almost certainly have been known to Lo Scheggia. The shovels borne by two members of Sheba's procession may also refer to another version of her discovery of the True Cross, also in the *Golden*

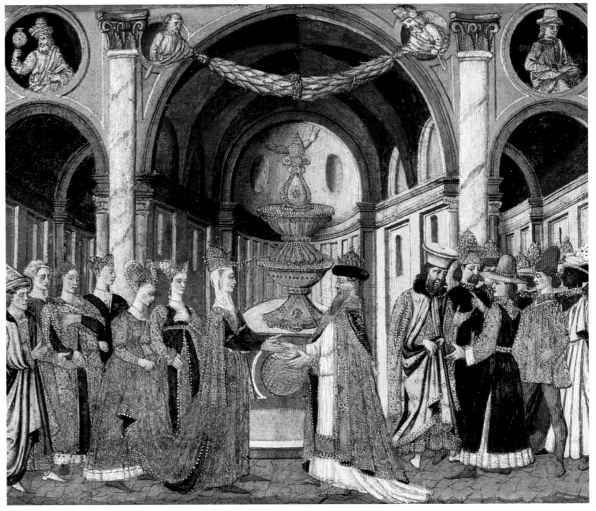

Cat. 6 (detail)

Legend. This recounts that after Sheba saw the wood in Solomon's forest house, she warned him that its future use would result in the destruction of the kingdom of the Jews. He ordered its removal and burial in the ground.[22]

Lo Scheggia's paintings also seem indebted to Boccaccio's account of Sheba, whom he identifies as Nicaula, Queen of Ethiopia, in his *De mulieribus claris*. He evokes Boccaccio's account of Nicaula's long journey across 'Ethiopia, Egypt, the coast of the Red Sea, and the deserts of Arabia'[23] by dividing his painting of Sheba's journey into parallel horizontal sections and depicting the sea (at the right). The three turbaned black Africans who appear in cat. 5 indicate that the painter (or his patron) accepted the account of the queen's African origins. Sheba's processional train, as depicted in these panels, recalls Boccaccio's description of the queen's journey accompanied by such a 'splendid entourage, glorious pomp, and multitude of royal retainers that Solomon himself, the wealthiest of all kings, was astonished by her magnificence'.[24]

This magnificence is conveyed in ways which fifteenth-century viewers would have comprehended easily. Sheba and her retinue are dressed in exceptionally expensive cloth of gold. The queen's outfit is all gold, while her ladies-in-waiting wear golden sleeves and head-coverings and even a golden girdle. Such clothing represents a more lavish version of the elaborate and expensive dress which brides were permitted (briefly) to wear, with especially impressive *balze* (spherical head-gear) and horned head-dresses (items particularly associated with marriage).[25]

The queen is carried in a golden cart (whose wheels are obvious underneath its textile hangings), reminiscent of triumphal *carri* used in contemporary triumphs, such as Alfonso of Aragon's progress into Naples in 1443 (which Lo Scheggia had also depicted).[26] It seems to envision the Florentine fourteenth-century poet Antonio Pucci's *History of the Queen of the Orient* (who may be Sheba): he described in the middle of the procession 'a chariot of fine gold', drawn by pages riding chargers; in this the queen sat, entertained by musicians (compare cat. 5).[27]

In their depictions of Solomon and Sheba, Lo Scheggia and his contemporaries created a new subject. Although ultimately derived from the Old Testament, it was fundamentally inspired by later texts. This narrative was brought to life using an array of disparate visual sources, including Ghiberti's bronze relief on the Baptistry doors, Florence's Greek visitors, an episode from the True Cross legend and depictions of the Journey of the Magi. These are seamlessly elided on the painted panels, which convincingly reanimate and reinterpret the story of Solomon and Sheba in the manner which would seem most comprehensible to their intended viewers in the *camera* of a fifteenth-century Florentine patrician palace.

Technical Notes

CAROLINE CAMPBELL

The panels are most probably poplar. They exhibit a range of damage marks consistent with their function as chest decoration, including pockmarking from keys and the scratching out of faces (such as Solomon's in cat. 6). In some areas (particularly the horse drawing Sheba's chariot in cat. 5) the metal leaf has disappeared and only the bole remains. The artist has made less use of silver leaf than one often finds in his *cassone* panels. The paint medium (which has not been tested) appears to be egg tempera.

NOTES

1 I Kings 10: 1.
2 For example, Apollonio di Giovanni, *The Journey of the Queen of Sheba* (Birmingham, Museum of Art); *The Meeting of Solomon and Sheba* (Boston, Museum of Fine Arts); *The Journey of the Queen of Sheba* (Boston, Museum of Fine Arts); *The Meeting of Solomon and Sheba* (ex-Ellen Callmann collection, New York); *The Journey of the Queen of Sheba* (ex-Merton collection, Maidenhead Thicket); *The Meeting of Solomon and Sheba* (unknown private collection); Florentine, around 1450, *The Meeting of Solomon and Sheba* (New Haven, Yale University Art Gallery); Florentine, 1450-1475, *The Meeting of Solomon and Sheba* (London, Victoria and Albert Museum); Bernardo di Stefano Rosselli (?), *The Journey of the Queen of Sheba* (private collection, ex-Luigi Bellini, Florence); Florentine (?), *The Meeting of Solomon and Sheba* (location unknown, ex-Artaud de Montor collection, Paris). See Ahl 1981, Callmann 1974, pls. 145-52; Miziołek 1997, figs. 5, 6 and 9. Two birth trays made in Ferrara show Florentine influence: Ferrarese, circle of Francesco del Cossa, *The Meeting of Solomon*

and Sheba (Boston, Museum of Fine Arts); Ferrarese, around 1470, *The Meeting of Solomon and Sheba* (Houston, Museum of Fine Arts); for more details see Däubler-Hauschke 2003, cat. 49 and 50. The story is also represented on *pastiglia* chests (for example, see Miziołek 1997, fig. 1).
3 Letter of 30 April 2000, for which see Brigstocke in Weston-Lewis 2000, p. 55, n. 3.
4 This feature was first observed by Callmann 1974, p. 32.
5 It is discussed (as Workshop of Apollonio) and reproduced in Callmann 1974, cat. 29, pp. 155-56.
6 I Kings 10: 1-13; II Chronicles 9: 1-9.
7 I Kings 10: 2, 10; II Chronicles 9: 1.
8 See Callmann 1974, figs. 145, 147, 148, 149.
9 The most important concession was the Eastern Church's adoption of the '*filioque*' clause of the Creed, meaning that the Holy Spirit proceeded equally from God the Father and God the Son - anathema to most Eastern Christians.
10 Scher in Evans 2004, cat. 321, p. 535.
11 Butterfield 2007-8, p. 22.
12 For a recent account of the chronology of Ghiberti's *Solomon and Sheba*, see Caglioti 2007-08, pp. 92-94.
13 Reproduced in Radke 2007-08, fig. 2.7.
14 Krohn 2008-09, p. 12.
15 Krautheimer 1956, p. 181-84.
16 Syson in Syson and Gordon 2001-02, pp. 29-34; Bambach in Evans 2004, cat. 318 a and b, 319, pp. 527-33.
17 Gombrich 1985, p. 19, n. 29.
18 Callmann 1974, p. 43.
19 Callmann 1974, p. 42.
20 Voragine 1993, vol. 1, p. 278.
21 Watson 1974 p. 124.
22 Voragine 1993, vol. 1, p. 278. Another version of this story is found in Christine De Pisan's *Cité des Dames* (De Pisan 1998, p. 105).
23 Boccaccio 2001, p. 138.
24 Boccaccio 2001, p. 138.
25 Herald 1984, pp. 50-51; Polidori Calamandrei 1924, pp. 88-94.
26 See Brilliant in Baskins 2008-09, cat. 15 and fig. 15a, pp. 150-153 (marble relief of the *Triumph of Alfonso V of Aragon*, Naples, Castelnuovo, and Lo Scheggia's depiction of this procession).
27 Pucci 1862, p. 27: 'Presso alla Donna [Reina] andavano ordinate / Molti suoni perch'ella si conforti; / . . . Nel mezzo avea un carro d'oro fino, /Tratta da dieci grossi palafreni / Lattati bianchi quanto l'ermelino / E d'oro aveano tutti quanti i freni: /Sopra ciascuno avea un Saracino / Perchè soavemente il carro meni / Di pietre e gemma avea la cortina / E dentro si posava la Reina'.

Florentine follower of Lo Scheggia, around 1460
(Master of the Ringling Triumph)

7 The Siege of Carthage and the Continence of Scipio
around 1460

Tempera and oil[1] on panel[2]
44.9 cm × 133.7 cm (panel); 42.5 cm × 130 cm
(painted surface)

The Courtauld Gallery, London
(Samuel Courtauld Trust), P.1966.GP.129

PROVENANCE

Probably Rucellai family, Florence, mid fifteenth century (?);
by inheritance to the Ginori family (?); William Blundell Spence,
Florence and London, by 1857 (offered to Queen Victoria and
the Prince Regent in late 1857); sold to Thomas Gambier Parry,
July 1858, for £40; by descent to Mark Gambier-Parry, by
whom bequeathed, 1966

LITERATURE

Schubring 1915, no. 141, pp. 254–55 (Master of the Santa Croce
Tournament); Troutman 1979, p. 9 (Florentine, mid-fifteenth
century); Gombrich 1985, p. 17, n. 21 (Florentine, around 1475);
Gros-Lafaige and Besson 1993–94 (Florentine, around 1460–
70), p. 18; Erlande-Brandenberg, Simmoneau and Benoît 2004
(Florentine, around 1460–70), pp. 70–71, fig. 34

In 1858, the dealer William Blundell Spence described this painting to a potential client, Thomas Gambier Parry, as 'Part of a marriage chest painted by Pier [sic] della Francesca for the Casa Rucellai. It represents the betrothal of a Rucellai to a Neapolitan noble. – and the Siege of Siena by the Rucellai, Vettori and Corsini Families. From the Rucellai it was inherited by the Ginori.'[3] It seems to be the first panel identified as being from a marriage chest to enter a British collection, as well as being the earliest of Gambier Parry's purchases from Spence. This is the first time it has been displayed at the Courtauld since the bequest of the Gambier-Parry collection in 1966. The panel, which is in good condition for a *cassone* frontal, has attracted minimal scholarly attention since its acquisition.

Although Spence's attribution of the painting to Piero della Francesca is extremely typical of his time, and can be discounted, he was right about the connection to the Rucellai, as the family's arms are portrayed prominently on a shield in the centre of the composition.[4] Rather than the 'Siege of Siena', it represents the taking of New Carthage by the Roman general Scipio. When Scipio entered the city, he found among the captives a girl of outstanding beauty. Scipio – himself a young man – learnt that she had been betrothed to a noble youth of her own people (identified variously as Indibilis or Allucius). He returned the girl to her betrothed, and added to her dowry the gold which her parents had brought to ransom her.

In fifteenth-century Florence, a number of texts provided information about Scipio's life and career, including three works by Petrarch, the 'Triumphs', a 'Life' of Scipio, and the unfinished *Africa* (of which Scipio is the hero).[5] Scipio's restrained behaviour was often cited as an example of continence.[6] These sources followed the first and most influential versions of the story, by Livy and Valerius Maximus, who includes it in chapter 3 of Book IV of his *Memorable Deeds and Sayings*, entitled 'Of Abstinence and Continence'.[7] The Courtauld painting is unique among surviving Florentine paintings of the subject in pairing the siege of Carthage with Scipio's continence. The other Florentine depictions of Scipio show Scipio's return of his beautiful captive and her parents' ransom money to her betrothed with the marriage feast of Allucius/Indibilis and his bride.[8]

The Courtauld panel's identification as the siege of Carthage is confirmed by comparison with a mid-fifteenth-century Florentine painting in the Musée des Beaux Arts, Angers.[9] This work shares the composition of the central and right-hand sections of the Courtauld *cassone* frontal,[10] and is inscribed CARTA (Carthage) above the entrance to the town.[11] However, the subject of the Courtauld painting has been obscured because its manner of depiction owes far more to fifteenth-century Florence than to ancient Rome or Carthage.

Carthage is attacked by Roman soldiers wearing fifteenth-century armour, and who use up-to-date weaponry including cross-bows and (most unusually) cannons.[12] The betrothal scene (at left) is also indebted to Florentine custom. Allucius/Indibilis places a ring on his betrothed's finger, watched by the numerous members of their families and friends (including those looking down from windows of a nearby palace) and by Scipio himself. An elderly bearded man blesses the young couple's union. He is presumably meant to represent the bride's father, but the manner of his representation also alludes to the custom current among Florentines of using a broker (*mezzano*) to arrange marriages. The scene recalls the exchange of rings (*anellamento*) which was the penultimate stage of the wedding ritual.[13] The visual transformation of this story to emphasise its connections to legitimate marriage has led to widespread confusion between representations of it and paintings of *The Rape and Reconciliation of the Sabines* (such as cat. 9 and 10), which was subjected to similar editing for identical reasons.

It was normal for Florentine artists to use details from their own time to tell ancient stories, but the extent to which this ancient story is made modern by its accoutrements of weaponry, clothing and architecture is atypical. Scipio's battle and continence are translated into paint using a visual language which would have enabled Florentines to take its moral

messages to heart, and perhaps also to understand its implications for a happy marriage, extolling male as well as female chastity.[14]

The painting's depiction of a battle as well as a marriage connects it to the growing vogue for martial scenes in Florentine domestic paintings from around 1450 that was noted by Ellen Callmann.[15] It would have originally been very bright in colour: the large areas of gold and silver (now discoloured) would have complemented the bright greens, which now appear almost black. The painting was associated by Schubring with the 'Master of the Santa Croce Tournament', an imaginary figure much of whose oeuvre has subsequently been divided between the workshops of Apollonio di Giovanni and Marco del Buono and of Lo Scheggia. The Courtauld painting has more in common with the later years of Lo Scheggia's workshop. In particular, it resembles closely a number of surviving battle scenes,[16] at least one of which seems to be by the same hand as cat. 7, and this also recalls the manner of Lo Scheggia. This panel (Ringling Museum, Sarasota) has been identified recently as the capture of Naples by Alfonso of Aragon in June 1442.[17] This artist was probably one of the many painters of chests who survive in the documentary record, but whose name cannot as yet be connected with any extant paintings.[18]

Certain distinctive motifs, such as the cannons, and the truncated defenders throwing missiles over the city walls, are found in both panels. They also share a particular and precise manner of depicting faces and eyes in profile, shown to special advantage in several male heads in hats set into crowds. The two paintings were certainly painted in the same workshop and by the same artist. They may even have been painted at the same time, although they do not seem to form a pair (their dimensions are different, and they display different coats of arms).[19] Their highly unusual cradling system (see 'Technical Notes') suggests that these paintings were in the same collection when they were treated in this way, perhaps when they were removed from the chests for which they were originally made.[20]

Technical Notes

TILLY SCHMIDT

The painting support is a single panel of wood which partly retains its original thickness of approximately 35 mm. A notch for the lock (which has been filled in) and characteristic use marks on the painted surface prove that the panel once formed the front board of a chest. A later unusual 'cradling' system can be seen on the back, consisting of both horizontal and vertical channels carved out of the original panel. Five tapered dovetail battens were then let into the vertical channels, probably causing splits and slight warping in the panel. Flaws in the wood were covered with patches of linen in order to alleviate the effects on the paint surface of moving wood. The ground is a typical Italian gesso, of calcium sulphate bound in animal glue.

This painting demonstrates many of the painting techniques used in fifteenth-century Florence, and the artist used a range of pigments typical of his time. Silver and gold leaf were applied to several areas (depicting armour and rich costume) on top of a red bole. The metal surfaces were engraved and diverse patterns were created with different punches. In places a *sgraffito* technique was employed, that is, scratching away opaque paint layers applied on top of the metal leaf to create patterns. Paint was applied partly in a hatching manner (a technique predominantly observed with egg tempera) and partly in broad strokes or translucent layers (indicating the use of an oily medium or a mixture of egg and drying oil).

The painting is in good condition for a work of this type with relatively few losses. However, over time some physical changes have occurred. The silvered areas have tarnished and have been reworked with a grey overpaint. Areas that once had a bright green colour, such as the foliage and the background in the architecture at the upper left edge, have undergone chemical deterioration and have discoloured to an indistinct dark hue. The work is currently covered in a yellowed resin varnish that reduces the depth of the painting and the contrast between the colours.

NOTES

1 This comment is based on visual identification and comparison rather than scientific analysis.

2 The wood is probably poplar (this comment is based on visual identification rather than scientific analysis).

3 Letter from William Blundell Spence to Thomas Gambier Parry (undated, but annotated by Gambier Parry 'July 1858. Spence. The Pictures'), p. 2.

4 The Rucellai arms are 'Per bend: *in chief gules* a lion passant *argent* and in base: barry, indented *or and azure*' (see Marquand 1919, fig. 71). The representation here can be compared to those found over the façade of the Palazzo Rucellai, Florence (and also

on a *pietra serena* coat of arms attributed to Geri da Settignano in the Detroit Institute of Arts, Detroit, acc. no. 26.451).

5 For an excellent summary of the literary reception of Scipio, see Baskins 2002, pp. 113–14, p. 120.

6 For example, Chastel 1959, pp. 251–53; Pernis 1994; Baskins 2002, p. 113.

7 Livy 1943, XXVI, ch. 50, pp. 190–95; Valerius Maximus 1995–97, IV, ch 3.1, vol. 2, pp. 19–21.

8 Apollonio di Giovanni, *The Continence of Scipio* (London, Victoria and Albert Museum), reproduced in Callmann 1974, pl. 200, and Apollonio di Giovanni, *The Continence of Scipio* (private collection), reproduced in Baskins 2002, fig. 5. Schubring thought that the Victoria and Albert painting and cat. 7 could have been a pair, and that they were by the same artist (Schubring 1915, p. 255).

9 Reproduced and discussed in Gros-Lafaige and Besson 1993–94, cat. 4, p. 18–19, and Erlande-Brandenberg, Simmoneau and Benoît 2004, fig. 33, p. 71.

10 This was first noted by Ellen Callmann, written communication cited by Gros-Lafaige and Besson 1993–94, p. 18, n. 6.

11 The inscription seems contemporary with the painting.

12 Gombrich 1985, p. 17, saw in the cross-bows a reflection of Pollaiuolo's *Martyrdom of Saint Sebastian* (London, National Gallery), but the Courtauld *cassone* panel must predate this.

13 Krohn 2008–09, p. 12.

14 Baskins 2002.

15 Callmann 1974, pp. 39–51. I am extremely grateful to Scott Nethersole for having shared with me the contents of 'Staged Violence', a chapter of his forthcoming PhD thesis (London, Courtauld Institute of Art) which studies battle scenes on furniture painting.

16 These include the painting at Angers cited in note 9, a panel at Ecouen (see Erlande-Brandenberg, Simmoneau and Benoît 2004, cat. 12, pp. 70–71); and *A Battle before a Walled City, perhaps the Siege of Assisi,* sold at Sotheby's, New York, 24 January 2008, lot 33.

17 Alisio *et al.* 2006, pp. 60–62; Brilliant in Baskins 2008–09, cat. 14, pp. 147–49.

18 Jacobsen 2001, p. 484.

19 The Ringling painting has been convincingly paired with *The Triumphal Entry of Alfonso of Aragon into Naples* (private collection, Naples, reproduced in Baskins 2008–09, cat. 15, pp. 150–53), although the two works seem to be by different artists.

20 I am grateful to Virginia Brilliant for her heroic efforts to arrange x-radiography of the Ringling panel, which should shed further light on the relationship between these two paintings.

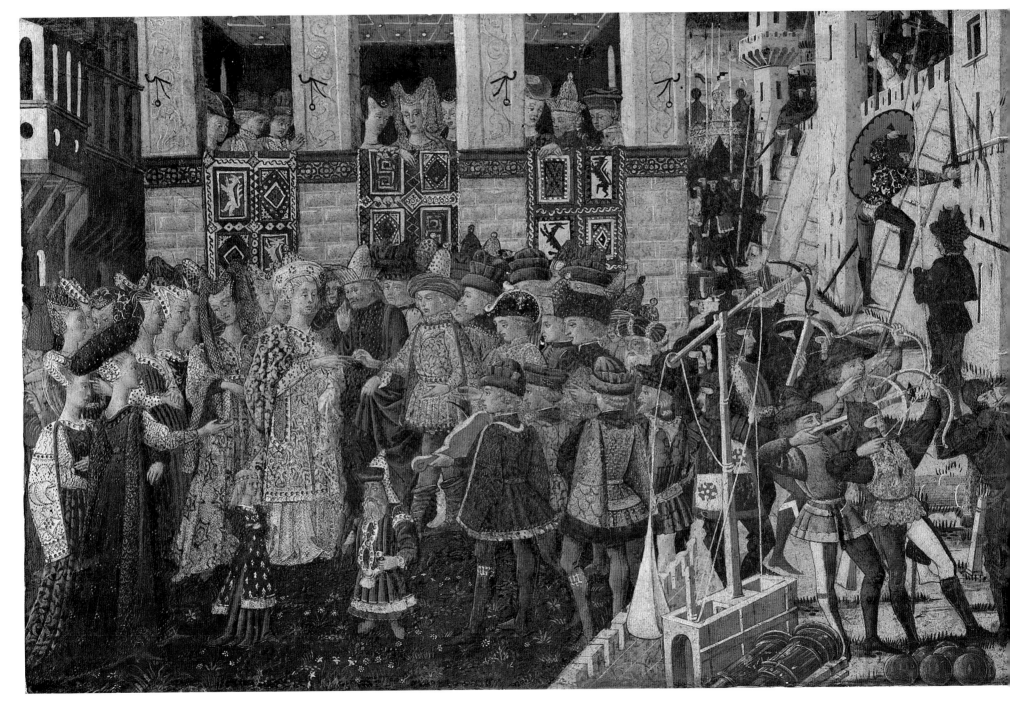

Cat. 7

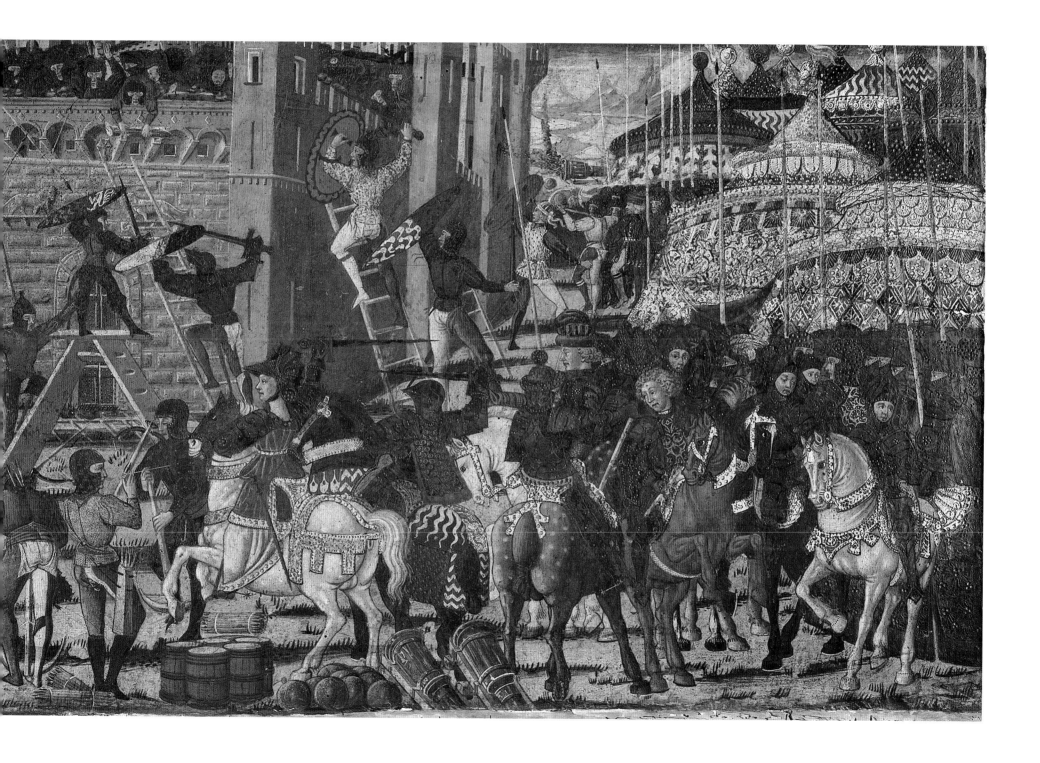

Chest

8

Probably around 1470–75, with late 19th- or
early 20th-century additions

Front panel: *The Battle of Pharsalus*
Right side panel: *A Knight and his Squire*
Left side panel: *A Knight and his Squire*

Wood, gesso, tempera (?) and gilding, 105 × 220 cm (overall)
Front panel 43.2 × 151.1 cm
Right side panel 44.5 × 45.1 cm
Left side panel 44.5 × 45.1 cm

The Courtauld Gallery, London
(Samuel Courtauld Trust), F.1947.LF.3

PROVENANCE
Purchased by Lord Lee of Fareham, before 1923; bequeathed
by Lord Lee of Fareham, 1947

LITERATURE
Plutarch 1917, chs. 63–73, 79, pp. 293–305, 320–25; Plutarch
1919, pp. 543–57; Borenius 1923–26, vol. 1, no. 2 (Florentine
school, *c.* 1450); Van Marle 1928 (Anghiari Master, front panel,
and Paris Master, side panels), pp. 560 (and reproduced), 573
(and reproduced); Lee 1967, p. 46, cat. 86 (as Florentine, mid-
fifteenth-century); Troutman 1979, pp. 57–58; Hughes 1997,
p. 223 (?Lo Scheggia)

EXHIBITION HISTORY
Birmingham 1955, no. 47

Of all the periods of ancient history that interested Florentines, perhaps the most significant was the collapse of the Roman Republic and the ensuing civil war. Numerous texts, in Latin and in the vernacular, recount the defeat of Pompey the Great by forces loyal to Julius Caesar,[1] which is depicted on the front panel of this chest.

According to Caesar's own account, and also those of Plutarch and Lucan, the battle took place on the plain of Pharsalus in northern Greece. As Plutarch mentions, Caesar showed great mastery in forcing Pompey to do battle so far from the power base of his navy.[2] In contrast, Pompey was unwise in following his aides' advice to fight, against his better judgement. However, at the outset fortune appeared to favour Pompey, who had more than double Caesar's twenty-two thousand men at his disposal.[3] Yet Caesar's well-trained legions were able to rout Pompey's in-experienced soldiers, especially his cavalry, who turned tail when confronted by the javelins of Caesar's men.[4] Pompey was defeated, and he fled, encountering the enemy even in his own tent.[5] He did not know where to go, but, after he had collected his wife and his son, decided to sail for Egypt and regroup from there. The young king Ptolemy (Cleopatra's sister) or rather his advisors plotted to kill him, so that they would please Caesar, and have nothing to fear from Pompey.[6]

Plutarch, whose account in his *Lives* of Caesar and Pompey is essentially followed in this painting, narrates that Ptolemy's servant Achillas was sent to murder Pompey. When he approached Pompey's ship in a fishing boat (shown here as a ship with furled sails), Pompey's friends advised him not to get into it. However, he ignored them, and shortly before reaching shore the Egyptians killed him. Pompey's body was tossed overboard (to be buried by his faithful servant Philip) and his head was kept for presentation to Caesar.[7] When Caesar received his erstwhile companion's head, he 'turned away with loathing', wept, and had Pompey's assassins put to death.[8]

The painting compresses the tragic fall of Pompey the Great into three episodes. The selection of these and their manner of depiction is determined both by

the long and thin structure of a *cassone* panel and what was appropriate to its decoration. The destruction of Pompey's numerous cavalry by Caesar's infantry occupies the front plane of the panel. In the centre, the soldier who plunges into the midst of the riders must be the centurion Caius Crassianus, who threw himself into the battle in redemption of the pledge he had given Caesar to 'have your praise today, whether I live or die'.[9] The havoc created by the infantry charge is shown by the fallen horses in the foreground. However, they have fallen decoratively and decorously, foreshortened in the manner of Uccello and also of Pesellino's *David and Goliath* (London, National Gallery).[10]

The battle dominates the panel, and the other two narrative elements are compressed into the middle background with no respect for chronology or geography. The camps of the armies at Pharsalus merge into the tent in which Caesar solemnly receives Pompey's severed head on the Egyptian shore. Pompey's arrival by boat could as well be at the coast of Greece as of Egypt. Such details would not have mattered to the original viewers of this panel, who would have wanted to see a pleasing and varied scene, whose potential moral meanings would have been straightforward to discern and extract.

Most of the pictorial decisions taken by the painter were made to heighten the decorative capacity of the panel, and to make the classical past resemble the Florentine Christian present. Like most other Florentine Quattrocento depictions of ancient history (compare cat. 1, 2, 7, 9 and 10), the participants wear approxima-tions of fifteenth-century costume. The cavalry have come out of a chivalric battle, while the soldiers wear armour, doublet and hose. The gift of Pompey's head to Caesar owes much to the Florentine iconographic tradition of the presentation of John the Baptist's head to Salome (a common subject in Florentine fourteenth- and fifteenth-century wall-painting).

The condition of the painting makes an attribution difficult. The mounted figure with a sword to the centre right of the battle scene is indebted to the same design as the man with an upraised sword at the right of the *Siege of Carthage* (cat. 7). However, the painting

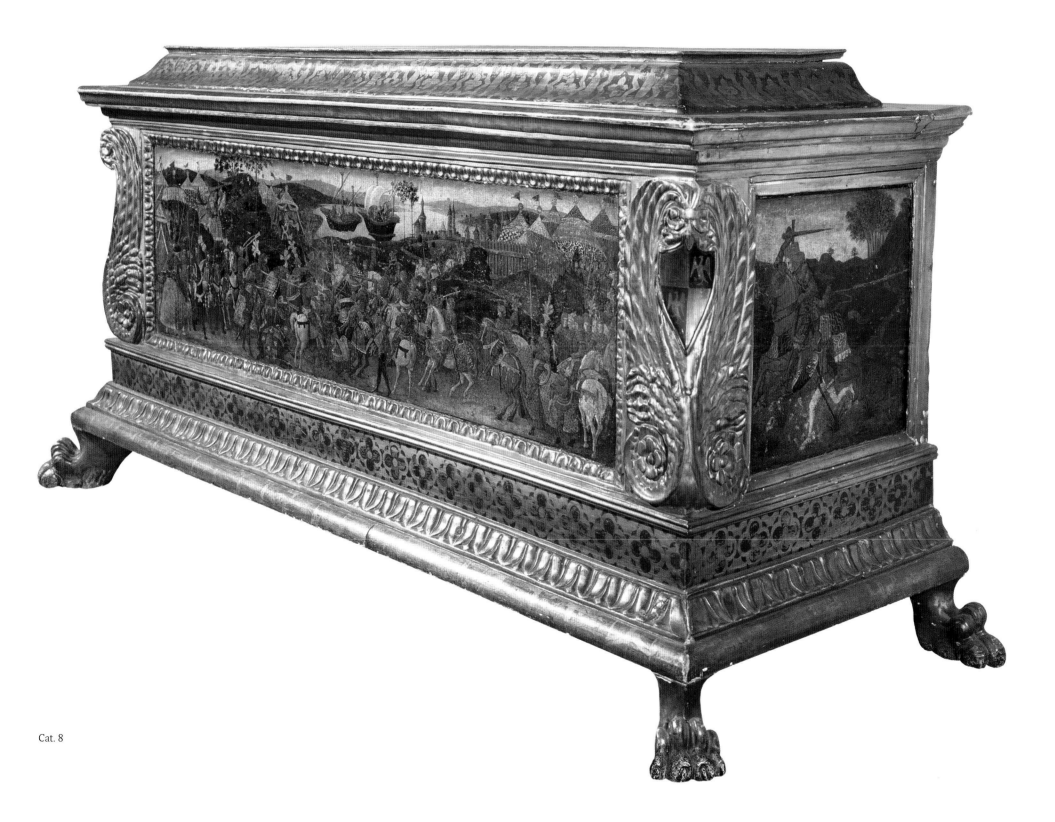

Cat. 8

has nothing more to do with Lo Scheggia's workshop. Certain features, notably the Netherlandish townscape at the centre right and the sketchily painted trees suggest a date no earlier than 1470–75. These recall the motifs popularised by the Ghirlandaio workshop but are found in many late fifteenth-century Florentine paintings, not simply those by Ghirlandaio's associates.

Iconographically, *The Battle of Pharsalus* belongs to a developing fashion for the depiction of battle scenes on *cassoni* in the later fifteenth century,[11] when the responsibility for commissioning wedding chests passed to the bridegroom's family (see above, 'The Wedding Chest'). Many of these paintings represent generic battles that are hard to identify, but a significant subset depict the battle of Pharsalus and the beheading of Pompey in Egypt – at least nine extant paintings, including the front panel of the now dismembered chest in fig. 22. Like the Courtauld painting all are dominated by the engagement of the two generals' cavalry, but the depiction of either Pompey's execution or the presentation of his severed head to Caesar enable identification of the subject.[12]

The Courtauld chest may have been paired originally with a *cassone* painted with the assassination of Julius Caesar. We know that two of the surviving *Battles of Pharsalus* were associated with depictions of Caesar's murder,[13] and at least one of these pairings is most probably original (both panels are in the Art Institute of Chicago).[14] This conjunction would have been most appropriate from the point of view of the narrative. By the middle of the fifteenth century, Florentines no longer viewed Caesar as an exemplar of *virtù*, but as a tyrant. Pompey's defeat and execution were interpreted similarly, although they did not have quite the same significance.[15]

Probably the death of Pompey, like the assassination of Caesar, was intended to point out the dangers of over-ambitious pride, and of failing to listen to a timely warning. These were salient messages in the troubled political atmosphere of mid-fifteenth-century Florence, where the Medici family exercised power, although within the nominal confines of a republic.

Technical Notes

GRAEME BARRACLOUGH

Although the basic structure of this *cassone* survives some parts have been substantially altered and restored. The front and back panels of the chest consist of a large thick single panel of wood, probably poplar. Dovetail joins at the corners are used to attach these to the side panels. The bottom of the chest is formed of three planks butt-joined together and nailed into the chest. At the front corners carved consoles frame the *cassone*. These elements form the basis of the original chest.

Probably in the nineteenth century or early twentieth century entirely new sections of moulding were added to the structure of the *cassone*. These elements include the small ripple moulding and the lamb's tongue ogee below the corner consoles and the carved lions' feet. It is likely that at this stage the entire chest was regilded; the crude blue and gold floral pattern added to the front and sides of the chest; and spurious coats of arms added to the consoles. Before 1923 the side panels were removed and replaced with two apparently fifteenth-century Florentine *testate* representing knights with pages. From the style and scale of the figures it is evident that these were painted by a different workshop (Schubring and Borenius attributed them to the ficticious 'Paris Master'). They were given *imprese* and insignia to tie in with those depicted in the front panel.

The current lid is not that originally attached to the chest (it is slightly too big for it); however, despite its nineteenth-century surface appearance, it too may also be a re-used fifteenth-century object.

The front painted panel is an integral structural component of the chest. It shows the decorative techniques of gilding, punching, incised decoration and *sgraffito* commonly employed in fifteenth-century *cassone* painting. The filled-in keyhole and lock and the damage around it indicate that the panel was always the front part of a chest.

The painted decoration has suffered and many areas have been heavily restored, although largely following the original design. The metal leaf which was applied to the armour and other areas has all gone, and has been repainted in grey and gold paint.

NOTES

1 See for example Campbell 2000a, p. 73, Appendix, nos. 22 (p. 237), 29 (p. 238), 35 (p. 241), 48 (p. 245), 52 (p. 245), 53 (p. 245), 54 (p. 246), 55 (p. 246), 112 (p. 277).

2 Plutarch 1917, ch. 76, pp. 312–15.

3 Plutarch 1917, ch. 69, pp. 296–97.

4 Plutarch 1919, ch. 45, pp. 550–51.

5 Plutarch 1919, ch. 45, pp. 552–53.

6 Plutarch 1917, ch. 77, pp. 318–19.

7 Plutarch 1917, chs. 78–79, pp. 320–23.

8 Plutarch 1917, ch. 80, pp. 324–25.

9 Plutarch 1919, ch. 44, pp 548–49.

10 Compare Paolo Uccello, *The Rout of San Romano* (London, National Gallery).

11 I wish to thank Scott Nethersole for showing me the chapter 'Staged Violence' from his unfinished PhD (University of London, Courtauld Institute).

12 Apart from the present painting, these are: Boston, Museum of Fine Arts; Chicago, Art Institute; private collection, London (ex-Gambier-Parry collection); private collection (Schubring 112); Paris, Musée des Arts decoratifs (Schubring 110); private collection (Callmann 1974, pl. 206); Brocklebank collection, London; location unknown (Callmann 1974, cat. 55).

13 Chicago, Art Institute, *The Assassination and Funeral of Julius Caesar* (1974.393) and *The Battle of Pharsalus and the Death of Pompey* (1974.394). A second pair of these subjects, which may also have had an association with the Apollonio shop, are only known to me through their citation by Van Marle (Van Marle 1928, pp. 554–55).

14 Lloyd 1993, pp. 13–17.

15 Lloyd 1993, p. 14.

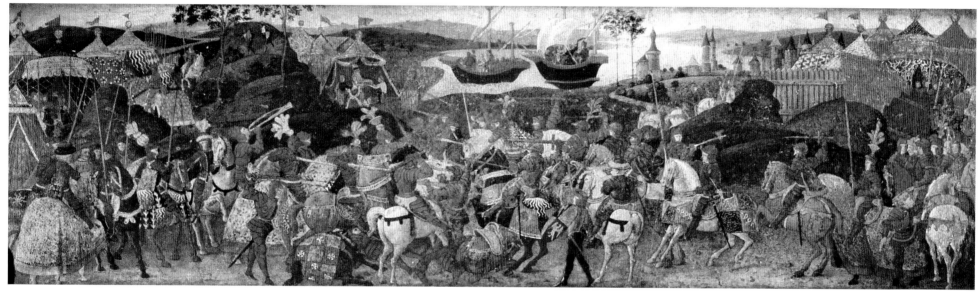

Cat. 8 (front panel)

Cat. 8 (left-hand panel)

9 The Rape of the Sabine Women
around 1480

Tempera and oil (?) on panel (probably poplar), 174 × 45 cm

Harewood House Trust,
Harewood House, Yorkshire

10 The Reconciliation of the Romans and the Sabines
around 1480

Tempera and oil (?) on panel (probably poplar), 173 × 45 cm

Harewood House Trust,
Harewood House, Yorkshire

LITERATURE

Livy 1919, Book I, chs. 9, 11, 12, 13, pp. 32–39, 41–51; Plutarch 1914, 'Life of Romulus', chs. 14–20, pp. 126–55; Schubring 1915, nos. 298–99, p. 287 and pl. LXXII (Florentine Master, dated 1465); Borenius 1936, cat. 4 and 5, pp. 4–5 (Bartolomeo di Giovanni); Gombrich 1985, pp. 21–22 (fig. 46); Callmann 1974 (Florentine, *c.* 1480); Fahy 1976 (Master of Marradi), p. 183; Hughes 1997, pp. 10, 15, 52, 54, 55, 133, 157, 159 (Master of Marradi); Baskins (Master of Marradi) 1998, pp. 110, 121; Musacchio 1998 (Master of Marradi), pp. 66–89; Campbell 2000a (Master of Marradi), pp. 139, 141; Brigstocke in Weston-Lewis 2000, p. 30; Erlande Brandenberg, Simmoneau and Benoît 2004 (Master of Marradi), p. 43

EXHIBITION HISTORY
New Gallery, 1893–94, nos. 104 and 124

PROVENANCE
Torello Bacci, Florence; sold to Alexander William, Lord Lindsay (later 25th Earl of Crawford and 8th Earl of Balcarres) in January 1865; purchased by the 6th Earl of Harewood (1882–1947); by descent

Livy and Plutarch (see Literature) recount that the Romans, having founded their city, were beset by a major problem: they had no wives, no prospect of children, and their neighbours were reluctant to inter-marry. Their imaginative solution was to invite these neighbours to a festival, to which the Sabines brought their wives and children. At a given signal, the Romans seized the young women, and forced them into marriage. This is the subject of cat. 9, while its pair continues the story. The Sabines, appalled by this barbarous act, declared war. In the midst of the ensuing conflict the women and children – led by Romulus's wife Hersilia – inserted themselves into the the fray and stopped the fighting between their husbands and their fathers, saying: 'If you regret . . . the relationship that unites you . . . turn your anger against us; we are the cause of war, the cause of wounds, and even death to both our husbands and our parents. It will be better for us to perish than to live, lacking either of you, as widows or as orphans.'[1] Thanks to this moving plea, peace was made, and 'they made one people out of two'.[2]

According to the Florentine chancellor Leonardo Bruni (*c.* 1369–1444), Florentines traced their descent from Romulus, and thus from the rape of the Sabines.[3] The story was well known in fifteenth-century Florence, both through versions of Livy and Plutarch's tellings and through more contemporary interpretations. These attempted to shift attention from the violence of the rape suffered by the Sabine women (criticised by Saint Augustine and other theologians)[4] – to praise for their peace-making and acceptance of marriages arranged in less than ideal circumstances. Most significantly of all, the Sabine women feature in Petrarch's 'Triumph of Chastity': the poet places 'Hersilia and her Sabines . . . whose name fills up every book' among the first exemplars of chaste behaviour who follow Chastity, who has triumphed over Cupid.[5] The 'Triumph of Chastity' also mentions Scipio Africanus (see cat. 7),[6] and the visual tradition of these exemplars of Roman chastity in Florence was extremely close.

Together with the continence of Scipio (cat. 7), the rape of the Sabine women was one of the Roman histories most commonly found on *cassone* fronts, depicted by the Apollonio shop, by Lo Scheggia (fig. 1) and by the many artists associated with them.[7] However, unlike Scipio (see cat. 7), it was still part of the furniture painting repertoire at the end of the fifteenth century. Both stories derived their currency from their association with marriage, and this is emphasised by the surviving panels, which reinterpret these ancient histories according to fifteenth-century wedding practice (see above, 'The Wedding Chest').

The Harewood panels are slightly longer and wider than the putative norm for *cassone* paintings.[8] Their massive nineteenth-century frames consciously evoke the forms of *spalliere*, and make these pictures look like *spalliera* panels. However, the remains of keyholes are evident at the back of each panel, and they are thus among the last *cassone* paintings to be produced for marriage chests in Florence. By the late fifteenth century, furniture paintings were more often made for insertion into other types of furniture or for display on the walls of the *camera*, either above chests or even higher up (see above, 'The Wedding Chest'). Their archaism is heightened by their debt to the earliest Florentine representations of the Sabine women, by the Apollonio shop. Two *cassone* fragments (Oxford, Ashmolean Museum, and Edinburgh, National Galleries of Scotland) of different versions of the subject are all that remain of these.

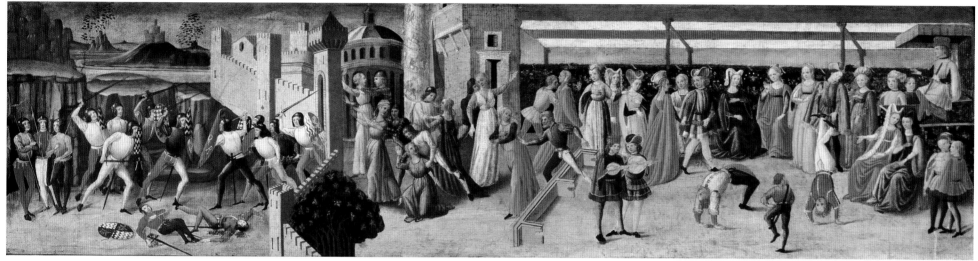

Cat. 9

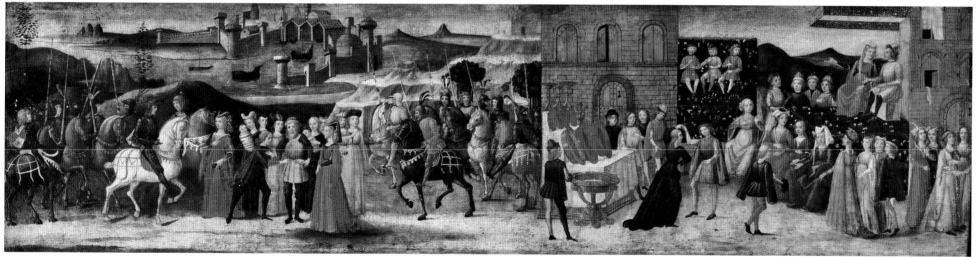

Cat. 10

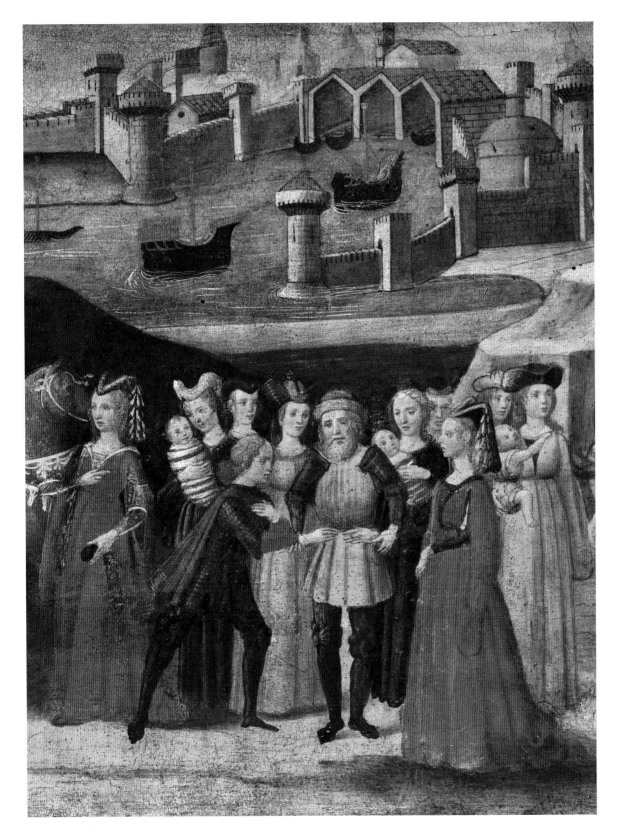

The first Harewood panel (cat. 9) is derived from a dismembered painting to which the fragment in Edinburgh must also have belonged, as it includes an almost identical portrayal of acrobats performing before a king, presumably Romulus. Other parts of the Harewood *Rape* – such as the benches, or the Sabine women – are rather awkward and studied. As a result it is probably a modernised version of Apollonio's original composition, brought up to date with the addition of some fashionable elements like the rather *all'antica*, high-waisted dresses of the fleeing Sabines underneath the walls of Rome. The composition may come directly from Apollonio di Giovanni, or it could have been mediated through two other loosely related paintings of the Sabines. These also combine early and late fifteenth-century features (formerly Malahide, Talbot de Malahide collection and Richmond, Cook collection).[9]

Ellen Callmann argued that the second Harewood panel represented the continence of Scipio and that this panel's pairing with the *Rape of the Sabines* was intended to contrast Scipio's righteous behaviour with the Romans' violence and immorality.[10] However, it seems more likely that the panel depicts the *Reconciliation of the Romans and the Sabines*, as the betrothal scene at the left only includes one young man, and Scipio is consistently described (by Livy, Plutarch and Petrarch) as a youth (compare cat. 7, where several young men are possible candidates for Scipio). This identification is also suggested by the women and babies (presumably the Sabine women and their Roman offspring).

The story is admittedly not straightforward to interpret, because it translates this ancient history into the idioms of Florentine fifteenth-century marriage. Rome is evoked in cat. 9 as a generic cityscape, with the addition of emblematic Roman monuments (including a column – presumably Trajan's – Sestius's Pyramid and the Castel Sant'Angelo). The reconciliation of all the Romans and Sabines is encapsulated in one scene, the betrothal of a youth and young girl, whose hands are brought together by a bearded man. These presumably represent Romulus and his Sabine wife Hersilia, while the older man must be Tatius, the

Sabine king. At the right, a wedding dance takes place. Its situation outside a distinctly Florentine palace, flanked by a *credenza* of gold plate, again reflects fifteenth-century practice.[11]

Credenze were often used in domestic painting of the late fifteenth century to denote the happy ending of marriage.[12] A particularly pertinent example is Botticelli's *The Banquet of Nastagio degli Onesti* (private collection), which gives a legitimate conclusion to Nastagio's use of the dead Anastagio's gruesome punishment of his beloved to gain his wife.[13] This would have conveyed forcibly the message that the forced union of the Romans and the Sabines was a true marriage.

This pair of panels was purchased by Lord Lindsay, one of the greatest British collectors of the Italian 'primitives', from the Florentine dealer Torello Bacci in January 1865. He bought them with a provenance to the wedding of Antonio Davanzati and Lisa Redditi in 1465. This connection, however, appears to have no substance, and is based exclusively on the fine but wholly mid-nineteenth-century frames, which bear prominently the Davanzati and Redditi arms.[14]

The date 1465 seems too early for these paintings. Certain features, such as the slightly classicised dress of the fleeing Sabine women in cat. 9, suggest they were made as much as fifteen years later.[15] Since 1976 the paintings have been attributed to the Master of Marradi, a close follower of Domenico Ghirlandaio who specialised in depicting historical scenes using contemporary dress. The attribution is confirmed by comparison with other works by this artist, in particular the chest frontal of *The Schoolmaster of Falerii* now in the National Gallery, London.[16] The Harewood panels are the Master's reinterpretation of a visual narrative developed before 1460. Their charming details and pleasing colours make them perhaps his most successful work for the domestic setting.

Technical Notes

GRAEME BARRACLOUGH

Both works are apparently executed on a single piece of fairly thick panel, probably poplar. There is no evidence of either panel having been thinned. On the rear of both panels near the top centre some of the wood has been carved out - probably the original housing for the lock of the chest. There are isolated patches of tiny holes in the ground layer in both panels, probably formed of air bubbles due to the flawed mixing and application of the gesso ground.

Unlike other *cassone* panels examined for this exhibition, this pair show minimal use of the decorative techniques of punching, *sgrafitto* and gilding; the gilding appears to be mostly mordant gilding. The artist employs incised lines in both works, mostly relating to architectural elements such as the tent canopy in the *Rape of the Sabines* (cat. 9). The technique of flesh painting is consistent and demonstrates a strong reliance on *verdaccio* (green earth) underpainting. Features such as the lips and eyes were picked out with minimal opaque paint and finished with limited use of white highlights. Whilst the use of green earth often indicates the use of a tempera medium, the craquelure in some areas, such as the sky in the *Reconciliation* panel, may indicate the use of a drying oil.

The elaborate frames were intended to make these *cassone* panels resemble *spalliere*. However, all the elements, including the gilding, moulding, carving, and painted decoration, are probably of nineteenth-century origin.

NOTES

1 Livy 1919, Book I, ch. 12, pp. 48–49.
2 Livy 1919, Book I, ch. 12, pp. 49–51.
3 Baskins 1998, p. 107.
4 Augustine 1984, pp. 66–67; Baskins 1998, p. 108.
5 'Poi vidi Ersilia con le sue Sabine, schiera che del suo nome empie ogni libro': Petrarch 1996, ll. 152–53, p. 254.
6 Petrarch 1996, ll. 169–77, p. 260.
7 For reproductions of these paintings see fig. 1 above, and Callmann 1974, pls. 196–99, 201, 270, and Baskins 1998, figs. 30, 40, 41, 42, 43. Callmann 1974, pl. 201, is identified by her as the *Continence of Scipio* but the presence of the Colosseum at the right and the conspicuous lack of the ransom Scipio gives Allucius as his bride's dowry means that it probably represents the *Reconciliation of the Romans and the Sabines*.
8 Schubring 1915, p. 15.
9 Reproduced in Callmann 1974, pls. 195 and 199.
10 Callmann 1974, p. 42.
11 Syson and Thornton 2001, p. 69; Bayer 2008-09, pp. 302-03, n. 8.
12 See for example Bayer 2008-09, cat. 139, 140b.
13 Rubin 2007, fig. 216.
14 The main body of both frames is composed of machine-cut wood, with some re-used pieces of older worm-eaten wood. I am grateful to Graeme Barraclough for this observation.
15 Campbell 2000a, p. 141.
16 London, National Gallery, NG3826.

*Florentine paintings for
the domestic setting from
The Courtauld Gallery not
included in the exhibition*

CAROLINE CAMPBELL, TILLY SCHMIDT
AND GRAEME BARRACLOUGH

APPENDIX NO. 1

Mariotto Albertinelli (1474–1515)
The Creation and Fall of Man, 1513–14

Oil on panel, 56.2 × 165.5 cm
The Courtauld Gallery, London
(Samuel Courtauld Trust), P.1966.GP.6

This delicate and elegant painting has been identified as one of 'three little stories' which Vasari mentions in his 'Life of Albertinelli' as being painted for the banker Giovanmaria di Lorenzo Benintendi between 1513 and 1515. Six small-scale paintings by Albertinelli survive of Adam and Eve and their descendants: the Courtauld painting; *The Expulsion from Paradise* (Zagreb, Strossmayer Gallery of Old Masters); *The Fall of Man* and *The Sacrifice of Isaac* (New Haven, Yale University Art Gallery); and two versions of *The Sacrifice of Cain and Abel* (Bergamo, Accademia Carrara, and Cambridge, MA, Harvard University Art Museums). It seems likely that the Zagreb, Courtauld and Bergamo paintings belong together, because they are of the same height and their figure scale and style are very similar.

The Courtauld *Creation and Fall* is not a *cassone* panel. It is too wide and tall, and exhibits none of the characteristic damages associated with paintings set into chests (see App. nos. 2 and 3). Moreover, the battens (which are probably original) have been found on other probable *spalliere*, such as Botticelli's *Venus and Mars* (fig. 6). Its dimensions and relatively good condition mean that it was probably set into the panelling of a room, or into a piece of furniture displayed at a higher level.

Technical Notes
GRAEME BARRACLOUGH

The painting support consists of three planks of wood, apparently poplar, of approximately 3 cm in depth. The middle piece is by far the largest, measuring 49.8 cm high, compared to 4.8 cm (top piece) and 2.4 cm (bottom piece). Two battens (also apparently of poplar) were dovetailed into the back of the panel. They both taper off considerably at the top. It seems likely that these are the original battens (although they have been thinned), used to attach the panel to a piece of furniture or to a wall.

The panel seems to have been prepared for painting with a gesso ground. Some underdrawing can be discerned with the naked eye, but it seems that the design was almost wholly resolved before the artist began to paint. The presence of several incised lines outlining parts of Eve's body (at right) suggests that at least some of the design was transferred mechanically to the panel by tracing.

Reserves were left for the figures and the animals, and broadly these were followed. However, most of the smaller animals (near the pond and around the elephant) were painted on top of the grass. Several small changes were also made to the position of the figures (for example, to Adam's knee at his creation, or to Adam's nose at the far right).

The range of pigments is consistent with a fifteenth- and early sixteenth-century palette. The blue robe of God the Father was painted with lapis lazuli (natural ultramarine).

PROVENANCE

Buonacorsi Perini, Florence; purchased in Italy by Irvine; William Buchanan; sale, Christie's, London, 12 May 1804, lot 6 (as Raphael); possibly Duke of Lucca, sale, Phillips, London, 5 June 1841; William Coningham sale, Christie's, London, 9 June 1849, lot 44 (as Albertinelli); acquired by Thomas Gambier Parry in 1849 through P. and D. Colnaghi, London; bequeathed by Mark Gambier-Parry, 1966

EXHIBITION HISTORY

London 1930, cat. 372, p. 209; Franklin 2005, cat. 20, pp. 104–05

LITERATURE

Vasari 1996, vol. 1, p. 684; Blunt 1967, pp. 8–11; Borgo 1976, no. 28, pp. 165–67, 349–57; Troutman 1979, pp. 3–4

Stefano d'Antonio di Giovanni di Guido (1405–1483)
Apollo and Daphne, around 1430

Tempera on panel (probably poplar), 48.1 × 167.5 cm
The Courtauld Gallery, London
(Samuel Courtauld Trust), P.1947.LF.2.61

Apollo's vain pursuit of the nymph Daphne is narrated in Book I of Ovid's *Metamorphoses* (ll. 452–567). The story is condensed into three episodes: Apollo's rejection of the power of love (here depicted rather like Paris's choice in the Judgement of Paris); Cupid's conquest of Apollo with his arrow and Daphne's flight from Apollo; and her transformation into a laurel bush and Apollo's grief at her loss.

The painting, evidently a *cassone* panel, was given by Schubring to the 'Paris Master'. Carl Strehlke and Andrea De Marchi have independently (in unpublished communications of June 2005 and September 1992) attributed this panel to Stefano d'Antonio di Giovanni di Guido, who, like Lo Scheggia, trained with Bicci di Lorenzo. This attribution seems very likely, and stylistic parallels can be drawn with other works by Stefano d'Antonio, particularly during his partnership with Bicci di Lorenzo (1426–34), such as the predella panels accompanying the *Annunciation*, *c.* 1430 (Baltimore, Walters Art Gallery). There are also affinities with the frescoes attributed to Stefano d'Antonio in the Palazzo Davanzati, Florence (Padoa Rizzo and Frosinini 1984, figs. 20 and 21).

Technical Notes
TILLY SCHMIDT

The support consists of two butt-joined wood panels. At some stage the panel was thinned down and a heavy cradle attached. The original housing for the lock was filled in.

To prepare the panel for painting, pieces of canvas were glued on to its surface and the joint between the two planks. The panel was then primed with gesso (calcium sulphate bound in animal glue).

Gold and silver were applied to certain areas on top of a red bole. Daphne's dress and the trunk of the tree which she became were silvered. The silver areas have been reworked, while some of the gilding remains intact. Daphne's gilded head-dress was further decorated with a leaf-shaped punch. A punch with a round tip was used to embellish the clothing.

The range of pigments is characteristic for a work of this date. This is the only one of the Courtauld *cassone* paintings to use natural lapis lazuli, an expensive blue pigment. Although the composition seems unaltered, the painting has been heavily reworked. For instance, the faces have been deliberately scratched and repainted. The large losses make it impossible to identify the painting techniques originally used.

PROVENANCE
Otto Schuster, Amsterdam; with Durlacher, London, by 1923; Schuster sale, Sotheby's, London, 16 July 1931, lot 20; purchased for Lord Lee of Fareham

EXHIBITION HISTORY
Birmingham 1955, cat. 84

LITERATURE
Schubring 1923, no. 917, pl. X (Paris Master); Schubring 1927a, pp. 104–05; Stechow 1932, p. 18 (Florentine, *c.* 1450); Lee 1967, no. 102; Troutman 1979, pp. 57–58; Padoa Rizzo and Frosinini 1984 (for Stefano d'Antonio); Jacobsen 2001, p. 631–32 (for Stefano d'Antonio)

Italian

The Triumph of Chastity, before 1875

Tempera and gold on panel (probably poplar)
73.5 × 179 cm
The Courtauld Gallery, London
(Samuel Courtauld Trust), P.1966.GP.200

This painting was bought by Thomas Gambier Parry in November 1875 from William Blundell Spence in Florence as North Italian School, fifteenth-century. Spence told Gambier Parry that it had a Brescian provenance. In an unpublished paper (2005–06) Lara Langer argued that the painting was indebted to the tarot cards produced by Bonifacio Bembo (1420–1482) and the *cassone* paintings of Liberale da Verona (1445–1526). However, the *Triumph of Chastity* is almost completely nineteenth-century in appearance, so it is impossible to be sure whether a fifteenth- or nineteenth-century painter had these prototypes in mind. It is equally unclear whether the painting is in origin Tuscan or North Italian.

It seems that this painting was made in the mid-nineteenth century reusing an earlier painted panel, which may have had the same subject. Technical examination (see below) was unfortunately unable to prove (or disprove) Langer's intriguing suggestion that the painting had been restored by Thomas Gambier Parry, who invented 'spirit fresco', a method of wall painting which he claimed was particularly suited to the English climate.

Technical Notes

TILLY SCHMIDT

Most of what is currently visible on the painted surface of this panel is probably of nineteenth-century origin. The decorative techniques, the pigments employed and the mordant gilding appear to date from this time, in a style reflecting fifteenth-century *cassone* painting. However, x-radiography, infra-red reflectography and paint cross-sections show the remains of paint layers underneath those visible today, so the present paint surface may be the substantial re-working of an earlier design.

The panel itself and the inner lambs-tongue moulding may have early origins. The panel is formed of two pieces (probably of poplar) with a central horizontal butt-join. Prior to the application of the ground layer this join was covered with canvas. At the rear of the panel toward the top centre is a hollowed-out section of wood, probably to house a lock.

PROVENANCE
William Blundell Spence, Florence; bought from Spence by Thomas Gambier Parry, November 1875 (for £200); bequeathed by Mark Gambier-Parry, 1966

LITERATURE
Troutman 1979, p. 22; Langer 2005–06

Florentine

A Triumph, around 1450

Tempera on panel (probably poplar)
42.5 × 134.6 cm
The Courtauld Gallery, London
(Samuel Courtauld Trust), P.1946.LF.130

A general (at the left) and his entourage – led by two prisoners – prepare to enter a city in a triumphal procession. The city has been identified as Rome and the general as Augustus (because of the eagle on his helmet); however, both are represented in such an unspecific manner that a precise definition is very difficult, if not impossible. Parallels have been drawn with Apollonio di Giovanni and Marco del Buono's *Triumph of Aemilius Paulus* (Cambridge, Fitzwilliam Museum) and a *Triumph of Scipio* (Paris, Musée des arts décoratifs) but these are not borne out by the generic nature of this *Triumph*. It seems unlikely that the painting represents a Roman scene, as the armour and clothing of the participants is wholly fifteenth-century.

The painting was purchased by Lord Lee after 1926 (it is not included in Borenius's catalogue of his collection) as by Masolino. Although this is over-generous, the rounded forms of the figures and beautifully painted faces make the rationale behind this attribution comprehensible, and the painting may reflect Masolino. Unfortunately, the panel is so abraded and over-painted that it is impossible to make a strong case for its authorship.

Technical Notes
TILLY SCHMIDT

The panel was made of a single piece of wood with an original thickness of about 36 mm. The lock housing is situated far off centre and the panel may thus have lost as much as 40 mm at the right. Along the entire bottom edge a strip of wood approximately 35 cm long has been nailed to the original panel. This is a later replacement and the entire bottom edge is reconstructed. From the x-radiograph it is evident that rectangular pieces of canvas were applied to the panel to even out surface irregularities before a gesso ground was applied.

Gold and silver were laid over a layer of red bole, and these areas were decorated with punching, engraving, and patterns applied in an organic lake pigment. The silver of the armour has oxidised, and has been reworked in red paint.

The paint has the characteristics of egg tempera (such as the under-painting of the faces in green earth), although an oily medium may have been used in some layers. Many areas were painted with red lake pigments on top of light underpaints; these have faded to pale pinks. The pigments used are typical of fifteenth-century Italy, with the exception of synthetic green verditer. This is a very early example of its use.

The entire lower edge and large sections of this painting have been reconstructed or overpainted.

PROVENANCE
Purchased by Lord Lee of Fareham after 1926; bequeathed by Lord Lee, 1947

LITERATURE
Lee 1967, p. 4, no. 11; Troutman 1979, p. 43

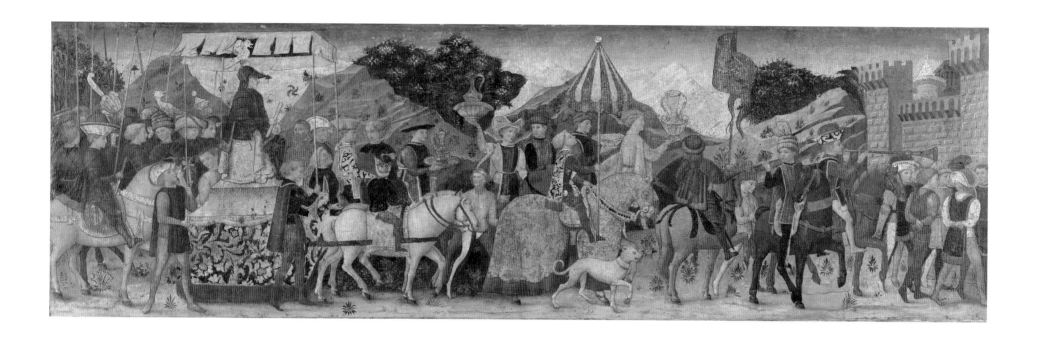

Bibliography

Ahl 1981: Diane Cole Ahl, 'Renaissance birth salvers and the Richmond 'Judgement of Solomon', *Studies in Iconography*, 7–8, 1981, pp. 157–174

Ahl 1996: Diane Cole Ahl, *Benozzo Gozzoli*, New Haven and London, 1996

Ajmar-Wollheim, Dennis and Matchette 2006: Marta Ajmar-Wollheim, Flora Dennis and Ann Matchette, eds., *Approaching the Italian Renaissance Interior: sources, methodologies, debates* (special issue of *Renaissance Studies*, 20, no. 5, November 2006), Oxford, 2006

Ajmar-Wollheim and Dennis 2006–07: Marta Ajmar-Wollheim and Flora Dennis, eds., *At Home in Renaissance Italy*, exh. cat., London, Victoria and Albert Museum, 2006–07

Alberti 1969: Leon Battista Alberti, *The Family in Renaissance Florence*, trans. Renée Neu Watkins, Columbia, S.C., 1969

Alberti 1994: Leon Battista Alberti, *I libri della famiglia*, Ruggiero Romano and Alberto Tenenti, eds., with revisions by Francesco Furlan, Turin, 1994

Alisio *et al.* 2006: Giancarlo Alisio, Sergio Bertelli and Antonio Pinelli, *Arte e politica tra Napoli e Firenze: un cassone per il trionfo di Alfonso d'Aragona*, Modena, 2006

Allen 1977: Shirley Allen, 'The Griselda tale and the portrayal of women in the Decameron', *Philological Quarterly*, 56, 1977, pp. 1–13

Altieri 1873: Marco Antonio Altieri, *Li nuptiali*, ed. Enrico Narducci, Rome, 1873

Ames-Lewis 1984: Francis Ames-Lewis, *The Library and Manuscripts of Piero di Cosimo de' Medici*, New York and London, 1984

Anderson 1970: Barbara Anderson, 'A *cassone* puzzle reconstructed', *Museum Studies*, 5, 1970, pp. 23–30

Andrews 1995: Lew Andrews, *Story and space in Renaissance art: the rebirth of continuous narrative*, Cambridge and New York, 1995

Antal 1948: Frederick Antal, *Florentine painting and its social background*, London, 1948

Artaud de Montor 1808: Alexis François Artaud de Montor, *Considérations sur l'état de la peinture en Italie dans les quatre siècles qui ont précédé celui de Raphael*, Paris, 1808

Artaud de Montor 1811: Alexis François Artaud de Montor, *Considérations sur l'état de la peinture en Italie dans les quatre siècles qui ont précédé celui de Raphael*, 2nd edn, Paris, 1811

Artaud de Montor 1843: Alexis François Artaud de Montor, *Peintres primitifs: Collection de tableaux rapportée d'Italie et publiée par M. le chevalier Artaud de Montor*, Paris, 1843

Augustine 1984: Saint Augustine, *The City of God*, trans. Henry Bettenson, Harmondsworth, 1984

Baden 2007: Linda Baden, ed., *Masterworks from the Indiana University Art Museum*, Bloomington, IN, 2007

Baker and Henry 2001: Christopher Baker and Tom Henry, *The National Gallery Complete Illustrated Catalogue*, London and New Haven, 2001

Bardini 1899: *Catalogue des objets d'art: Antiques, du Moyen Âge et de la Renaissance provenant de la Colletion [sic] Bardini a Florence, dont la vente aura lieu à Londres chez Mr. Christie . . . le 5 juin 1899*, Florence, 1899

Barkan 1986: Leonard Barkan, *The Gods made Flesh: Metamorphosis and the Pursuit of Paganism*, New Haven and London, 1986

Barker 2000: Nicholas Barker, 'Lord Lindsay and the Bibliotheca Lindesiana', in Weston-Lewis 2000, pp. 9–15

Barolsky 1998: Paul Barolsky, 'As in Ovid, so in Renaissance art', *Renaissance Quarterly*, 51, no. 2, 1998, pp. 451–74

Baron 1966: Hans Baron, *The Crisis of the Early Florentine Renaissance. Civic Humanism and Republican Liberty in an Age of Classicism and Tyranny*, 2nd edn, Princeton, NJ, 1966

Barriault 1991: Anne B. Barriault, 'The abundant, beautiful, chaste and wise: domestic painting of the Italian Renaissance in the Virginia Museum of Fine Arts', *Arts in Virginia*, 30, 1991, pp. 2–21

Barriault 1994: Anne B. Barriault, *Spalliera paintings of Renaissance Tuscany: fables of poets for patrician homes*, University Park, PA, 1994

Bartoli 1998: Roberta Bartoli, *Biagio di Antonio*, Milan, 1999

Baskins 1991: Cristelle Baskins, 'Griselda, or the Renaissance bride stripped bare by her bachelor in Tuscan *cassone* painting', *Stanford Italian Review*, 10, 1991, pp. 153–75

Baskins 1991a: Cristelle Baskins, '"La festa di Susanna": Virtue on trial in Renaissance sacred drama and painted wedding chests', *Art History*, 14, 1991, pp. 329–44

Baskins 1993: Cristelle Baskins, 'Typology, sexuality, and the Renaissance Esther', in *Sexuality and Gender in Early Modern Europe: Institutions, Texts, Images*, ed. James Grantham Turner, Cambridge, 1993, pp. 31–54

Baskins 1998: Cristelle Baskins, *Cassone painting, humanism and gender in early modern Italy*, Cambridge and New York, 1998

Baskins 2002: Cristelle Baskins, '(In)famous men: the continence of Scipio and formations of masculinity in Italian Renaissance domestic painting', *Studies in Iconography*, 23, 2002, pp. 109–36

Baskins 2008–09: Cristelle Baskins, ed., *The Triumph of Marriage: Painted Cassoni of the Renaissance*, exh. cat., Boston, Isabella Stewart Gardner Museum, 2008–09

Baxandall 1972: Michael Baxandall, *Painting and Experience in Fifteenth-Century Italy*, Oxford, 1972

Bayer 2008–09: Andrea Bayer, ed., *Art and Love in Renaissance Italy*, exh. cat., New York, Metropolitan Museum of Art, 2008–09

Bec 1975–76: Christian Bec, 'Sur la lecture de Boccace à Florence', *Studi sul Boccaccio*, 9, 1975–76, pp. 247–60

Bec 1984: Christian Bec, *Les livres des florentins: 1413–1608*, Florence, 1984

Bellosi 1966: Luciano Bellosi, 'Il Maestro della crocifissione Griggs: Giovanni Toscani', in *Paragone (Arte)*, 193, 1966, pp. 44–58

Bellosi 1999: Luciano Bellosi, 'Il Maestro del Cassone Adimari e il suo grande fratello', in Bellosi and Haines 1999, pp. 7–33

Bellosi 2000: Luciano Bellosi, 'Giovanni Toscani', *Grove Dictionary of Art online* (http://www.oxfordartonline.com/subscriber/article/grove/art/T085793?q=toscani&source)

Bellosi and Haines 1999: Luciano Bellosi and Margaret Haines, *Lo Scheggia*, Florence, 1999

Belozerskaya 2005: Marina Belozerskaya, *Luxury Arts of the Renaissance*, Los Angeles, 2005

Benson and Borenius 1914: Robert Benson and Tancred Borenius, *Catalogue of Italian Pictures at 16, South Street, Park Lane, London, and Buckhurst in Sussex, collected by Robert and Evelyn Benson*, London, 1914

Berenson 1932: Bernard Berenson, *Italian Pictures of the Renaissance: A List of the Principal Artists and their Works, with an Index of Places*, Oxford, 1932

Berenson 1963: Bernard Berenson, *Italian Pictures of the Renaissance: A List of the Principal Artists and their Works, with an Index of Places: Florentine School*, 2 vols., London, 1963

Bertani 2001: Licia Bertani *et al.*, *The Horne Museum. A Florentine House of the Renaissance*, Florence, 2001

Berti 1972: Luciano Berti, *Il Museo di Palazzo Davanzati a Firenze* (Gallerie e musei di Firenze), Milan, 1972

Bessi 1990: Rossella Bessi, 'Un traduttore al lavoro: Donato Acciaiuoli e l'elaborazione del volgarizzamento delle *Historiae*', in Paolo Viti, ed., *Leonardo Bruni, Cancelliere della repubblica di Firenze*, Florence, 1990, pp. 321–38

Biagi 1899: G. Biagi, *Due corredi nuziali fiorentini 1320–1493 da un libro di ricordanze dei Minerbetti*, Florence, 1899

Birbari 1975: Elizabeth Birbari, *Dress in Italian Painting, 1460–1500*, London, 1975

Birmingham 1955: *Italian Art from the Thirteenth Century*, exh. cat., Birmingham, Museum and Art Gallery, 1955

Blunt 1967: Anthony Blunt, *The Gambier-Parry Collection: Provisional Catalogue*, London, 1967

Blunt 1967a: Anthony Blunt, 'The history of Thomas Gambier-Parry's collection', *Burlington Magazine*, 109, 1967, pp. 112–16

Bober and Rubinstein: Phyllis P. Bober and Ruth Rubinstein, *Renaissance Artists and Antique Sculpture: A Handbook of Sources*, London, 1987

Bode 1902: Wilhelm von Bode, *Die italienischen Hausmöbel der Renaissance*, Berlin, 1902

Boccaccio 1966: Giovanni Boccaccio, *Decameron*, ed. Cesare Segre with notes by Maria Segre Consigli, Milan, 1966

Boccaccio 1971: Giovanni Boccaccio, 'Il Ninfale fiesolano', ed. M. Marti, in Giovanni Boccaccio, *Opere minori in volgare*, Milan, 1971, vol. 3, pp. 637–785

Boccaccio 1971a: Giovanni Boccaccio, 'Commedia delle ninfe fiorentine', ed. M. Marti, in Giovanni Boccaccio, *Opere minori in volgare*, Milan, 1971, vol. 3, pp. 9–206

Boccaccio 1991: Giovanni Boccaccio, *Diana's Hunt/Caccia di Diana; Boccaccio's First Fiction*, ed. and trans. Anthony Cassell and Victoria Kirkham, Philadelphia, 1991

Boccaccio 2001: Giovanni Boccaccio, *De mulieribus claris*, trans. Virginia Brown, Cambridge, MA, 2001

Bonsignore 1497: Giovanni Bonsignore, *Ovidio Methamorphoseoe [sic] vulgare . . . vulgarizata et allegorizata per Joani de Bonsignore*, Venice (Zoane Rosso Vercellese), 1497

Borenius 1921: Tancred Borenius, *The Holford Collection, Dorchester House*, London, Oxford, 1921

Borenius 1922: Tancred Borenius, 'Unpublished *cassone* panels', *Burlington Magazine*, 41, 1922, pp. 70–75, 131–32, 189–94

Borenius 1923–26: Tancred Borenius, *A Catalogue of the Pictures etc at 18 Kensington Palace Gardens, London, collected by Viscount and Viscountess Lee of Fareham*, 2 vols., London, 1923–26

Borenius 1926: Tancred Borenius, 'Italian *cassone* paintings', *Apollo*, 3, 1926, pp. 132–39

Borenius: Tancred Borenius, *Catalogue of the Pictures and Drawings at Harewood House and Elsewhere in the Collection of the Earl of Harewood*, Oxford, 1936

Borgo 1976: Ludovico Borgo, *The Works of Mariotto Albertinelli*, London and New York, 1976

Boskovits and Brown 2003: Miklós Boskovits and David Alan Brown, with Robert Echols *et al.*, *Italian Paintings of the Fifteenth Century, The Collections of the National Gallery of Art, Systematic Catalogue*, Washington, D.C., 2003

Braham 1977: Allan Braham, 'The bed of Pierfrancesco Borgherini', *Burlington Magazine*, 121, December 1977, pp. 754–65

Branca 1985–86: Vittore Branca, 'Interpretazioni visuali del Decameron', *Studi sul Boccaccio*, 15, 1985–86, pp. 87–119

Branca 1986: Vittore Branca, ed., *Mercanti scrittori: ricordi nella Firenze tra medievo e rinascimento*, Milan, 1986

Branca 1999: Vittore Branca, ed., *Boccaccio visualizzato: Narrare per parole e per immagini fra Medioevo e Rinascimento*, Turin, 1999, 3 vols.

Bridgeman 1986: R. Jane Bridgeman, *Aspects of Dress and Ceremony in Quattrocento Florence*, PhD thesis, Courtauld Institute of Art, University of London, 1986

Brigstocke 1993: Hugh Brigstocke, *Italian and Spanish Paintings in the National Gallery of Scotland*, 2nd edn, Edinburgh, 1993

Brigstocke 2000: Hugh Brigstocke, 'Lord Lindsay as a Collector of Paintings', in Weston-Lewis 2000, pp. 25–33

Brown 1995: Alison Brown, ed., *Language and Images of Renaissance Italy*, Oxford, 1995

Brown 2003: David Alan Brown, 'Introduction' in Boskovits and Brown 2003, pp. xiii–xvii

Brucker 1980: Gene Brucker, *Firenze nel Rinascimento*, Florence, 1980

Brucker 1986: Gene Brucker, *Giovanna and Lusanna: Love and Marriage in Renaissance Florence*, Berkeley, 1986

Bruschi 1995: Alberto Bruschi, 'Preziosi cassoni o tristi sarcofagi?', *Gazzetta antiquaria*, n.s. 24, 1995, pp. 34–39

Bryson 1986: Norman Bryson, 'Two narratives of rape in the visual arts: Lucretia and the Sabine Women', in Sylvana Tomaselli and Roy Porter, eds., *Rape*, New York, 1986, pp. 152–73

Bullen 1981: Barrie Bullen, 'The source and development of the idea of the Renaissance in early nineteenth-century French criticism', *Modern Language Review*, 76, 1981, pp. 311–22

Burckhardt 1990: Jacob Burckhardt, *The Civilisation of the Renaissance in Italy*, trans. S.G.C. Middlemore with an introduction by Peter Burke, London, 1990

Burke 1969: Peter Burke, *The Renaissance Sense of the Past*, London, 1969

Burke 1972: Peter Burke, *Culture and Society in Renaissance Italy*, London, 1972

Burke 1994: Peter Burke, *Popular Culture in Early Modern Europe*, Aldershot, 1994

Butterfield 2007–08: Andrew Butterfield, 'Art and innovation in Ghiberti's Gates of Paradise', in Radke 2007–08, pp. 17–41

Cabrini 1990: Anna Maria Cabrini, 'Le "Historiae" di Bruni: Risultati e ipotesi di una ricerca sulle fonte', in Paolo Viti, ed., *Leonardo Bruni, Cancelliere della repubblica di Firenze*, Florence, 1990, pp. 247–319

Caglioti 2007–08: Francesco Caglioti, 'Reconsidering the creative sequence of Ghiberti's Doors', in Radke 2007–08, pp. 86–97

Calderai and Chiarugi 2006–07: Fausto Calderai and Simone Chiarugi, 'The *Lettuccio* (Daybed) and *Cappellinaio* (Hat Rack)', in Ajmar-Wollheim and Dennis 2006–07, pp. 122–23

Callmann 1974: Ellen Callmann, *Apollonio di Giovanni*, Oxford, 1974

Callmann 1977: Ellen Callmann, 'An Apollonio di Giovanni for an historic marriage', *Burlington Magazine*, 119, March 1977, pp. 174–81

Callmann 1979: Ellen Callmann, 'The growing threat to maritial bliss as seen in fifteenth-century Florentine paintings', *Studies in Iconography*, 5, 1979, pp. 73–92

Callmann 1980: Ellen Callmann, *Beyond Nobility: Art for the Private Citizen in the Early Renaissance*, exh. cat., Allentown Art Museum, Allentown, PA, 1980

Callmann 1988: Ellen Callmann, 'Apollonio di Giovanni and Painting for the Early Renaissance Room', *Antichità Viva*, 27, nos. 3–4, 1988, pp. 5–18

Callmann 1995: Ellen Callmann, 'Stories from Boccaccio in Italian Painting, 1375–1525', *Studi sul Boccaccio*, 23, 1995, pp. 19–78

Callmann 1999: Ellen Callmann, 'William Blundell Spence and the Transformation of Renaissance *cassoni*', *Burlington Magazine*, 141, June 1999, pp. 338–48

Callmann 1999a: Ellen Callmann, 'Masolino da Panicale and Florentine *cassone* painting', *Apollo*, 150, August 1999, pp. 42–49

Campbell 1995: 'Ovid Metamorphosised', MA report, Courtauld Institute of Art, University of London, 1995

Campbell 2000: Caroline Campbell, *Re-visioning Antiquity: Domestic Paintings, Manuscript Compendia and the Experience of the Ancient Past in Fifteenth-Century Florence*, PhD thesis, Courtauld Institute of Art, University of London, 2000

Campbell 2000a: Caroline Campbell, 'Revaluing dress in History Paintings for Quattrocento Florence', in Neher and Shepherd 2000, pp. 137–45

Campbell 2007: Caroline Campbell, 'Lorenzo Tornabuoni's History of Jason and Medea series: Chivalry and Classicism in 1480s Florence', *Renaissance Studies*, 21, 2007, pp. 1–19

Campbell 2007a: 'The Morelli-Nerli chests', in Swallow 2007, pp. 28–29

Campbell forthcoming: Caroline Campbell, '*Favole tolte da Ovidio*. The Transformation of Ovid's *Metamorphoses* on Florentine *cassoni*', in Cristelle Baskins and Alan Chong, eds., *The Triumph of Marriage* (papers first delivered at a symposium, Isabella Stewart Gardner Museum, Boston, 7–8 November 2008), forthcoming

Campbell and Chong 2005–06: Caroline Campbell and Alan Chong, *Bellini and the East*, exh. cat., Boston, Isabella Stewart Gardner Museum and London, National Gallery, 2005–06

Carew-Reid 1995: Nicole Carew-Reid, *Les fêtes florentins au temps de Lorenzo il Magnifico*, Florence, 1995

Cavazzini 1999: Laura Cavazzini, ed., *Il fratello di Masaccio: Giovanni di Ser Giovanni detto lo Scheggia*, exh. cat., San Giovanni Valdarno, Casa Masaccio, 1999

Cecchi 1990: Alessandro Cecchi, 'Percorso di Baccio d'Agnolo legnaiuolo e architetto fiorentino dagli esordi al palazzo Borgherini', *Antichità Viva*, 29, no. 1, 1990, pp. 31–46

Cennini 2003: Cennino Cennini, *Il libro d'arte*, ed. Fabio Frezzato, Vicenza, 2003

Chastel 1959: André Chastel, *Art et humanisme à Florence au temps de Laurent le Magnifique: Études sur la Renaissance et l'humanisme platonicien*, Paris, 1959

Chastel 1978: André Chastel, 'La legende de la Reine de Saba', in *Fables, formes, figures*, Paris, 1978, vol. 1, pp. 61–101

Chiarugi 1995: Simone Chiarugi, *Botteghe di mobilieri in Toscana*, Florence, 1995

Christiansen 1983: Keith Christiansen, 'Early Renaissance Narrative Painting in Italy', *Bulletin of the Metropolitan Museum of Art*, 41, 1983, pp. 3–48

Chong 2008–09: Alan Chong, 'The American Discovery of *cassone* Painting', in Baskins 2008–09, pp. 66–93

Ciappelli 1989: Giovanni Ciappelli, 'Libri e lettere a Firenze nel 15 secolo: le "ricordanze" e la recostruzione delle biblioteche private', *Rinascimento*, 2 ser., 29, 1989, pp. 267–91

Ciappelli 1997: Giovanni Ciappelli, *Carnevale e quaresima: comportamenti sociali e cultura a Firenze nel Rinascimento*, Rome, 1997

Ciasca 1922: R. Ciasca, *Statuti dell'Arte dei Medici e Speciali*, Florence, 1922

Cochrane 1967: Eric Cochrane, *Historians and Historiography in the Italian Renaissance*, Chicago, 1967

Cochrane 1980: Eric Cochrane, *Historians and Historiography in the Italian Renaissance*, Chicago, 1980

Cole 1969: Bruce Cole, 'The interior decoration of the Palazzo Datini in Prato', *Mitteilungen des Kunsthistorischen Institutes in Florenz*, 14, 1969, pp. 61–82

Colvin 1898: Sidney Colvin, *A Florentine Picture Chronicle: being a series of 99 drawings representing scenes and personages of ancient history sacred and profane by Maso Finiguerra (reproduced from the originals in the British Museum)*, London, 1898

Courtauld 1979: *General catalogue of the Courtauld Institute Galleries*, ed. Anthony Blunt, London, 1979

Crépin-Leblond 1999: Thierry Crépin-Leblond, Review of 'Graham Hughes, *Renaissance Cassoni : Masterpieces of Early Italian Art Painted Marriage Chests, 1400–1550*, London, 1997', *Revue de l'art*, 125, 1999, p. 78–79

Crowe and Calvacaselle 1864: J.A. Crowe and G.B. Calvacaselle, *A History of Painting in Italy*, 3 vols., London, 1864

Damisch 1992: Hubert Damisch, *Le jugement de Pâris*, Paris, 1992

Däubler-Hauschke 2003: Claudia Silvia Däubler-Hauschke, *Geburt und Memoria: Zum italienischen Bildtyp der deschi da parto*, Munich, 2003

Davies 1961: Martin Davies, *The Early Italian Schools: National Gallery catalogues*, 2nd edn, London, 1961

Davies 1995: Arabella Davies, *The Morelli-Nerli cassoni and spalliere: A technical examination and cultural appraisal*, unpublished thesis submitted in partial requirement for the postgraduate diploma in easel paintings, London, Courtauld Institute of Art, 1995

Davies 1995a: Arabella Davies, 'The Morelli-Nerli *cassoni* and *spalliere*: A technical examination and cultural appraisal', *The Conservator*, 19, 1995, pp. 36–44

Dean and Lowe 1998: Trevor Dean and K.J.P Lowe, eds., *Marriage in Italy, 1300–1650*, Cambridge, 1998

De Carli 1997: Cecilia De Carli, *I deschi da parto e la pittura del primo Rinascimento toscano*, Turin, 1997

De Giorgio and Klapisch-Zuber 1996: Michela De Giorgio and Christiane Klapisch-Zuber, eds., *Storia del matrimonio*, Rome, 1996

D'Elia 2004: Anthony D'Elia, *The Renaissance of Marriage in Fifteenth-Century Italy*, Cambridge, MA, 2004

delle Colonne 1974: Guido delle Colonne, *Historia Destructionis Troiae*, ed. Mary Meek, Bloomington, 1974

Del Monte 1950: Alberto Del Monte, 'La storiografia fiorentina dei secoli XII e XIII', *Bulletino dell'Istituto storico italiano*, 62, 1950, pp. 176–80

Dempsey 1992: Charles Dempsey, *The Portrayal of love: Botticelli's 'Primavera' and Humanist Culture at the Time of Lorenzo the Magnificent*, Princeton and London, 1992

De Pizan 1998: Christine de Pizan, *The Book of the City of Ladies*, trans. Earl Jeffrey Richards, revised edn, New York, 1998

DePrano 2004: Maria DePrano, *The art works honoring Giovanna degli Albizzi: Lorenzo Tornabuoni, the humanism of Poliziano, and the art of Niccolò Fiorentino and Domenico Ghirlandaio*, Ann Arbor, 2004

Di Lorenzo 2002–03: Andrea Di Lorenzo, *Due collezionisti alla scoperta dell'Italia. Dipinti e sculture dal Museo Jacquemart-André di Parigi*, exh. cat., Milan, Museo Poldi-Pezzoli, 2002–03

Dominici 1927: Giovanni Dominici, *On the Education of Children, c. 1404*, trans. Arthur Basil Conté, Washington, D.C., 1927

Dominici 1860: Giovanni Dominici, *Regola del governo di cura familiare, c. 1404*, ed. Dominco Salvi, Florence, 1860

Dunkerton, Christensen and Syson: Jill Dunkerton, Carol Christensen and Luke Syson, 'The Master of the Story of Griselda and Paintings for Sienese Palaces', *National Gallery Technical Bulletin*, 27, 2006, pp. 4–71

Edinburgh 2000: see Weston Lewis 2000

Erlande-Brandenberg, Simmoneau and Benoît 2004: Alain Erlande-Brandenberg, Karinne Simmoneau, Christine Benoît, *Les cassoni peints du Musée National de la Renaissance*, exh. cat., Ecouen, Musée National de la Renaissance, Paris, 2004

Ettlinger 1972: Leopold D. Ettlinger, 'Hercules Florentius', *Mitteilungen des Kunsthistorischen Institutes in Florenz*, 16, 1972, pp. 119–42

Evans 2004: Helen Evans, ed., *Byzantium. Faith and Power (1261–1557)*, exh. cat., New York, Metropolitan Museum of Art, 2004

Even 1997: Yael Even, 'Daphne (without Apollo) reconsidered: some disregarded images of sexual pursuit in Italian Renaissance and Baroque Art', *Studies in Iconography*, 18, 1997, pp. 143–59

Faenson 1983: Liubov Faenson, *Italian Cassoni from the Art Collections of Soviet Museums*, Leningrad, 1983

Fahy 1967: Everett Fahy, 'Some Early Italian Pictures in the Gambier-Parry Collection', *Burlington Magazine*, 109, March 1967, pp. 128–39

Fahy 1968: Everett Fahy, 'The Master of Apollo and Daphne', *Museum Studies*, 3, 1968, pp. 21–41

Fahy 1976: Everett Fahy, *Some Followers of Domenico Ghirlandaio*, New York, 1976

Fahy 1984: Everett Fahy, 'The Tornabuoni-Albizzi panels', in *Scritti di storia dell'arte in onore di Federico Zeri*, Milan, 1984, 2 vols., vol. 1, pp. 233–47

Fahy 1989: Everett Fahy, 'The Argonaut Master', in *Gazette des Beaux-Arts*, 114, 1989, pp. 295–99

Fahy 2000: Everett Fahy, *L'archivio storico fotografico di Stefano Bardini. Dipinti, disegni, miniature, stampe*, Florence 2000

Fahy 2008–09: Everett Fahy, 'The Marriage Portrait in the Renaissance, or Some Women named Ginevra' in Bayer 2008–09, pp. 17–28

Farr 1993: Dennis Farr, ed., *Thomas Gambier Parry as Artist and Collector*, exh. cat., London, Courtauld Gallery, 1993

Farr 1993a: Dennis Farr, 'Thomas Gambier Parry as a collector' in Farr 1993, pp. 30–45

Ferrari 1964: Maria Luisa Ferrari, *Cassoni rinascimentali*, Milan, 1964

Ferrazza 1994: Roberto Ferrazza, *Palazzo Davanzati e le collezioni di Elia Volpi*, Florence, 1994

Filippini 1992: Cecilia Filippini, 'Tematiche e soggetti rappresentati su forzieri, spalliere e deschi da parto', in Gregori, Paoletti and Acidini Luchinat 1992, pp. 234–37

Fleming 1973: John Fleming, 'Art dealing and the Risorgimento, I', *Burlington Magazine*, 115, January 1973, pp. 4–16

Fleming 1979a: John Fleming, 'Art Dealing in the Risorgimento, II', *Burlington Magazine*, 121, August 1979, pp. 492–508

Fleming 1979b: John Fleming, 'Art Dealing in the Risorgimento III', *Burlington Magazine*, 121, September 1979, pp. 568–80

Fortini Brown 2004: Patricia Fortini Brown, *Private Lives in Renaissance Venice: Art, Architecture and the Family*, New Haven and London, 2004

Fra Ildefonso 1785: Fra Ildefonso di San Luigi, *Croniche di Giovanni di Iacopo e di Lionardo di Lorenzo Morelli (Delizie degli eruditi toscani*, vol. 19), Florence, 1785

Franklin 2005: David Franklin, ed., *Leonardo da Vinci, Michelangelo, and the Renaissance in Florence*, exh. cat., Ottawa, National Gallery of Canada, 2005

Franklin 2006: Margaret Franklin, *Boccaccio's Heroines: Power and Virtue in Renaissance Society*, Aldershot, 2006

Frick 1996: Carole Collier Frick, *Dressing a Renaissance City: Society, Economics and Gender in the Clothing of Renaissance Florence*, Ann Arbor, 1996

Fry 1912-13: Roger Fry, 'Note on the Anghiari and Pisa *cassoni* panels', *Burlington Magazine*, 22, 1912-13, p. 237

Fry 1920: Roger Fry, *Catalogue of an Exhibition of Florentine Painting before 1500*, exh. cat., London, Burlington Fine Arts Club, London, 1920

Gabrielli 2007: Edith Gabrielli, *Cosimo Rosselli: catalogo ragionato*, Turin, 2007

Gambier Parry List 1860: Thomas Gambier Parry, 'List of the pictures in the Gambier Parry collection, Highnam Court', Ms.

Gambier Parry List 1863: Thomas Gambier Parry, 'List of the pictures in the Gambier Parry collection, Highnam Court', Ms.

Gambier Parry 1897: Ernest Gambier Parry, 'The Highnam Court Collection', Ms.

Garnett 2000: Oliver Garnett, 'The Letters and Collection of William Graham: Pre-Raphaelite Patron and pre-Raphael Collector', *Walpole Society*, 62, 2000, pp. 145-344

Geissler 2007: Thomas Geissler, 'Discoveries on a Pair of *Cassoni*', *Victoria and Albert Museum Conservation Journal*, no. 55, Spring 2007 (http://www.vam.ac.uk/res_cons/conservation/journal/number_55/cassoni/index.html)

Geronimus 2006: Dennis Geronimus, *Piero di Cosimo: Visions Beautiful and Strange*, London and New Haven, 2006

Gennari Santori 2003: Flaminia Gennari Santori, *The Melancholy of Masterpieces: Old Master Paintings in America 1900-1914*, Milan, 2003

Gennari Santori 2005: Flaminia Gennari Santori, 'Renaissance *fin de siècle*: models of patronage and patterns of taste in American press and fiction (1880-1914)', in Law and Østermark-Johansen 2005, pp. 105-20

Giannini 2007: Cristina Giannini, ed., *Donatello e una casa del Rinascimento: Capolavori dal Jacquemart-André*, exh. cat., Florence, Palazzo Medici Riccardi, 2007

Ghisalberti 1932: Fausto Ghisalberti, 'Giovanni del Vergilio espositore delle *Metamorfosi*', *Giornale Dantesco*, 34, 1932, pp. 1-110

Ginzburg 1990: Carlo Ginzburg, 'Titian, Ovid, and sixteenth-century codes for erotic illustration', in *Myths, Emblems, Clues*, trans. John Tedeschi and Anne Tedeschi, London, 1990, pp. 77-95

Goldthwaite 1993: Richard Goldthwaite, *Wealth and the Demand for Art in Italy, 1300-1600*, Baltimore, 1993

Gombrich 1985: Ernst H. Gombrich, 'Apollonio di Giovanni: A Florentine *Cassone* Workshop seen through the Eyes of a Humanist Poet' in *Norm and Form*, 4th edn, 1985, pp. 11-28

Goodison and Robertson 1967: Jack W. Goodison and G.H. Robertson, *Fitzwilliam Museum Catalogue of Paintings: Vol. 2, Italian Schools*, Cambridge, 1967

Gordon 2003: Dillian Gordon, *The Fifteenth-Century Italian Paintings: National Gallery Catalogues*, London, 2003

Gregori, Paolucci and Acidini Luchinat 1992: Mina Gregori, Antonio Paolucci and Cristina Acidini Luchinat, eds., *Maestri e botteghe:*

Pittura a Firenze alla fine del Quattrocento, exh. cat., Florence, Palazzo Strozzi, 1992

Grendler 1989: Paul Grendler, *Schooling in Renaissance Italy: Literacy and Learning*, Baltimore, 1989

Gros-Lafaige and Besson 1993-94: Anne Gros-Lafaige and Christine Besson, *Le matin des peintres. Tableaux sur bois du XIVe au XVe siècles des musées d'Angers*, exh. cat., Angers, Musées d'Angers, 1993-94

Guerrini 2001: Roberto Guerrini, ed., *Biografia dipinta: Plutarco e l'arte del Rinascimento, 1400-1550*, La Spezia, 2001

Guido 1967: Guido da Pisa, *I Fatti di Enea*, ed. Francesco Foffano, Florence, 1967

Güthmuller 1981: Bodo Güthmuller, *Ovidio Metamorphoseos vulgare: Formen und Funktionen der volkssprachlichen Wiedergabe Klassischer Dichtung in der Italienischen Renaissance*, Boppard am Rhein, 1981

Güthmuller 1989: Bodo Güthmuller, 'Die volgarizzamenti', in *Die Italienische Literatur im Zeitalter Dante, Teil 2, Die Literatur bis zur Renaissance* (Grundriss der Romantischen Literaturen des Mittelalters', vol. 10), ed. August Buck, Heidelberg, 1989, pp. 201-54, 339

Haas 1998: Louise Haas, *The Renaissance Man and his Children: Childbirth and Early Childhood in Florence, 1300-1600*, New York, 1998

Haines 1999: Margaret Haines, 'Il mondo dello Scheggia: Persone e luoghi di una carriera', in Bellosi and Haines 1999, pp. 35-64

Hankins 1995: James Hankins, 'The Baron thesis after forty years and some recent studies on Leonardo Bruni', *Journal of the History of Ideas*, 56, 1995, pp. 1-30

Hankins 1997: James Hankins, *Repertorium Brunianum. A Critical Guide to the Writings of Leonardo Bruni*, 2 vols., Rome, 1997

Hegarty 1996: Melinda Hegarty, 'Laurentian Patronage in the Palazzo Vecchio: The Frescoes of the Sala dei Gigli', *Art Bulletin*, 78, 1996, pp. 264-85

Henneberg 1991: Josephine von Henneberg, 'Two Renaissance "cassoni" for Cosimo I de' Medici in the Victoria and Albert Museum', *Mitteilungen des Kunsthistorischen Institutes in Florenz*, 35, 1991, pp. 115-32

Herald 1981: Jacqueline Herald, *Renaissance Dress in Italy, 1400-1500*, London, 1981

Herlihy and Klapisch-Zuber: David Herlihy and Christiane Klapisch-Zuber, *Les toscans et leurs familles. Une étude du 'catasto' florentin du 1427*, Paris, 1978

Highnam Court Sale 1971: *Sale at Highnam Court, Gloucestershire, by order of T. Fenton Esq.*, 2-5 November 1971

Hollander 1977: Robert Hollander, *Boccaccio's Two Venuses*, New York, 1977

Horne 1908: Herbert P. Horne, *Alessandro Filipepi, Commonly Called Sandro Botticelli, Painter of Florence*, London, 1908

Hughes 1986: Diane Owen Hughes, 'Distinguishing signs: ear-rings, Jews, and Franciscan rhetoric in the Italian Renaissance city', *Past and Present*, 112, 1986, pp. 3-59

Hülsen 1911: Christian Hülsen, 'Di alcune nuove vedute prospettiche di Roma', *Bolletino della Commissione archaelogica communale di Roma*, 39, 1911, pp. 3-23

Hughes 1997: Graham Hughes, *Renaissance Cassoni: Masterpieces of Early Italian Art: Painted Marriage Chests 1400-1500*, London, 1997

Ianziti 1998: Gary Ianziti, 'Bruni on writing history', *Renaissance Quarterly*, 51, 1998, pp. 367-91

Irving 1819: Washington Irving, 'Essay on Roscoe', *The Sketch Book (23 June 1819)*, New York, Boston, Baltimore and Philadelphia, 1819

Jacks 1993: Philip Jacks, *The Antiquarian and the Myth of Antiquity: the Origins of Rome in Renaissance Thought*, Cambridge, 1993

Jacobsen 2001: Werner Jacobsen, *Die Maler von Florenz zu Beginn der Renaissance* (Italienische Forschungen des Kunsthistorischen Institutes in Florenz, ed. Max Seidel, vol. 4:1), Berlin, 2004

Jacobson Schutte 1980: Anne Jacobson Schutte, '"Trionfo delle donne": tematiche di rovesciamento di ruoli nella Firenze rinascimentale', *Quaderni storici*, 44, 1980, pp. 474-96

Jarves 1860: James Jackson Jarves, *Descriptive catalogue of 'Old Masters', collected by James J. Jarves, to illustrate the history of painting from A.D. 1200 to the best periods of Italian art, and deposited in the 'Institute of Fine Arts', 625, Broadway, New York*, Cambridge, MA, 1860

Jarves 1861: James Jackson Jarves, *Art Studies: the Old Masters of Italy. Painting*, New York, 1861

Jayne 1996: Emily Jayne, '*Cassoni* dances and marriage ritual in fifteenth-century Italy', in Douglas Rutledge, ed., *Ceremony and Text in the Renaissance*, Newark, 1996, pp. 139-54

Kanter 1994: Laurence Kanter, *Italian Paintings in the Museum of Fine Arts, Boston, vol. 1: Thirteenth-Fifteenth Century*, Boston, 1994

Kanter 2000: Laurence Kanter, 'The 'cose piccole' of Paolo Uccello', *Apollo*, 152, no. 462, 2000, pp. 11-20

Kauffmann 1973: C.M. Kauffmann, *Catalogue of the Foreign Paintings in the Victoria and Albert Museum*, London, 1973, 2 vols.

Kemp, Massing, Christie and Groen 1991: Martin Kemp, Ann Massing, with Nicola Christie and Karin Groen, 'Paolo Uccello's *Hunt in the Forest*', *Burlington Magazine*, 133, 1991, pp. 164-78

Kent 2000: Dale Kent, *Cosimo de' Medici and the Florentine Renaissance: the Patron's Oeuvre*, Oxford, 2000

Kerr 2008: Éowyn Kerr, 'Renaissance painted *cassoni*', *Victoria and Albert Museum Conservation Journal*, 56, Spring 2008 (http://vam.ac.uk/res-cms/conservation/journal/number-56/cassoni/ index.html)

Killerby 2002: Catherine Killerby, *Sumptuary Law in Italy 1200-1500*, Oxford, 2002

King 1998: Catherine King, *Renaissance Woman Patrons: Wives and Widows in Italy, c. 1300-1550*, Manchester, 1998

Kirkham and Watson 1975: Victoria Kirkham and Paul F. Watson, ''Amore e virtù'. Two Salvers depicting Boccaccio's *Commedia delle ninfe fiorentine* in the Metropolitan Museum of Art', *Metropolitan Museum Journal*, 10, 1975, pp. 35-50

Klapisch-Zuber 1984: Christiane Klapisch-Zuber, 'Le 'zane' della sposa: la fiorentina e il suo corredo nel Rinascimento', *Memoria*, 11-12, nos. 2-3, 1984, pp. 12-23

Klapisch-Zuber 1984a: Christiane Klapisch-Zuber, 'Le chiavi fiorentine di barbablù: l'apprendimento della lettura a Firenze nel XV secolo', *Quaderni Storici*, 57, 1984, pp. 765-92

Klapisch-Zuber 1985: Christiane Klapisch-Zuber, *Women, Family and Ritual in Renaissance Italy*, trans. Lydia Cochrane, Chicago, 1985

Klapisch-Zuber 1985a: Christiane Klapisch-Zuber, 'Zacharias, or the Ousted Father: Nuptial Rites in Tuscany between Giotto and the Council of Trent', in Klapisch-Zuber 1985, pp. 178-212

Klapisch-Zuber 1985b: Christiane Klapisch-Zuber, 'The Griselda Complex: Dowry and Marriage Gifts in the Quattrocento', in Klapisch-Zuber 1985, pp. 213-46

Klapisch-Zuber 1994: Christiane Klapisch-Zuber, 'Les coffres de marriage et les plateaux d'accouchées à Florence', in *À travers l'image : lecture iconographique et sens de l'oeuvre*, ed. Sylvie Deswarte-Rosa, Paris, 1994, pp. 309-23

Klapisch-Zuber 1995: Christiane Klapisch-Zuber, 'Les noces feintes. Sur quelques lectures de deux themes iconographiques dans les "cassoni" florentins', *I Tatti Studies*, 6, 1995, pp. 11-30

Kolsky 2003: Stephen Kolsky, *The Genealogy of Women: Studies in Boccaccio's De mulieribus claris*, New York, 2003

Kolsky 2005: Stephen Kolsky, *The Ghost of Boccaccio: Writings on Famous Women in Renaissance Italy*, Turnhout, 2005

Krautheimer 1956: Richard Krautheimer, *Lorenzo Ghiberti*, Princeton, NJ, 1956

Kress 2000: Susanne Kress, 'Die konstruierte Ort der storia: Architekturkulissen in Cassoni- und Spallierzyklen der Florentiner Renaissance', in *Architektur und Erinneruung*, ed. Wolfram Martini, Göttingen, 2000, pp. 45-69

Kress 2004: Susanne Kress, 'Die camera di Lorenzo, bella in Palazzo Tornabuoni: Rekonstruktion und künstlerische Ausstattung eines Florentiner Hochzeitzimmers des späten Quattrocento', in *Domenico Ghirlandaio: Künstlerische Konstruktion von Identität im Florenz der Renaissance*, ed. Michael Rohlmann, Weimar, 2004, pp. 245-85

Kristeller 1916: Paul O. Kristeller, 'Truhen und Truhenbilder der Italienischen Frührenaissance', *Kunst und Kunsthandwerk*, 19, 1916, pp. 145-65

Krohn 2008-09: Deborah Krohn, 'Marriage as a Key to Understanding the Past', in Bayer 2008-09, pp. 9-16

Krohn 2008-09a: Deborah Krohn, 'Rites of Passage: Art Objects to Celebrate Betrothal, Marriage and the Family', in Bayer 2008-09, pp. 60-67

Laclotte and Moench 2005: Michel Laclotte and Esther Moench, *Peinture italienne : Musée du Petit Palais, Avignon*, Paris, 2005

Lanckoronski 1905: Count Karl Lanckoronski, *Einiges über Italienischen bemalte Truhen*, Vienna, 1905

Langer 2005-06: Lara Langer, *The Courtauld 'Triumph of Chastity'*, unpublished essay submitted in partial requirement for the MA in the History of Art, Courtauld Institute, University of London, 2005-06

Lanzi 1852: Luigi Lanzi, *The Story of Painting in Italy*, trans. Thomas Roscoe, 3 vols., London, 1852

La Penna 1968: Antonio La Penna, 'Il significato di Sallustio nella storiografia e nel pensiero politico di L. Bruni', in Antonio La Penna, *Sallustio e la rivoluzione romana*, Milan, 1968

Lee 1967: Peter Murray, *Catalogue of the Lee Collection*, London, 1967

Latini 1993: Brunetto Latini, *The Book of the Treasure (Li livres dou tresor)*, trans. Paul Barette and Spurgeon Baldwin, New York, 1993

Law and Østermark-Johansen 2005: John E. Law and Lene Østermark-Johansen, eds., *Victorian and Edwardian Responses to the Italian Renaissance*, Aldershot, 2005

Lesbros 2007: Delphine Lesbros, 'Regard sur les figures couchés dans les couvercles des *forzieri*', *Images Re-vues*, no. 3, 2007 (http://www.imagesrevues.org/Article_Archive.php?id_article=18)

Levi Pisetzky 1964-69: Rosita Levi Pisetzky, *Storia del costume in Italia*, Milan, 1964-69, 5 vols.

Lindow 2007: James Lindow, *The Renaissance Palace in Florence*, Aldershot, 2007

Litta 1819-83: Pompeo Litta, *Famiglie celebri italiani*, Milan, 1819-83

Livy 1919: Livy [Titus Livius], with an English translation by B.O. Foster, in 13 volumes, vol. 1, Books I and II, London and New York, 1919

Livy 1924: Livy [Titus Livius], with an English translation by B.O. Foster, in 13 volumes, vol. 3, Books V, VI and VII, London and New York, 1924

Livy 1943: Livy [Titus Livius], with an English translation in 13 volumes, vol. 7, Books XXVI-XXVII, trans. Frank G. Moore, London and Cambridge, 1943

Lloyd 1977: Christopher Lloyd, *A Catalogue of the Earlier Italian Paintings in the Ashmolean Museum*, Oxford, 1977

Lloyd 1993: Christopher Lloyd, *Catalogue of Italian Paintings before 1600 in the Art Institute, Chicago*, Chicago, 1993

London 1893-94: *Early Italian Art from 1300-1550*, exh. cat., London, New Gallery, 1893-94

London 1930: *Exhibition of Italian Art 1200-1900*, exh. cat. by Kenneth Clark, London, Royal Academy of Arts, 1930

London 1999-2000: see Rubin and Wright 1999-2000

London 2008-09: Lorne Campbell, Miguel Falomir, Jennifer Fletcher and Luke Syson *et al.*, *Renaissance Faces: Van Eyck to Titian*, exh. cat., London, National Gallery, 2008-09

Lurati 2005: Patricia Lurati, 'Il trionfo di Tamerlano: una nuova lettura iconografica di un cassone del Metropolitan Museum of Art', *Mitteilungen des Kunsthistorischen Institutes in Florenz*, 49, nos. 1-2, 2005, pp. 101-18

Lurati 2006: Patricia Lurati, 'Esotismi dei costumi femminili tardogotici nei cassoni nuziali toscani', in *Beni artistici e storici del Trentino*, 12, pp. 351-65

Lydecker 1987: John Kent Lydecker, *The Domestic Setting of the Arts in Renaissance Florence*, PhD thesis, The Johns Hopkins University, Baltimore, 1987

Lydecker 1987a: John Kent Lydecker, 'Il patriziato fiorentino e la committenza artistica per la casa', in *I ceti dirigenti nella Toscana del Quattrocento. Atti del V Convegno, 1982*, ed. Donatella Rugiandini, Florence, 1987, pp. 209-21

Macinghi Strozzi 1877: Alessandra Macinghi Strozzi, *Lettere di una gentildonna fiorentina del secolo XV ai figliuoli esuli*, ed. Cesare Guasti, Florence, 1877

Manton 2001: Elizabeth Manton, *A Trecento Tuscan Wedding Chest in the Victoria and Albert Museum: Courtly Iconography in a Marital Context*, MA report, Courtauld Institute of Art, University of London, 2001

Marucci 1963: Luisa Marucci, *Il Cassone Adimari*, Milan, 1963

Marquand 1919: Allan Marquand, *Robbia Heraldry*, Princeton, 1919

Martindale 1988: Charles Martindale, ed., *Ovid Renewed: Ovidian Influences on Literature and Art from the Middle Ages to the Twentieth Century*, Cambridge, 1988

Martines 1995: Lauro Martines, 'The Italian Renaissance tale as history', in Brown 1995, pp. 313-30

Masini and Salvadori 1991: Paola Masini and Daniela Salvadori, *Museo di Palazzo Davanzati: I cassoni dal XIV al XVI secolo: Itinerario e proposte didattiche*, Florence, 1991

Matchette 2006: Ann Matchette, 'To have and have not: the disposal of household furnishings in Florence', *Renaissance Studies*, 20, no. 5, 2006, pp. 701-16

Matthews-Grieco 2006-07: Sara Matthews-Grieco, 'Marriage and sexuality', in Ajmar-Wollheim and Dennis 2006-07, pp. 104-19

Mazet 2006: Héloise Mazet, 'Autour de l'iconographie du cheval et du chevalier dans l'oeuvre de Giovanni di Ser Giovanni, dit Lo Scheggia', electronic publication: www.lulu.com

Mazzoni 2004: Gianni Mazzoni, *Falsi d'autore: Icilio Federico Joni e la cultura del falso tra Otto e Novecento*, exh. cat., Siena, Palazzo Squarcialupi, 2004

Medici 1991: Lorenzo de' Medici, *Comento de' miei sonetti*, ed. T. Zanato, Florence, 1991

Medici 1995: Lorenzo de' Medici, *The Autobiography of Lorenzo de' Medici the Magnificent: A Commentary on My Sonnets*, trans. James Wyatt Cook, Binghampton, 1995

Miedema 1996: Nine Miedema, *Die 'Mirabilia Romae'. Untersuchungen zu ihrer Uberlieferung mit Edition der deutschen und nederländischen Texte*, Tübingen, 1996

Miziołek 1996: Jerzy Miziołek, *Soggetti classici sui cassoni fiorentini alla vigilia del Rinascimento*, Warsaw, 1996

Miziołek 1996a: Jerzy Miziołek, 'The Lanckoronski collection in Poland', *Antichità Viva*, 24, 1996, pp. 22-37

Miziołek 1997: Jerzy Miziołek, 'The Queen of Sheba and Solomon on some early-Renaissance *cassone* panels a *pastiglia dorata*', *Antichità Viva*, 26, 1997, pp. 6-23

Miziołek 1998: Jerzy Miziołek, 'La storia di Achille su due cassoni fiorentini dell'ultimo Trecento', *Mitteilungen des Kunsthistorischen Institutes in Florenz*, 41, 1998, p. 33-67

Miziołek 2000: Jerzy Miziołek, 'Alcune osservazioni sulla storia di Amore e Psiche nella pittura italiana del Tre e Quattrocento', *Fontes*, 3, 2000, pp. 133-54

Miziołek 2002: Jerzy Miziołek, '*Cassoni istoriati* with "Torello and Saladin": Observations on the Origins of a New Genre of Trecento Art in Florence', in *Italian Panel Painting of the Duecento and Trecento* (Studies in the History of Art, 61), ed. Victor M. Schmidt, New Haven and London, 2002

Miziołek 2006: Jerzy Miziołek, 'The "Odyssey" *cassone* panels from the Lanckoronski Collection: on the origins of depicting Homer's epic in the art of Italian Renaissance', *Artibus et historiae*, 27, 2006, p. 57-88

Mode 1982: Robert Mode, *The Monte Giordano famous men cycle of Cardinal Giordano Orsini and the 'Uomini famosi' tradition in fifteenth-century Italian art*, Ann Arbor, 1982

Molho 1994: Anthony Molho, *Marriage Alliance in Late Medieval Florence*, Cambridge, MA, 1994

Morley 1999: John Morley, *Furniture in the Western Tradition*, London, 1999

Morris and Hopkinson 1977: Edward Morris and Martin Hopkinson, *Walker Art Gallery, Liverpool: Foreign Catalogue*, Liverpool, 1977

Motture and Syson 2006-07: Peta Motture and Luke Syson, 'Art in the *casa*', in Ajmar-Wollheim and Dennis 2006-07, pp. 268-83

Musacchio 1998: Jacqueline Marie Musacchio, 'The Medici-Tornabuoni *desco da parto* in context', *Metropolitan Museum Journal*, 33, 1998, pp. 137-51

Musacchio 1999: Jacqueline Marie Musacchio, *The Art and Ritual of Childbirth in Renaissance Italy*, London and New Haven, 1999

Musacchio 2003: Jacqueline Marie Musacchio, 'The Medici sale of 1495 and the second-hand market for domestic goods in Florence', in Marcello Fantoni, Louisa Matthew and Sara Matthews Grieco, eds., *The Art Market in Italy (Fifteenth-Seventeenth Centuries)*, Ferrara, 2003, pp. 313-23

Musacchio 2006-07: Jacqueline Marie Musacchio, 'Conception and birth', pp. 124-135 in Ajmar-Wollheim and Dennis 2006-07

Musacchio 2008: Jacqueline Marie Musacchio, *Art, Marriage and Family in the Renaissance Florentine Palace*, New Haven and London, 2008

Musacchio 2008-09: Jacqueline Marie Musacchio, 'The triumph of everyday life', in Baskins 2008-09, pp. 31-46

Musacchio 2008-09a: Jacqueline Marie Musacchio, 'Wives, Lovers and Art in Italian Renaissance Courts' in Bayer 2008-09, pp. 29-42

Neher and Shepherd 2000: Gabriele Neher and Rupert Shepherd, eds., *Revaluing Renaissance Art*, Aldershot, 2000

Nelson 2007: Jonathan Katz Nelson, 'Putting Botticelli and Filippino in their place: the intended height of *spalliera* paintings and *tondi*', in *Invisibile agli occhi: Atti della giornata di studi in ricordi di Lisa Venturini, Firenze, Fondazione Roberto Longhi, 15 dicembre 2005*, ed. Nicoletta Baldini, Florence, 2007, pp. 53-63

Neri 1976: Neri di Bicci, *Le ricordanze*, ed. Bruno Santi, Pisa, 1976

New Gallery 1893-94: *An Exhibition of Early Italian Art*, London, New Gallery, 1893-94

Newbery, Bisacca and Kanter 1990: Timothy Newbery, George Bisacca and Laurence Kanter, *Italian Renaissance Frames*, exh. cat., New York, Metropolitan Museum of Art, 1990

Newton 1975: Stella Mary Newton, *Renaissance Theatre Costume and the Sense of the Historic Past*, London, 1975

Nichols 1986: Francis Morgan Nichols, trans., and Eileen Gardner, ed., Anon., *The Marvels of Rome (Mirabilia Urbis Romae)*, New York, 1986

Nützmann 2000: Hannelore Nützmann, *Alltag und Feste: Florentinische Cassone- und Spalliera-malerei aus der Zeit Botticellis*, Berlin, Staatliche Museen zu Berlin, 2000

Olsen: Christine Olsen, 'Gross Expenditure: Botticelli's Nastagio degli Onesti panels', *Art History*, 15, 1992, pp. 146-70

Ortner 1998: Alexandra Ortner, *Petrarcas "Trionfi" in Malerei, Dichtung und Festkultur:Untersuchung zur Entstehung und Verbreitung eines florentinischen Bildmotivs auf cassoni und deschi da parto des 15. Jahrhunderts*, Weimar, 1998

Ovid 1955: Ovid [P. Ovidius Naso], *Metamorphoses*, trans. Mary Innes, Harmondsworth, 1955

Ovid 1977: P. Ovidius Naso, *Metamorphoses*, trans. and ed. Frank J. Miller, London, 1977, 3rd edn, 6 vols.

Pacciani 1992: Riccardo Pacciani, 'Immagini, arti e architetture nelle feste di età laurenziana', in Ventrone 1992, pp. 119-37

Padoa Rizzo and Frosinini 1984: Anna Padoa Rizzo and Cecilia Frosinini, 'Stefano d'Antonio di Vanni (1405-1483). Opere e documenti', *Antichità Viva*, 23, 1984, pp. 5-33

Padoa Rizzo and Guidotti 1986: Anna Padoa Rizzo and Alessandra Guidotti, 'Pubblico e secolo', *Ricerche storiche*, 26, 1986, pp. 535-50

Paolini 1991: Claudio Paolini, 'Una "raffinata dimora signorile"', in *MCM*, V, 1991, 14, pp. 28-31

Paolini 2006-07: 'Chests', in Ajmar-Wollheim and Dennis 2006-07, pp. 120-21

Paribeni 2001: Andrea Paribeni, 'Iconografia, committenza, topografia di Costantinopoli: sul cassone di Apollonio di Giovanni con la "Conquista di Trebisonda"', *Rivista dell'Istituto Nazionale d'Archeologia e Storia dell'Arte*, 3 ser., 24, 2001, pp. 255-304

Paribeni 2002: Andrea Paribeni, 'Una testimonianza iconografica della battaglia di Ankara (1402) in Apollonio di Giovanni', in *Europa e Islam tra i secoli XIV e XVI*, ed. Michele Bernardini, Naples, 2002, pp. 427-41

Partridge 2006: Wendy Partridge, 'The Triumphs of Petrarch', in *Studying and Conserving Pictures: Occasional Papers on the Samuel H. Kress Collection*, New York, 2006, pp. 99-111

Pavoni 1997: Rosanna Pavoni, ed., *Reviving the Renaissance: The Use and Abuse of the Past in Nineteenth-Century Italian Art and Decoration*, Cambridge, 1997

Penny 2005: Nicholas Penny, 'Cradles in the *Portego*', *London Review of Books*, 5 January 2005, pp. 20-22

Pernis 1994: Maria Grazia Pernis, 'Fifteenth-century Patrons and the Scipio-Caesar Controversy', *Text*, 6, 1994, pp. 181-95

Petrarch 1879: Francesco Petrarca, *The Sonnets, Triumphs and other Poems of Petrarch, edited by Thomas Campbell*, London, 1879 (http://www.gutenberg.org/files/17650/17650-8.txt)

Petrarch 1996: Francesco Petrarca, *Trionfi, rime estravaganti, codice degli abbozzi*, ed. Vincio Pacca and Laura Paolino, Milan, 1996

Phillips 1999: sale catalogue, *Old Master Paintings*, Phillips, London, 6 July 1999

Plutarch 1914: Plutarch, *Parallel Lives, with an English Translation by Bernadotte Perrin*, 10 vols., London and New York, vol. 1, 1914

Plutarch 1917: Plutarch, *Parallel Lives, with an English Translation by Bernadotte Perrin*, 10 vols., London and New York, vol. 5, 1917

Plutarch 1919: Plutarch, *Parallel Lives, with an English Translation by Bernadotte Perrin*, 10 vols., London and New York, vol. 7, 1919

Polidori Calamandrei 1924: E. Polidori Calamandrei, *Le vesti delle donne fiorentine nel Quattrocento*, Florence 1924 (reprinted Rome, 1973)

Pope-Hennessy and Christiansen 1980: Sir John Pope-Hennessy and Keith Christiansen, 'Secular painting in 15th-century Tuscany: Birth trays, *cassone* panels, and portraits', *Metropolitan Museum of Art Bulletin*, 38, 1980, pp. 2-64

Preyer 1993: Brenda Preyer, *Il Palazzo Corsi-Horne: dal diario di restauro di H. Horne*, Rome, 1993

Preyer 2000: Brenda Preyer, 'Renaissance "Art and Life" in the Scholarship and Palace of Herbert P. Horne', in *Gli anglo-americani a Firenze. Idea e costruzione del Rinascimento, Atti del convegno*, ed. Marcello Fantoni, Rome, 2000, pp. 235-48

Preyer 2004: Brenda Preyer, 'Around and in the Gianfigliazzi Palace in Florence: developments on the Lungarno Corsini in the fifteenth and sixteenth centuries', *Mitteilungen des Kunst-historischen Institutes in Florenz*, 48, 2004, pp. 55-104

Preyer 2006-07: Brenda Preyer, 'The Florentine *casa*', in Ajmar-Wollheim and Dennis 2006-07, pp. 34-49

Pucci 1862: Antonio Pucci, *Historia della Reina d'Oriente di A.P. fiorentino poema cavalleresco del sec. XIII, pubblicato e restituito alla sua buona primitiva lezione su testi a penna dal dottore Anicio Bonucci*, Bologna, 1862

Radke 2007-08: Gary Radke, ed., *The Gates of Paradise. Lorenzo Ghiberti's Renaissance Masterpiece*, exh. cat., Atlanta, High Museum, 2007-08

Ragghianti Collobi 1949: Licia Ragghianti Collobi, *Lorenzo il Magnifico e gli arti: Mostra d'arte antica*, exh. cat., Florence, Palazzo Strozzi, 1949

Randolph 1998: Adrian Randolph, 'Performing the bridal body in fifteenth-century Florence', *Art History*, 21, 1998, pp. 182-200

Randolph 2002: Adrian Randolph, *Engaging Symbols: Gender, Politics and Public Art in Fifteenth-Century Florence*, New Haven and London, 2002

Randolph 2005: Adrian Randolph, 'Gendering the period eye: *deschi da parto* and Renaissance visual culture', *Art History*, 27, 2005, pp. 538-62

Randolph 2008-09: Adrian Randolph, 'Unpacking *cassoni*: marriage, ritual, memory', in Baskins 2008-09, pp. 15-30

Rankin 1906: William Rankin, 'Cassone fronts in American collections', *Burlington Magazine*, 9, 1906, pp. 288-91

Rankin 1906-07: William Rankin, 'Cassone fronts in American collections', *Burlington Magazine*, 10, 1906-07, pp. 67-68, 205-06, 332-35

Rankin 1907: William Rankin, '*Cassone* fronts in American collections', *Burlington Magazine*, 11, 1907, pp. 131-32, 339-41

Rankin 1907-08: William Rankin, '*Cassone* fronts in American collections', *Burlington Magazine*, 12, 1907-08, pp. 63-64

Rankin 1908: William Rankin, '*Cassone* fronts in American collections', *Burlington Magazine*, 13, 1908, p. 382

Reynolds and Wilson 1983: Leighton Durham Reynolds and Nigel Wilson, *Texts and Transmission: A Survey of the Latin Classics*, Oxford, 1983

Reynolds and Wilson 1991: Leighton Durham Reynolds and Nigel Wilson, *Scribes and Scholars: A Guide to the Transmission of Greek and Latin Literature*, Oxford, 1991

Ricketts 1997: Jill Ricketts, *Visualising Boccaccio: Studies on Illustrations of the Decameron from Giotto to Pasolini*, Cambridge and New York, 1997

Robbins 2004: Jillian Curry Robbins, *The Art of History: Livy's Ab urbe condita and the Visual Arts of the Early Renaissance*, PhD thesis, Florida State University, 2004

Roscoe 1796: William Roscoe, *The Life of Lorenzo de' Medici, called the Magnificent*, 2 vols., Liverpool, 1796

Roscoe (?) 1816: William Roscoe (?), *Catalogue of the Genuine and Entire Collection of Drawings and Pictures the Property of William Roscoe which will be sold by Auction by Mr Winstanley at his rooms in Marble Street Liverpool 23 September and five following days*, advertisement, Liverpool, 1816

Roscoe 1822: William Roscoe, *Illustrations Historical and Critical of the Life of Lorenzo de' Medici*, London and Edinburgh, 1822

Rubin 1994: Patricia Lee Rubin, *Giorgio Vasari: Art and History*, New Haven and London, 1994

Rubin 1994a: Patricia Lee Rubin, 'Vasari, Lorenzo and the Myth of Magnificence', in Florence, Istituto Nazionale di Studi sul Rinascimento, ed., *Lorenzo il Magnifico e il suo mondo, Convegno internazionale di studi, Firenze, 9-13 giugno 1992*, Florence, 1994, pp. 427-42

Rubin 2007: Patricia Lee Rubin, *Images and Identity in Fifteenth-Century Florence*, New Haven and London, 2007

Rubin and Ciappelli: Patricia Lee Rubin and Giovanni Ciappelli, eds., *Art, Memory and Family in Renaissance Florence*, Cambridge, 2000

Rubin and Wright 1999-2000: Patricia Lee Rubin and Alison Wright, *Renaissance Florence: The Art of the 1470s*, exh. cat., London, National Gallery, 1999-2000

Rubinstein 1995: Nicolai Rubinstein, *The Palazzo Vecchio 1298-1532. Government, Architecture and Imagery in the Civic Palace of the Florentine Republic*, Oxford, 1995

Ruvoldt 2004: Maria Ruvoldt, *The Italian Renaissance Imagery of Inspiration: Metaphors of Sex, Sleep and Dreams*, Cambridge, 2004

Sabbatini 1905: Remigio Sabbatini, *Le scoperte dei codici latini e greci nei secoli XIV e XV*, Florence, 1905

San Juan 1992: Rose Marie San Juan, 'Mythology, women and Renaissance private life: the myth of Eurydice in Italian Renaissance furniture painting', *Art History*, 15, 1992, pp. 127-45

Sarti 2001: Susanna Sarti, *Giovanni Pietro Campana (1800-80): The Man and his Collection*, Oxford, 2001

Sarti 2002: Giovanni Sarti, *Fonds d'or et fonds peints italiens (1300-1560)*, exh. cat., Paris, Galerie G. Sarti, no. 3, 2002

Sbaraglio 2007: Lorenzo Sbaraglio, 'Note su Giovanni dal Ponte "cofanaio"', *Commentari d'arte*, 13, no. 38, 2007, pp. 38-41

Scalini 2001: Mario Scalini, ed., *Riflessi di una galleria: dipinti dell'eredità Bardini*, Livorno, 2001

Scalia and De Benedictis 1984: Fiorenza Scalia and Cristina De Benedictis, eds., *Il Museo Bardini a Firenze*, Milan, 1984

Schiaparelli 1908: Attilio Schiaparelli, *La casa fiorentina ed i suoi arredi nei secoli XIV e XV*, Florence, 1908

Schubring 1904: Paul Schubring, *Das italienische Grabmal der Frührenaissance*, Berlin, 1904

Schubring 1907: Paul Schubring, *Donatello. Des Meisters Werke*, Stuttgart and Leipzig, 1907

Schubring 1912: Paul Schubring, '*Cassone* panels in English private collections', *Burlington Magazine*, 22, 1913, pp. 158-65, 196-203, 326-31

Schubring 1915: Paul Schubring, *Cassoni: Truhen und Truhenbilder der italienischen Frührenaissance: Ein Beitrag zur Profanmalerei im Quattrocento*, 2 vols., Leipzig, 1915

Schubring 1922: Paul Schubring, '*Cassone* pictures in America', *Art in America and Elsewhere*, 11, 1922-23, pp. 231-43

Schubring 1923: Paul Schubring, *Cassoni: Truhen und Truhenbilder der italienischen Frührenaissance: Ein Beitrag zur Profanmalerei im Quattrocento*, 2nd edn, 2 vols. and supplement, Leipzig, 1923

Schubring 1927: Paul Schubring, 'New *cassone* panels, *Apollo*, 5, 1927, pp. 155-56

Schubring 1927a: Paul Schubring, 'Two new "deschi" in the Metropolitan Museum', *Apollo*, 6, 1927, pp. 105-07

Schubring 1928: Paul Schubring, 'New *cassone* panels', *Apollo*, 8, 1928, pp. 177-83

Schubring 1929: Paul Schubring, 'Petrarch's *trionfo* of fame', *Pantheon*, 4, 1929, pp. 561-62

Schubring 1929a: Paul Schubring, 'Neue Cassoni', in *Belvedere*, 8, 1929, pp. 176-79

Schubring 1930: Paul Schubring, 'Neue Cassoni', in *Belvedere*, 9, 1930, pp. 1-3

Settis 1984-86: Salvatore Settis, ed., *Memoria dell'antico nell'arte italiana*, Turin, 3 vols., 1984-86

Settis 1995: Salvatore Settis, 'Traiano a Hearst Castle. Due cassoni estensi', *I Tatti Studies*, 6, 1995, pp. 31-82

Seymour 1970: Charles Seymour Jr., *Early Italian Paintings in the Yale University Art Gallery: A Catalogue*, New Haven and London, 1970

Seznec 1953: Jean Seznec, *The Survival of the Pagan Gods: The Mythological Tradition and its Place in the Renaissance*, Princeton, 1953

Shapley 1966: Fern Rusk Shapley, *Paintings from the Kress Collection, Italian School, XIII-XV Century*, New York, 1966

Shapley 1979: Fern Rusk Shapley, *Catalogue of the Italian Paintings, Washington: National Gallery of Art*, Washington, D.C., 1979

Simintendi 1846: Arrigo Simintendi, *I primi V libri delle Metamorfosi d'Ovidio, volgarizzate da Ser Arrigo Simintendi da Prato*, ed. Casimiro Basi and Cesare Guasti, 3 vols., Prato, 1846-50

Simmoneau 2007: Karinne Simmoneau, 'Diana, Callisto and Arcas: A Matrimonial Panel from the Springfield Museum of Fine Arts', *Renaissance Studies*, 21, 2007, pp. 44-61

Smith Sale 1938: *Sale of Effects of Sir Herbert Smith*, Witley Park, Worcestershire, 27-29 September 1938

Spallanzani and Bertelà 1992: Marco Spallanzani and Gaeta Bertelà, eds., *Libro d'inventario dei beni di Lorenzo il Magnifico*, Florence, 1992

Spychalska-Boczkowska 1968: Anna Spychalska-Boczkowska, 'Diana with Meleagros and Actaeon', *Bulletin du Musée National de Varsovie*, 9, 1968, pp. 29-36

Staderini 2004: Andrea Staderini, 'Un contesto per la collezione di "primitivi" di Alexis-François Artaud de Montor', *Proporzioni*, 5, 2004 [2006], pp. 23-62

Stechow 1932: Wolfgang Stechow, *Apollo und Daphne* (Studien der Bibliothek Warburg no. 23), Leipzig, 1932

Stechow 1944: Wolfgang Stechow, 'Marco del Buono and Apollonio di Giovanni. *Cassone* Painters', *Bulletin of the Allen Memorial Art Museum, Oberlin College*, 1, 1944, pp. 5-24

Strehlke 2004: Carl Brandon Strehlke, *Italian Paintings, 1250-1450, in the John G. Johnson Collection and the Philadelphia Museum of Art*, Philadelphia, 2004

Sturgis 1868: Russell Sturgis Jr., *Manual of the Jarves Collection of Early Italian pictures, Deposited in the Gallery of the Yale School of Fine Arts*, New Haven, 1868

Sutton 1958: Denys Sutton, 'London's new art gallery', *Country Life*, 13 November 1958, pp. 1120-21

Swallow 2007: Deborah Swallow et al., *The Courtauld Gallery Masterpieces*, London, 2007

Syson 2006-07: Luke Syson, 'Representing Domestic Interiors', in Ajmar-Wollheim and Dennis 2006-07, pp. 86-101

Syson 2007-08: Luke Syson et al., *Renaissance Siena: Art for a City*, exh. cat., London, National Gallery, 2007-08

Syson and Thornton 2001: Luke Syson and Dora Thornton, *Objects of Virtue: Art in Renaissance Italy*, London, 2001

Thomas 1995: Anabel Thomas, *The Painter's Practice in Renaissance Tuscany*, Cambridge, 1995

Thomas 2002: Anabel Thomas, 'Seven virtues and the liberal arts for the bedchamber? Tracking the history of Italian Renaissance *cassone* panels', *Critica d'arte*, 65, no. 16, 2002, pp. 67-77

Thornton 1969: Peter Thornton, 'I mobili italiani del Victoria and Albert Museum. Parte prima: Il XIV e il XV secolo', *Arte Illustrata*, 19-21, 1969, pp. 76-87

Thornton 1984: Peter Thornton, '*Cassoni-forzieri, goffani* and *cassette*. Terminology and its Problems', *Apollo*, 120, 1984, pp. 246-51

Thornton 1991: Peter Thornton, *The Italian Renaissance Interior, 1400-1600*, London and New York, 1991

Tinagli 1997: Paola Tinagli, *Women in Italian Renaissance Art: Gender, Representation, Identity*, Manchester, 1997

Tinagli 2000: Paola Tinagli, 'Womanly virtues in Quattrocento Florentine marriage furnishings', in *Women in Italian Renaissance culture and society*, ed. Letizia Panizza, Oxford, 2000, pp. 265-84

Tomasi 2003: Michele Tomasi, 'Miti antichi e riti nuziali: sull'iconografia e la funzione dei cofanetti degli Embriachi', *Iconographica*, 2, 2003, pp. 126-45

Tomory 1976: Peter Tomory, *Catalogue of the Italian Paintings before 1800, Sarasota, John and Mable Ringling Museum of Art*, Sarasota, 1976

Trexler 1980: Richard Trexler, *Public Life in Renaissance Florence*, New York, 1980

Trexler 1997: Richard Trexler, *The Journey of the Magi. Meanings in History of a Christian Story*, Princeton, NJ, 1997

Troutman 1979: Philip Troutman, *The paintings' collections of the Courtauld Institute of Art*, London and Chicago, 1979

Uguccioni 1988: Alessandra Uguccioni, *Salamone e la regina di Saba. La pittura di cassone a Ferrara; presenze nei musei americani*, Ferrara, 1988

Van Marle 1923-38: Raimond Van Marle, *The Development of the Italian Schools of Painting*, 19 vols., The Hague, 1923-38

Van Marle 1928: Raimond Van Marle, *The Development of the Italian Schools of Painting*, vol. 10, The Hague, 1928

Van Marle 1931: Raimond Van Marle, *Iconographie de l'art profane au Moyen-Âge et à la Renaissance, et la décoration des demeures*, 2 vols., The Hague, 1931-32

Valerius Maximus 1995-97: Valerius Maximus, *Faits et dits mémorables*, ed. and trans. Robert Combès, 2 vols., Paris, 1997

Vasari 1550 and 1568: Giorgio Vasari, *Le vite de' più eccellenti pittori, scultori ed architettori nelle redazioni del 1550 e 1568*, eds. Paola Barocchi and Rosa Bettarini, 6 vols., Florence, 1966-87 (vol. 3, 1971; vol. 4, 1976; vol. 5, 1984)

Vasari 1996: Giorgio Vasari, *Lives of the Painters, Sculptors and Architects*, trans. Gaston de Vere, introduction by David Ekserdjian, 2 vols., London, 1996

Velli 1991: S. Tommaso Velli, 'L'iconografia del "Ratto delle Sabine". Un'indagine storica', *Prospettiva*, 63, 1991, pp. 17-39

Ventrone 1992: Paola Ventrone, ed., *Le tems revient: 'l tempo si rinuova. Feste e spettacoli nella Firenze di Lorenzo il Magnifico*, exh. cat., Florence, Palazzo Medici Riccardi, 1992

Ventrone 1992a: Paola Ventrone, 'Feste e spettacoli nella Firenze di Lorenzo il Magnifico', in Ventrone 1992, pp. 21-51

Ventrone 1996: Paola Ventrone, 'Lorenzo's "politica festiva"', in *Lorenzo the Magnificent: Culture and Politics*, ed. Michael Mallett and Nicholas Mann, London, 1996, pp. 114-15

Verino 1790: Ugolino Verino, *De illustratione urbis florentiae*, Paris, 1790

Verino 1940: Ugolino Verino, *Flametta*, ed. L. Mencaraglia, Florence, 1940

Vertova 1979: Luisa Vertova, 'Cupid and Psyche in Renaissance Painting before Raphael', *Journal of the Warburg and Courtauld Institutes*, 42, 1979, pp. 104-21

Vertova 2000: Luisa Vertova, 'La favola di Psiche riscoperta a Firenze', *Fontes*, 3, 2000, pp. 107-31

Vidas 2003-04: Marina Vidas, 'The Copenhagen *cassoni*: constructing narrative images for Quattrocento audiences', *Anelecta Romana Instituti Danici*, 29, 2003-04, pp. 55-65

Voragine 1993: Jacobus de Voragine, *The Golden Legend. Readings on the Saints*, trans. William Granger Ryan, 2 vols., Princeton, NJ, 1993

Wackernagel 1981: Martin Wackernagel, *The World of the Florentine Renaissance Artist*, trans. Alison Luchs, Princeton, NJ, 1981

Wainright 1999: Clive Wainright, 'Shopping for South Kensington: Fortnum and Henry Cole in Florence 1858-1859', in *C.D.E. Fortnum and the Collecting and Study of Applied Arts and Sculpture in Victorian England*, ed. Ben Thomas and Timothy Wilson, Oxford, 1999, pp. 171-85

Walcher Casotti 1997: Maria Walcher Casotti, 'Breve nota sui cassoni con i "Trionfi" del Petrarca di Trieste', in *Scritti per L'Istituto Germanico di Storia dell'Arte di Firenze: settanta studiosi italiani*, ed. Cristina Acidini Luchinat, Florence, 1997

Warburg 1996: Aby Warburg, *Il rinascimento del paganesimo antico*, ed. Gertrude Bing, Florence, 1996

Watson 1971: Paul F. Watson, 'Boccaccio's *Ninfale fiesolano* in early Florentine *cassone* painting', *Journal of the Warburg and Courtauld Institutes*, 34, 1971, pp. 331-33

Watson 1974: Paul F. Watson, 'The Queen of Sheba in Christian Tradition', in *Solomon and Sheba*, ed. James Pritchard, New York, 1974, pp. 115-45

Watson 1979: Paul F. Watson, *The Garden of Love in Tuscan Art of the Early Renaissance*, Philadelphia, 1979

Watson 1979-80: Paul F. Watson, 'Apollonio di Giovanni and Ancient Athens', *Bulletin of the Allen Memorial Art Museum*, 37, 1979-80, pp. 3-25

Watson 1985-86: Paul F. Watson, 'A Preliminary List of Subjects from Boccaccio in Italian Painting, 1400-1500 - Boccaccio visualizzato, III', *Studi sul Boccaccio*, vol. 15, 1985-86, pp. 149-166

Watson 1987: Paul F. Watson, 'More Subjects from Boccaccio in Italian Renaissance Painting', *Studi sul Boccaccio*, vol. 16, pp. 273-74

Watson 2003: Paul F. Watson, *Virtù et Voluptas in Cassone Painting* (PhD thesis submitted to Yale University, 1970), Ann Arbor, 2003

Wegner 2008: Susan Wegner, *Beauty and Duty: The Art and Business of Renaissance Marriage*, exh. cat., Brunswick, Bowdoin College Museum of Art, 2008

Weston-Lewis 2000: Aidan Weston-Lewis, ed., *'A Poet in Paradise': Lord Lindsay and Christian Art*, exh. cat., Edinburgh, National Gallery of Scotland, 2000

Welch 1997: Evelyn Welch, *Art and Society in Italy 1350-1500*, Oxford, 1997

Whitaker 1986: Lucy Whitaker, *The Florentine Picture Chronicle - A reappraisal*, MPhil thesis, University of London, Courtauld Institute of Art, 1986

Witthof 1982: Brucia Witthof, 'Marriage rituals and marriage chests in Quattrocento Florence', *Artibus et historiae*, 5, 1982, pp. 43-59

Wright 2005: Alison Wright, *The Pollauiolo Brothers: The Arts of Florence and Rome*, New Haven and London, 2005

Zeri and Gardner 1971: Federico Zeri and Elisabeth Gardner, *Italian Paintings: A Catalogue of the Collection of the Metropolitan Museum of Art: Florentine School*, 2 vols., New York, 1971

Photographic Credits